David Busch's Quick Snap Guide to

Adobe Photoshop.com

An Instant Start-Up Manual for Editing and Sharing Your Photos Online

David D. Busch

COURSE TECHNOLOGY
CENGAGE Learning™

**David Busch's Quick Snap Guide to Adobe®
Photoshop.com: An Instant Start-Up
Manual for Editing and Sharing Your
Photos Online**
David D. Busch, Rebekkah Hilgraves

**Publisher and General Manager,
Course Technology PTR:**
Stacy L. Hiquet

Associate Director of Marketing:
Sarah Panella

Manager of Editorial Services:
Heather Talbot

Marketing Manager:
Jordan Casey

Executive Editor:
Kevin Harreld

Project Editor:
Jenny Davidson

Technical Reviewer:
Michael D. Sullivan

PTR Editorial Services Coordinator:
Jennifer Blaney

Interior Layout Tech:
Bill Hartman

Cover Designer:
Mike Tanamachi

Indexer:
Katherine Stimson

Proofreader:
Sara Gullion

For product information and technology assistance, contact us at
Cengage Learning Customer & Sales Support, 1-800-354-9706

For permission to use material from this text or product,
submit all requests online at **cengage.com/permissions**
Further permissions questions can be emailed to
permissionrequest@cengage.com

Adobe and Photoshop.com are either registered trademarks or
trademarks of Adobe Systems Incorporated in the United States and/or
other countries.

All other trademarks are the property of their respective owners.

Library of Congress Control Number: 2008929220

ISBN-13: 978-1-59863-815-8

ISBN-10: 1-59863-815-7

Course Technology
25 Thomson Place
Boston, MA 02210
USA

Cengage Learning is a leading provider
of customized learning solutions with
office locations around the globe,
including Singapore, the United
Kingdom, Australia, Mexico, Brazil, and
Japan. Locate your local office at:
international.cengage.com/region

Cengage Learning products are
represented in Canada by Nelson
Education, Ltd.

For your lifelong learning solutions, visit
courseptr.com

Visit our corporate website at
cengage.com

Printed in the United States of America
1 2 3 4 5 6 7 11 10 09

This is for all you fledgling
image editors out there.
Help is on the way.

Acknowledgments

Once again thanks to the folks at Course Technology PTR, who have pioneered publishing digital imaging books in full color at a price anyone can afford. Special thanks to executive editor Kevin Harreld, who always gives me the freedom to let my imagination run free with a topic, as well as my veteran production team including project editor Jenny Davidson and technical editor Mike Sullivan. Also thanks to Mike Tanamachi, cover designer; Bill Hartman, layout; and my agent, Carole McClendon, who has the amazing ability to keep both publishers and authors happy.

About the Authors

With more than a million books in print, **David D. Busch** is one of the best-selling authors of books on digital photography and imaging technology, and the originator of popular series like *David Busch's Pro Secrets* and *David Busch's Quick Snap Guides*. He has written eight hugely successful guidebooks for Nikon digital SLR models, ten additional user guides for other camera models, as well as many popular books devoted to dSLRs, including *Mastering Digital SLR Photography, Second Edition* and *Digital SLR Pro Secrets*. As a roving photojournalist for more than 20 years, he illustrated his books, magazine articles, and newspaper reports with award-winning images. He's operated his own commercial studio, suffocated in formal dress while shooting weddings-for-hire, and shot sports for a daily newspaper and upstate New York college. His photos have been published in magazines as diverse as *Scientific American* and *Petersen's PhotoGraphic*, and his articles have appeared in *Popular Photography & Imaging, The Rangefinder, The Professional Photographer*, and hundreds of other publications. He's also reviewed dozens of digital cameras for CNet and *Computer Shopper*.

When About.com named its top five books on Beginning Digital Photography, debuting at the #1 and #2 slots were Busch's *Digital Photography All-In-One Desk Reference for Dummies* and *Mastering Digital Photography*. During the past year, he's had as many as five of his books listed in the Top 20 of Amazon.com's Digital Photography Bestseller list—simultaneously! Busch's 100-plus other books published since 1983 include bestsellers like *David Busch's Quick Snap Guide to Using Digital SLR Lenses*. He is a member of the Cleveland Photographic Society, which has been in continuous operation since 1887, and can be located at www.clevelandphoto.org.

Co-author **Rebekkah Hilgraves** is the founder and president of SheTech and Company, which began as a part-time, one-person consultancy in the mid-1990s. Specializing in user training and online curriculum, Hilgraves has been working her way through the IT industry for many years, starting in technical support and moving through technical documentation, training, project management, and finally small business consulting, which includes web hosting, web design and maintenance, internet and social media marketing, small networks, software support and the ubiquitous "other duties as assigned" (which is probably the entirety of any consultant's job description). She is also an acclaimed soprano who actively performs in numerous operas, solo recitals, and as a guest concert artist in venues throughout the United States.

Contents

Preface

You're getting some great photos with your digital camera. In fact, you're humbly convinced that you may have a few dozen (or hundred) photographic masterpieces. It's time to share your favorite images with the world. Adobe's online image sharing and editing service, Photoshop.com, is exactly what you need to post your pictures in albums that anyone with Internet access can enjoy. Even better, it offers the tools that will let you crop your images, improve their color and tones, and add a few creative enhancements that really make them shine. Best of all, for those with a modest number of photos to start with, Photoshop.com is absolutely free. What more could you ask for?

How about a book that provides a quick introduction to getting the most out of Photoshop.com, and using all its features? If you'd like a friendly escort who can show you that Adobe's online service is even easier to use than you thought, and who can reveal hidden tools you can use to improve your photos, you need this *Quick Snap Guide*. If you want to seamlessly meld your existing Facebook, Flickr, or many of the other online photo collections, you'll find that here, too.

We're not going to bog you down with technical mumbo-jumbo and confusing options. We're going to tell you just what you need to get started using Photoshop.com effectively to display, fix, and touch-up your photos, and create interesting new images from existing shots, so you can amaze your friends, family, colleagues… and yourself.

Introduction

Photoshop.com, *nee* Photoshop Express, caused a bit of a sensation when Adobe unveiled its plans early in 2008. Certainly, online photo album sharing and image editing had been available for years, and had achieved a certain level of maturity in the latter part of the first decade of the new Millennium. It was obvious that the services that Adobe promised in the initial Photoshop Express beta were soon to become an essential part of everyone's lives (can you visualize, for example, *not* having Facebook or MySpace, or even Flickr?). But the beta of Photoshop Express (which eventually became Photoshop.com) was from Adobe, the world leader in image editing software for everyone from newbies (Adobe Photoshop Elements) to grizzled

professionals (Adobe Photoshop CS4). Clearly, this was an important step forward.

As it turned out, Photoshop.com proved to be even better than anyone expected. It's easier to use than any previous Adobe image editing product, has the key features of the existing online sharing/editing services (plus a few more), and, best of all, seamlessly integrates with Photoshop Elements 7.0 for Windows (and, soon with the 7.0 Macintosh edition). Photoshop.com doesn't replace Elements; it makes Elements even better. And, if your needs are basic enough, you may not even need computer-based image editing software at all. It's entirely possible to store your collection online, share images with others, tweak your photos to make them even better, as well as make and send hardcopy prints when you need them.

But as easy as Photoshop.com is to use and work with, experience has shown that many people are more comfortable with a book they can have at their side as they sit at the computer (or to browse through while seated comfortably in an armchair), paging through searching for the tips, tricks, and instruction they need to get up and running quickly. That's the goal of this *Quick Snap* book.

This is the fifth book in the *Quick Snap* guidebook series, each of which takes a single puzzling area of digital photography or image editing and condenses every concept into a few pages that explain everything you need to know in easy-to-absorb bullet points, some essential text that summarizes just what you absolutely need to know, and is clearly illustrated with a few compelling photographs. Previous

books in this series have dealt with point-and-shoot and digital SLR cameras, using lenses, and working with light. This one is devoted entirely to the mysteries of Photoshop.com.

Like all the *Quick Snap* guides, this book is aimed at avid snapshooters and photographers who may be new to digital photography, and are overwhelmed by their options while underwhelmed by the explanations they receive in most of the photography books available. The most comprehensive guidebooks try to cover too much material. You're lost in page after page of background and descriptions, most of which you're not really interested in. Books of this type are great if you already know what you don't know, and you can find an answer somewhere using voluminous tables of contents or lengthy indexes.

This book is designed for those who'd rather leaf through a catalog of ideas and techniques, arranged in a browseable layout. You can thumb through this *Quick Snap* guide and find the exact information you need quickly. All the basics of creating an account on Photoshop.com, uploading your first photos, building your albums, and sharing them with friends and family are presented within two-page and four-page spreads, so all the explanations and the illustrations that illuminate them are there for easy access. This book should solve many of your problems with a minimum amount of fuss and frustration.

Then, when you're ready to learn more, you might want to look for more *Quick Snap* guides that cover different topics. They are offered by Course Technology, each approaching a photographic topic from a different perspective. They include:

Quick Snap Guide to Digital Photography
This one is aimed at those who are working with their first point-and-shoot camera, and need to understand how to zoom, work with memory cards, when to use flash, and how to choose accessories. This book will help you even before you buy your first digital camera, and it brings you up to speed with your new camera after you take it out of the box. It's not specific to any particular camera model; this book has only the solid basics that apply to just about every point-and-shoot camera on the market.

Quick Snap Guide to Digital SLR Photography
If you're new to digital SLRs, this book belongs in your camera bag as a reference, so you can always have the basic knowledge you need with you, even if it doesn't yet reside in your head. It serves as a refresher that summarizes the basic features of digital SLR cameras, and what settings to use and when, such as continuous autofocus/single autofocus,

aperture/shutter priority, EV settings, and so forth. The guide also includes recipes for shooting the most common kinds of pictures, with step-by-step instructions for capturing effective sports photos, portraits, landscapes, and other types of images.

David Busch's Quick Snap Guide to Using Digital SLR Lenses
Like this book, this lens guide concentrates on a single set of topics—choosing and using lenses. If you're ready to go beyond the basics but are unsure which interchangeable lens or two to buy, and, more importantly, how and when to use them, this book offers focused, concise information and techniques. It includes overviews of how lenses work, and which types are available, discussions of all lens controls and features, including image stabilization/vibration reduction, and how to select the best lens and settings for particular types of photos.

David Busch's Quick Snap Guide to Lighting
Like this book, this lighting guide concentrates on a single set of topics: in this case, how light affects your photos, and what you can do to make the best of the lighting you have, and with the lighting you can create. This book is for anyone looking to expand his or her skills and take control over images, but who is put off by advanced photo guides that assume you either know a lot or know what it is that you *don't* know. This one starts with the basics, and leads you through lighting techniques that will really make your images shine.

Photoshop.com - Create and learn, get ideas, and share your work - Mozilla Firefox

File Edit View History Bookmarks Tools Help

https://www.photoshop.com/

girl avatar

Most Visited Stock Images Control Panel Administ... HEMA - online winkelen Hosting and Design ABC Movers Inc. RSS Feeds BNI Share on Facebook

Photoshop.com - Create and lear...

PHOTOSHOP.COM

Sign Out My Account FAQ Feedback Help ▾

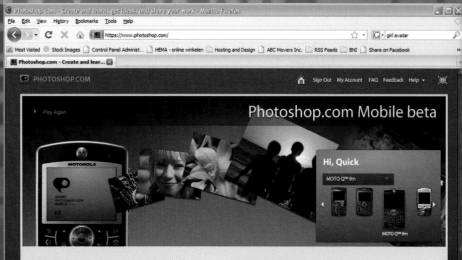

▶ Play Again

Photoshop.com Mobile beta

Hi, Quick

MOTO Q™ 9m

MOTO Q™ 9m

Upload, view, and share photos on the go

Adobe® Photoshop.com Mobile is the easiest way to upload, view, and share your photos online from your phone:

· Upload and store photos online as soon as you take them (get 2GB of storage free)
· View your online photos and albums from your phone
· Share them wherever you are

All you need is a supported Windows Mobile® phone and a Photoshop.com membership. To download the beta, follow the steps in the blue box above or type **m.photoshop.com** on your phone's browser.

Supported phones

More Windows Mobile phones will be added. Check back for updates.

Seeing is believing

Take a tour of Photoshop.com Mobile. See what you can do with your phone photos.

Watch the video

Other mobile phones

ShoZu™ Use ShoZu to upload photos to your Photoshop.com account from over 350 other handsets, including the Apple® iPhone™, BlackBerry® Pearl™, Motorola RAZR2, Nokia 5210, and Nokia 6301.

Learn more

1 Getting Started: Introduction to Editing with Photoshop.com

Photoshop.com is a new web service that gives you a way to upload, edit, store, and share your photographs using your computer at home, your laptop while on the road, and even with your mobile phone through Photoshop.com Mobile. Integrated with Photoshop Elements, and packed full of features, the basic service is offered free from Adobe.

You may be familiar with the Photoshop family of software offerings from Adobe; perhaps you use Photoshop or Photoshop Elements. The flagship program Photoshop CS4 is costly software used by many professional photographers and graphic designers to touch up or completely alter images; Offering a dazzling array of special effects and tools, it's pretty much overkill for the casual user, even if you're a talented photographer. Photoshop Elements 7.0 is less costly but still has a modest price tag attached, and it is currently available only for Windows. The earlier Elements 6.0 version used with Macs is not tightly integrated with Photoshop.com.

Photoshop.com offers many of the best features of the full Photoshop products, and some really fun effects—and all for free! You receive 2GB of online storage space, and you can signup for a subscription (not free!) for even more storage. But even the free version plays nicely with several online social networks, so you can share your images with family and friends.

This chapter helps you get started with Photoshop.com; you'll create a new account and start right in with loading images into the service. We'll start getting acquainted with the basic account features and discuss some of the ways you can organize your image storage. Although there are countless ways the service can be used, we'll offer tips on optimizing your account from snapshots and family albums to full-resolution art photography.

The good news is that you no longer need to be an expert at the imaging software to create expert images! By the time you're done with this chapter, you'll have your own Photoshop.com account, and you will have photographs loaded and captioned in libraries and albums.

Please be aware that, as with any dynamic online service, some features and details may change from the time of this writing. (When I *started* this book, the beta version of the service was called Photoshop Express.) Be flexible, look around, and keep your eyes on the general principles—you'll very likely find what you're looking for.

Creating an Account

There are a few different ways to arrive at the Photoshop.com site. You can use your favorite search engine to find Photoshop.com or Photoshop Express. Generally, the first result is the one you want. You can also navigate to the Adobe Products site at http://www.adobe.com, and from there look under Products for the Photoshop Family. Look for the psx icon or Photoshop Express or Photoshop.com. By far the simplest method, however, is by navigating directly to the site at http://www.photoshop.com (see Figure 1.1), or by summoning that website through Photoshop Elements 7.0, if you use it. We mention so many options because as websites are updated (as they were during the writing of this book), exact URLs are often subject to change.

Figure 1.1 The opening screen of Photoshop.com offers a rotating series of photographs featuring different effects and settings to which Photoshop.com users have access.

Tip

Photoshop.com is built using Adobe Flex, an open-source (non-proprietary) framework for building rich Internet applications, and it is delivered via the Adobe Flash Player—no surprise, as both Photoshop and Flash are Adobe products—so even to sign up, you must have the latest Flash Player installed and enabled on your web browser. You can visit the Adobe website and download Flash before you start.

Creating Your Photoshop.com ID

Your Photoshop.com ID serves multiple purposes: it is used for your login ID (your e-mail address), it serves as the focal point for an account that includes your basic information, and it will be used as the destination for a personalized website where you will be able to share images with others. To get started, do the following:

❶ Click the Join Now button to start the registration process.

❷ You'll be presented with a window asking you for some basic identifying information, such as your name and e-mail address (it must be a valid address that you can access for the verification step). (See Figure 1.2.)

❸ You'll be asked to create and confirm a password, which must be between six and twelve characters, and can be any combination of capital and lowercase letters, numbers, and special characters such as the dollar sign ($), pound sign (#), and so on. It's best to use a combination of all these character types for increased security. You know the drill: use a password that you will remember but that is not easily guessed by a third party.

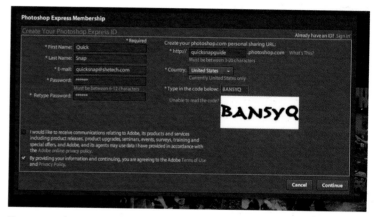

Figure 1.2 The screen where you create your account contains a number of different required fields, and it offers you a way to create a personal page to share your pictures.

3

Creating Your Personal Sharing URL

While you are creating your account, Photoshop.com automatically sets up a mini-website for you—the "personal sharing URL" is where you create the name for that mini site.

Photoshop.com creates what's called a "subdomain" using the ID you choose. Your challenge: it must be unique! It can be your full name, a favorite nickname, your company name, etc., but it can't be the same as any other ID on the system, or else Photoshop.com will kick it back to you and ask you to try again. There *are* language restrictions, so certain words are not permitted. You can probably guess which ones.

Choose carefully! Once your account is created, you cannot go back and change this URL unless you delete the account and start over.

◆ **Country.** When I wrote this, United States was the only country you could select because the site was optimized for use in the U.S., and it was available only in English. Photoshop.com will be adding languages and mirror sites (websites that duplicate the functions of Photoshop.com) around the world in the future, so you may have additional choices when you signup.

◆ **Security Code.** To keep the service from getting spammed by automated signups (a hazard any time there is an online form available), Photoshop.com requires you to enter the security code displayed in the signup window. This tells the service that there's actually a live human being filling out this form!

◆ **Adobe Communications.** You can choose to receive communications from Adobe or not by checking or unchecking the corresponding box. While the service is relatively new and still undergoing updates, we recommend permitting Adobe to send you information about product updates.

◆ **Terms of Use and Privacy Policy.** You must check the box agreeing to the Terms of Use and Privacy Policy before your registration process is complete. By its nature, Photoshop.com is designed as a sharing service, so these are a little different from the usual; you may want to review them before going on. Note that the "rights" you are granting Adobe to your images are needed so your photos can be shared on the site. The company has stated that it will not grab your pictures for unauthorized uses, such as advertising.

Once you have entered all your information, click Continue to take the next step in the process. Assuming there are no issues such as a Personal Sharing URL conflict, you will be presented with a success screen. (See Figure 1.3.)

Account Created

Thank you for joining Photoshop.com
Your account has been created, and you're only a step away from having fun with your Photoshop.com membership.

Verify your e-mail address
We've just sent you a verification e-mail. If you don't see the message in your inbox, try your junk mail folder. As soon as you verify your e-mail address, you'll be able to start using your new account.

Your Account Details
Membership Type: Basic, 2 GB
Personal URL: http://shetechandcompany.photoshop.com

Figure 1.3 When the first part of your registration is complete, you will be presented with a success screen similar to the one shown here.

Verifying Your Photoshop.com ID

Shortly after you complete the initial registration, you will receive an e-mail message, automatically generated by the Photoshop.com service. It contains a brief introductory message and a link to validate your e-mail address. The validation e-mail should arrive within minutes, depending on how often your e-mail service checks for new messages. If you do not receive a validation e-mail, check your spam filter; it may be blocking the message. Add Photoshop.com to the list of accepted domains so that future messages are not blocked.

To complete the process, do the following:

❶ Check the Inbox of the e-mail address you provided when creating the account (see Figure 1.4).

❷ You must actually click the link that's included in the validation e-mail, as shown in Figure 1.4; otherwise, you will not be able to access your Photoshop.com account.

❸ Once you have done so, the registration will be complete (see Figure 1.5) and you can start playing!

Figure 1.4 Check your e-mail Inbox for a message that looks like this. You must validate your e-mail address to access Photoshop.com.

Figure 1.5 Once you have verified your e-mail address, you will be shown a confirmation message with a Sign In button.

Signing In for the First Time

To use your new Photoshop.com account you must sign in, even immediately after you have validated your e-mail address. This assures Photoshop.com that you really are who you say you are! To sign in, do the following:

❶ Click on the Sign In button from the Congratulations screen, or if you come back later, you'll see the same button on the opening screen of Photoshop.com.

❷ You'll then be presented with a login window (see Figure 1.6). Enter your Adobe ID, which is the e-mail address you used to register (not the Personal Sharing URL), and your password.

Photoshop.com Membership

Sign In with your Adobe ID

quicksnap@shetech.com

●●●●●●●

☑ Remember Me

Forgot Password?

Sign In Cancel

Not a member? Learn More

Join Now!

Privacy Policy

Figure 1.6 When you're ready to sign in to Photoshop.com, you'll be presented with a login screen asking for your Adobe ID and password.

❸ If you are using a home computer that is not shared, you can set the site to remember you each time you come back—if the computer is shared by other family members or is a public computer, we recommend leaving this option unchecked! If you check this option on a shared computer, other people will have automatic access to your Photoshop.com account, including your pictures and, once you've set it up, access to your images on other social networking sites such as Facebook, Flickr, and so on.

Free Account vs. Subscription

Even with a free account on Photoshop.com, you can store up to 2GB worth of images, which gives you room for a lot of photos! Depending on the size and resolution of the images you upload, that can be anywhere from a few hundred images at very high resolution to a few thousand at lower resolution (the kinds of images you would share online with friends). As a comparison, Flickr's free service only permits you to upload a maximum of 100MB worth of images per month (not a storage limit, but a bandwidth limit), though their subscription service offers unlimited uploads. Facebook permits an unlimited number of photographs to be uploaded but extremely limited editing capabilities. The good news is that you can share your images across these services via Photoshop.com—more on that in a later chapter.

If you find that 2GB is not enough for you—particularly if you load up a lot of very high-resolution images—Photoshop.com offers an affordable subscription service, similar to other photo-sharing sites. Annual fees are based on the amount of storage you require on the system, starting at around $50/year. You can also purchase a Plus membership with Photoshop Elements, giving you 20GB of storage—enough for up to 15,000 photos. Membership details are available at the Adobe website (http://www.adobe.com/products/photoshopelwin/membership/).

Generally speaking, the Basic level membership is sufficient for most users. Particularly if you are uploading pictures solely for viewing on the web, images can be set to take up less space by changing the JPEG quality setting, the resolution (dpi), or the actual number of pixels in an image (which translates to physical size). We will discuss image resolution in a later section.

Parts of the Home Page

If you have used recent versions of Photoshop Elements, you may notice that Photoshop.com bears a striking resemblance to it. Version 7 is even integrated with Photoshop.com for photo editing and sharing (previous versions of Photoshop Elements shared images to Photoshop Showcase, a different service).

The opening page of Photoshop.com is a landing pad for accessing all its features. The layout of the Photoshop.com site is both simple and intuitive. I've marked Figure 1.7 with numbers, corresponding with the functions listed here:

❶ Across the top left, you see the Photoshop.com logo—a little house that shows you the way back to your home page—and My Photos, My Gallery, and Browse buttons.

❷ To the right along the top, you see buttons for Sign Out, My Account, Help, and a full-screen mode button—very nice if you don't want your browser toolbar to take up screen real estate.

❸ On the second line, you will find only two icons; the one on the left side is for uploading photographs.

❹ The icon on the right of the second menu line is for refreshing the page.

❺ Down the left column of the home page, you see a greeting along with your public gallery address and news headlines from Photoshop.com. These headlines will be updated regularly as Adobe continues to add and expand features.

❻ In the main area of the home page you will find several links. The top one takes you to your image Library.

❼ You can also link to accounts you may have on other social networking or image sharing sites; more on that in a later section.

❽ Finally, you can browse other users' galleries if they have set them to be publicly available. This is a great way to see what other users are doing with their images—you may be inspired by a particularly creative shot or find a use for one of the many Photoshop.com features that you may not have realized.

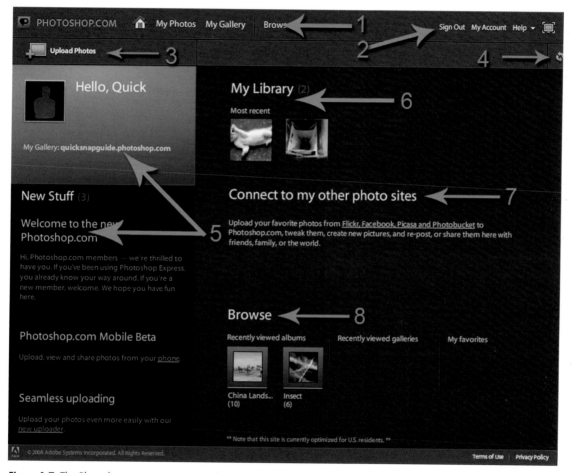

Figure 1.7 The Photoshop.com entry page includes news headlines, links to your gallery and any other photo sites of which you might be a member, and links to other public galleries.

Adjusting Account Settings

Any time you are signed in to Photoshop.com, you can update most of your account settings, with the exception of your personal URL.

Across the top of the screen in any section of the site, find the My Account link. Use that link to view and update your account settings (see Figure 1.8).

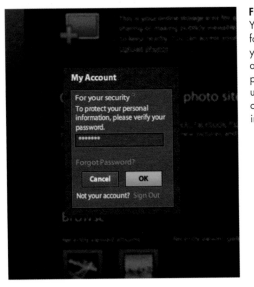

Figure 1.8
You'll be prompted again for your password before you can adjust your account settings. This prevents unauthorized users from accessing or changing your personal information.

You'll be presented with an account summary page (see Figure 1.9) with the following details:

◆ **Your Adobe ID.** This is the ID you used when you signed up for the Photoshop.com service, and it is usually your e-mail address.

◆ **Your name.** This is the name you entered when you signed up for the Photoshop.com service.

◆ **Membership level.** If you are using the free service, this will show as Basic; if you paid for a higher membership level, this will appear as Plus or another level.

◆ **Member Since.** This is the date you signed up for the Photoshop.com service.

◆ **Personal URL.** This is the web address you chose when you signed up. It appears in the form of http://[youraddress].photoshop.com and cannot be changed as of this writing.

◆ **Storage.** Assuming this is your first time using Photoshop.com, your Total Storage should show as 2.0GB (2.0GB Remaining). The storage area has a handy thermometer-type graphical gauge indicating how much space you have used.

Figure 1.9 Check on your account settings, including how much storage space you have, in the My Account window.

To make changes to your account information, select the Personal Info link, shown on the left in Figure 1.10. There may be occasions when you need to update this information. In the resulting screen, you can change the following:

◆ **Your display name.** This is the name displayed to other users when you choose to share your images. It can be your full name, your nickname, or some other variation if you choose not to reveal your real name. If you're better known on various forums by a screen name rather than your real moniker, you can use that.

◆ **Your e-mail address.** If your e-mail address changes (if, for example, you change e-mail providers), you can update it here; changing it will also change your Adobe ID.

◆ **Your password.** It is a good idea to change your password on occasion to reduce the chances of it being guessed or hijacked by a third party.

You cannot change your personal URL or Country. This restriction may change in later versions of Photoshop.com. You can also update your communication preferences in this window.

If you make changes, click OK to save them; otherwise, click Cancel to return to the previous page.

Set Profile Image

When you get back to the main page, you may notice that there is an image placeholder beside your name. You can set your own profile image, either a photograph or an avatar (a graphical representation or illustration), by first uploading an image to your Library and then selecting it as your profile picture.

We learn how to upload pictures in the next couple of pages!

Figure 1.10 You can update some of your personal information in the Personal Info window.

Choosing Photos for Photoshop.com

With the Basic service offering up to 2GB of photo storage, you have quite a bit of headroom before you run out of space in your account. Even then, you may be surprised at how quickly you hit your limit. Along the way, you might find yourself needing to choose between images—which to discard, which to keep, which to upload, what sizes, and so on.

Deciding What Photos to Include

Photoshop.com can be used a number of ways; the two broadest uses are editing and sharing. You might want to use the editing component of the service if, for instance, you take high-resolution art photographs and want to make alterations or corrections. Because Photoshop.com offers simple methods for otherwise challenging tasks, such as color correction or red-eye correction, it's a great solution for the talented amateur.

Tip

Pixel is short for "picture element" and is defined by the World Wide Web Consortium (W3C) as follows: "The information stored for a single grid point in the image. The complete image is a rectangular array of pixels."

High-resolution photographs, like the one shown in Figure 1.11, contain more pixels than low-resolution images do; therefore, they take up a lot more space and take much longer to upload. If this is the case, you'll probably only want to upload single images at a time, or small batches from a single shoot.

Figure 1.11 This image, uploaded as a higher-resolution photo, would be suitable for printing in a larger format, such as a poster.

So choose carefully, and save them back to your local drive when you're done making changes—this saves your space on Photoshop.com for those images you want to keep and share with other users and services.

> **Tip**
>
> High-resolution images are considerably larger files than those intended for web use only, and therefore take up a great deal more space on any disk drive or web service.

If, on the other hand, you have snapshots that don't require high resolution, like the one shown in Figure 1.12, your files need not be so large. You can resize them before uploading to save space. Sharing images on the web demands much less in terms of image/pixel resolution (high resolutions may be as high as 1,200 dpi, or dots per inch, whereas web images are generally between 72 and 96 dpi), so you can upload and store far more.

Figure 1.12 A lower-resolution or snapshot image such as this resized photo (a very happy man!) can easily be shared online without impacting user internet connections too much.

However you decide to use Photoshop.com, and no matter what type of image resolution you prefer, it is *always* a good idea to keep local backups of your pictures! Photoshop.com is a shared service, run by software, and like any shared service, it is occasionally subject to errors. Adobe has, of course, put failsafes in place to prevent loss, but no system is perfect; you should not rely on it or any other online service solely. You should have an additional backup, such as one archived on a DVD or an external hard drive, to protect your images.

A good way to look at it is this: keeping your images in both places improves your chances of recovering your pictures if *one or the other* should fail.

Uploading Photos

The first thing you will want to do on Photoshop.com, once you have decided which images you want to upload, is to… well, upload them. It's a piece of cake, too, thanks to the seamless and simple Upload function.

From your Photoshop.com home page, there are three places you can start (Photoshop.com makes it as easy as possible to upload your images!):

◆ Clicking the Upload Photos button at the top left of the screen will immediately launch the upload utility.

◆ Just below the My Library link in the main area, you will see another, larger icon that looks like a plus sign over a computer screen. Once you upload your first images, that icon will dim.

◆ At the end of the My Library text itself, you will see a text link to the same online upload utility. As with the larger icon mentioned immediately above, this will dim once you have uploaded your first images. (Once you're in the My Library section, you'll be offered several ways to upload photos from there as well. More on the Library later on…)

◆ In addition to the online upload utility, Photoshop.com now offers a small downloadable program you can install on your PC that allows you to upload images to your account without accessing the website.

> **Tip**
>
> Please note that there are size limitations: currently Photoshop.com will accept images up to 6,000 × 6,000 pixels, (and no larger than 10MB) and online editing only works on jpeg (.jpg) images up to about 2,500 pixels. A red X appears in the status column next to photos that are too large for editing.

Optimizing Your Available Capacity

As we mentioned before, you can optimize your available storage capacity by selecting certain maximum image resolution. Because there are so many ways that photographs can be used (marketing, printing, or sharing, to name just a few), you will need to decide for yourself what the best use of your available space will be. Here are some things to keep in mind:

◆ **Printing images for brochures.** If you will be printing images or making them available for print, you'll want to choose higher resolution images for best image clarity. A minimum of 300 dpi works best for paper printing such as brochures and marketing materials, and you'll need to set the "quality" setting of your jpg images to "high" or "best." These images will take up a moderate amount of space; the higher the .jpg quality, the more space will be required.

◆ **Printing images as photos.** For photo printing, you can go as high as 1,200 dpi for best resolution. Remember that this takes up a *lot* more space on your account, so use these sparingly! Again, .jpg resolution should be set to the highest quality for best color resolution. Figure 1.13 shows the relative size of high-resolution and low-resolution images.

◆ **Sharing images online only.** If you are just sharing your images online with friends and family, you can set your image resolution to 72 dpi. The images will still display beautifully on-screen, and will take up the least amount of space. In this case, the .jpg image quality setting can be "medium" (50% or so), and still look quite nice on-screen.

◆ **Determining space used.** If you ever want to know how much space you have used, remember that you can look up your account summary by selecting My Account in the upper-right corner (you'll be asked to enter your password again). The screen that appears will show you how much space you have used and how much you have left.

Browsing for Files

Selecting any one of the online upload links or icons opens up a Windows browse box (shown in Figure 1.14), which permits you to look for images on your local system.

You can search your computer's hard drive(s), and network drives if you have them, and you can even upload directly from cameras, PDAs, Smartphones, or other external devices when they're attached. They typically appear as a "removable drive" or by the brand name of the unit

if you have camera-specific software installed.

❶ Navigate to the directory where your images are located.

❷a Select a single image by clicking on it; or

❷b Select multiple images by using Shift + click for multiple consecutive images; or

❷c Select multiple non-consecutive images by using Ctrl + click; or

❷d Use Ctrl + A to select all of the images in a folder.

❸ Click the Open button to add the images to your upload list.

Figure 1.13 Higher resolution images print well even at larger sizes (left), while lower resolution images (lower right) will appear smaller and less precise, but work well for screen display.

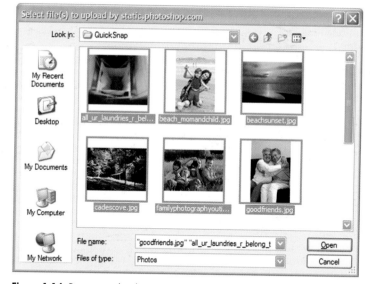

Figure 1.14 Browse to the directory on your local machine where you have stored the images you want to upload.

Uploading to Your Library

Once you have selected your images, you have the option of uploading them directly to your Library without placing them in an album, or to an album within the Library.

Let's look at the Library option first. What this means is that the images are uploaded to

Photoshop.com, but without being collected into a specific group (albums are not required for image uploading, but, just like your old-fashioned book-type photo albums, they can be useful for keeping images organized).

❶ Once you have browsed for and selected your images, you are shown an upload list where you have a chance to remove images that you might have selected by mistake. Check your list and remove any you might have added by mistake.

❷ Select the Upload To Library option.

❸ Click the Upload button.

❹ When complete, you'll see a success message, and your image will be viewable from your Library page.

❺ Click the Done button to return to your Library.

Depending on the number and size of the images, as well as your internet connection speed, it may take a while to upload all the images. A checkmark will appear when the images have finished uploading, as shown in Figure 1.15.

> ### TIP
>
> Please note: you must have full rights to any images you upload to Photoshop.com! If you upload copyrighted images without their owners' consent, you may be subject to legal reprisals.

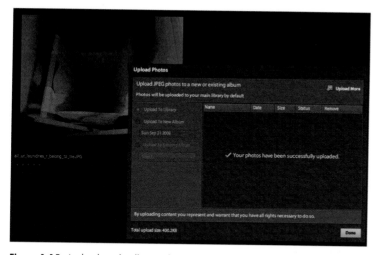

Figure 1.15 A checkmark tells you that your photos have been successfully uploaded.

Figure 1.16 Uploading images to your Photoshop.com Library.

Uploading to an Album

There are two ways to upload images to an album. The first is to add pictures and create the album "on the fly," and the second is to create the album, then upload the images into it.

Creating an Album on the Fly

To upload one or more images to an album that you create on the fly, do the following:

❶ Select one of the Upload Photos icons or links as before.

❷ Select pictures from your computer.

❸ In the resulting dialog box, select the Upload to New Album option.

❹ Give your new album a name. Today's date is set by default, but you may want to choose a more memorable name to help with organization.

❺ Confirm that the images in the upload list are the pictures you want in your new album, and remove any you don't want to upload.

❻ Click the Upload button (see Figure 1.17).

Again, depending on the size and number of the image files, and the speed of your internet connection, the upload process may take a little time. Be patient, and when the upload is complete, you will see a success message. Click Done to see the results!

Creating an Album First

As with many of the options in Photoshop.com, you have multiple ways to access the album creation function.

◆ Select the Add icon (shown in Figure 1.18), which is the icon farthest to the right near the Albums link in the left column of either your Library page or your Album page.

◆ Select the New Album icon from the center of your Album view (when you have at least one album, that icon disappears), or

◆ Select the New Album icon on the left end of the bottom menu in that same view.

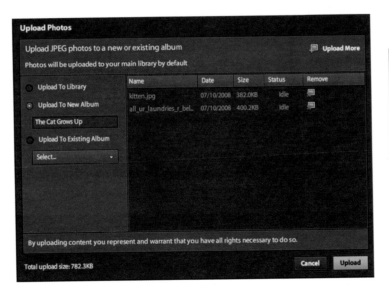

Figure 1.17 Creating an album while uploading new images.

Figure 1.18 Clicking on the Add icon next to the Albums list opens up a new album name field.

Each of these options leads to the same steps:

❶ An unnamed album will appear in the album list, with the name field open and highlighted so you can give it a name.

❷ Type a name for the album.

❸ Click away from the field to save the name.

Uploading to Your Newly Created Album

Once you have created your new album, you'll want to upload images into it.

❶ Select the Upload Photos icon from the upper left of the screen.

❷ You'll get a browse dialog to locate pictures on your computer.

❸ Select your picture or pictures and click Open to add them to your upload list.

❹ Check your upload list to confirm the images you're uploading belong in your new album, and delete any that do not belong.

❺ Select your new album as the target for your upload.

❻ Once again, click the Upload button and wait for your pictures to be transferred to Photoshop.com. (See Figure 1.20.)

❼ Click Done when you see the success message. You'll be taken automatically to the album where you just uploaded images. Note that you can adjust the slider above the photos to adjust the size of the thumbnail image (see Figure 1.21).

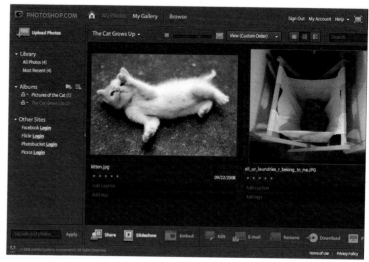

Figure 1.20 Selecting an existing album for your upload.

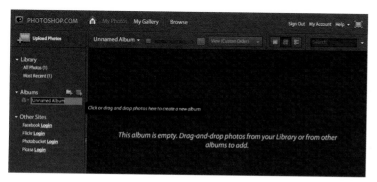

Figure 1.19 Creating a new album is a snap in Photoshop.com!

Figure 1.21 Your images are successfully uploaded into an album.

19

Creating and Managing Albums and Album Groups

We have already seen a couple of different ways to create albums. Now let's talk about album groups. There are many ways you can use albums and album groups in combinations; for example, if you have pictures of an event, say, a wedding, and photographs from multiple people (one fun thing a lot of wedding planners do is leave disposable cameras at each table—some of the best candid shots come from those cameras!), you can create an album group for the wedding itself, and individual albums for each photographer or camera.

Creating Album Groups

It's just as simple to create an album group as it is to create individual albums.

❶ Start with the icon immediately to the right of the Albums link in the left column of your Library view. It looks like a file folder, with a green + sign. (See Figure 1.22.)

Figure 1.22 The album group icon looks like a folder with a plus (+) sign beside it.

❷ As with creating an album, a field will open up where you can name your new album group. (See Figure 1.23.)

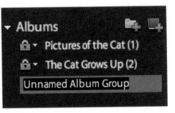

Figure 1.23 A field will open up where you can give your new album group a name.

❸ In the main desktop area of your Library view, you'll also see a message telling you that your album group is empty; you have the option of creating a new album or moving an existing album into the new group.

❹ Click the New Album icon from the main page to create a new album, or to move an existing album, simply click and drag it into your album group. It's that easy!

20

Deleting an Image

If you decide that you want to remove an image from your Library or from an album, there are also a couple of ways to do it.

◆ **The remove icon.** From either your Library or Albums view, you can select the image and delete it using the Remove photo icon along the bottom of the screen (that icon will be grayed out until an image is selected).

◆ **The Photo Options menu.** When you hover your mouse over an image in your Library, a small gray band will appear along the bottom of the image. Clicking on the down arrow next to Photo

Options opens a menu where you can carry out a number of operations. Remove from Library is at the bottom of that menu. (See Figure 1.24.)

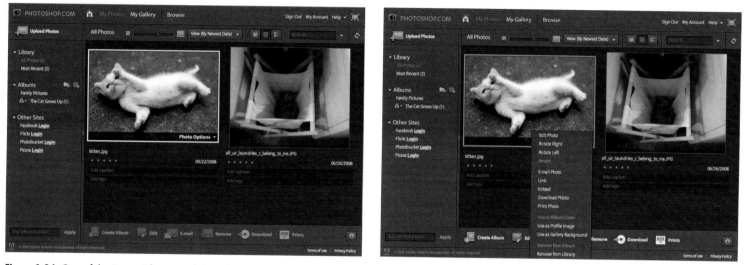

Figure 1.24 One of the "pretty" features of Photoshop.com is its ample use of Flash functionality, including the Photo Options menu, which appears when you hover your mouse over an image.

Deleting an Album

If you decide that you want to discard an album and all it contains, you once again have a couple of different methods for doing so (the designers of this software made certain it was as intuitive and simple as possible!).

❶ From either your Library or Albums view, simply hover your mouse over the album in question and a small red X will appear to the right of the album's name. (See Figure 1.25.)

❷ Hover your mouse over the X; you'll see a small Remove this album hint.

❸ Click the X.

❹ You will be asked to confirm that you really, truly do want to remove the album. Click OK to confirm removal. (See Figure 1.26.)

Happily, as the confirmation window reminds you, this does *not* mean that the images themselves get removed from Photoshop.com; they stay in the Library. It's just like taking all of your paper photographs out of an album and stacking them back in that big ol' storage box in the basement.

The other way to delete an album is from the Album view, when you're looking at all your albums.

❶ Click on the album you want to remove, and the Remove icon at the bottom of the screen will be highlighted.

❷ Click on the Remove icon.

❸ You will once again be asked to confirm that you want to remove the album. Click OK to confirm.

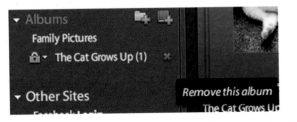

Figure 1.25 Hovering your mouse over an album in your list will expose a red X.

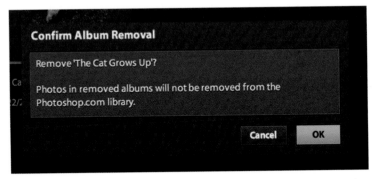

Figure 1.26 A confirmation window gives you a chance to change your mind before you delete an album.

Deleting an Album Group

You can also delete an entire album group if you want, and that is just as easy as deleting an image or an album.

❶ Hover your mouse over the album group name in the left column, and a red X will appear beside it, along with a hint about its function if you hover your mouse over the X. (See Figure 1.27.)

❷ Click the red X to delete the album group.

❸ To make certain you aren't deleting the album group by mistake, Photoshop.com gives you a confirmation window before deleting. Click OK to delete the group, or Cancel if you don't want to delete the album group. (See Figure 1.28.)

Your images will be kept in the Library, but unfiled.

> **Tip**
>
> Removing an album group will also remove any albums you might have created under it, but *not* the images themselves—the images will be kept in the Library, but with no organization.

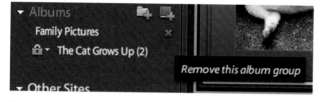

Figure 1.27 Hovering your mouse over an album group will show you a red X to delete it, along with a tip.

Confirm Album Group Removal

Remove 'Family Pictures'?

Albums and album groups within this album group will also be removed.

Photos in removed albums will not be removed from the Photoshop.com library.

Cancel OK

Figure 1.28 As with deleting images or albums, you get a chance to change your mind before deletion is final.

File Upload Utility for PC

Photoshop.com also offers a small downloadable utility that allows you to seamlessly add images to your Photoshop.com account by dragging and dropping directly from your computer.

Downloading and Installing

The left-hand sidebar of your home page offers a link to the download utility under New Stuff.

❶ Click on the New Uploader link to get the process started (the link may change name and location over the course of time).

❷ The first window that appears tells you that to install the upload utility, it must also install Adobe AIR if you do not already have it installed.

❸ Click the Install button in that window to continue.

❹ If you are installing Adobe AIR for the first time, that installer will appear first. Click OK to continue. (See Figure 1.29.)

❺ Once Adobe AIR is installed, you will see another dialog window appear asking if you want to install the software. The security that comes with the installer should be marked as Verified, which means that you can trust the source. (See Figure 1.30.)

❻ If you want to continue, click Install. You can also click Cancel if you change your mind at this point.

Figure 1.29 The file upload utility also installs Adobe AIR so you can drag and drop images.

Figure 1.30 You are asked to confirm that you want to install the upload software.

❼ Select your preferences. Adobe AIR is a required component, so that check box cannot be changed. You can, however, choose to create a desktop shortcut or not, choose whether to launch the utility when the installation is complete, and configure the installation location. The default is C:\Program Files. Change that location by clicking on the folder icon to the right of the location field and browsing to your preferred directory, or creating a new installation folder. (See Figure 1.31.)

❽ Click Continue when you are satisfied with your choices.

❾ Read and agree to the installation terms, then click I Agree to continue.

Tip

Photoshop.com wants you to understand that when you install this software, you are introducing a potential (though slight) security risk because the utility will be sharing information between your computer and the Photoshop.com site.

Logging into Photoshop.com Through the Uploader

When the installation is complete (it only takes a short time), and if you selected Start application after installation, the software will start up and you'll need to carry out a few more steps to get it running.

The first time you use the software, it will present another agreement window requiring you

to agree to the Terms of Use and Privacy Policy. These are similar to the ones offered when you signed up for Photoshop.com in the first place. The software will not start if you do not agree to the terms.

❶ Select the I agree... checkbox, and click Continue.

❷ You must log in the same way you do on the Photoshop.com site. Use your Adobe ID (usually your e-mail address) and the password you set for your Photoshop.com account. (See Figure 1.32.)

❸ Click OK to sign in.

Figure 1.31 You will be asked to set some preferences. Because Adobe AIR is a required component, that check box cannot be changed.

Figure 1.32 You must provide your Photoshop.com login credentials for the upload utility to communicate with your online account.

Adding Photos Using the Uploader

Not surprisingly, the photo Uploader looks much like the Photoshop.com site, and its album and image upload tools make it even easier to add images to your account online.

Adding Files and Creating Albums

You can create new albums from the Photoshop.com Uploader and add images either directly to your Library or to an album using a couple of different methods.

◆ Create a new album by clicking on the "New Album" icon in the left side of the lower pane and giving it a name. (See Figure 1.33.)

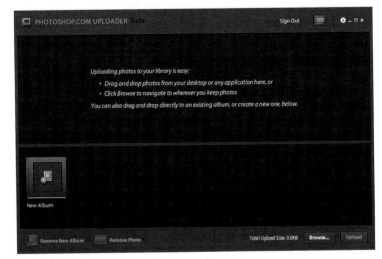

Figure 1.33 The Uploader provides brief but useful tips for creating new albums and uploading images.

◆ Add photos to your new album by dragging images from your local system and dropping them into your new album's icon, or browse for them by clicking the "Browse" button and navigating your folders.

◆ You can also create a new album by dragging images from your desktop to the "New Album" icon. The Uploader will start a new album as above and open a field so you can give it a name.

◆ Click on the album's icon to view its contents.

◆ Add photos to your Library without adding them to an album by clicking and dragging from your local machine into the upper pane. (See Figure 1.34.)

Syncing with Photoshop.com

Once you're done dropping images into the Uploader, you need to sync it up with Photoshop.com.

❶ Click the Upload button to sync up with Photoshop.com online.

❷ You'll see a progress bar, along with statistics about your Photoshop.com storage capacity.

❸ When the upload is complete, you'll get a message saying so. Click OK.

❹ To see your images and/or albums in Photoshop.com, simply click the Refresh icon at the upper-right corner of the Photoshop.com screen, and presto! There they are! (See Figure 1.35.)

Signing Out of the Uploader

When you are done with the Uploader, you can easily put it away, or sign in to a different account if you have more than one.

❶ Click the Sign out button near the top-right corner of the Uploader window.

❷ You will get a dialog box asking if you want to sign into a different account. Click Exit to sign out and exit the program.

❸ If you want to sign into a different account, click OK, and you will be presented with the login window again.

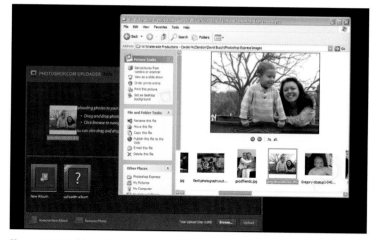

Figure 1.34 Adding images to your Library is even easier with the drag-and-drop capability of the new Photoshop.com Uploader.

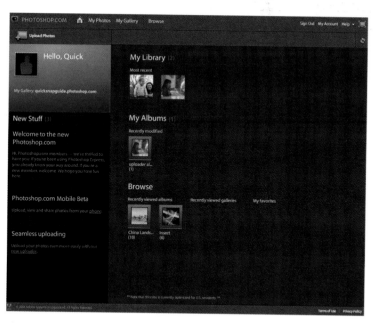

Figure 1.35 Once your upload is complete, clicking the Refresh icon in Photoshop.com will show your newly uploaded images. Simple!

File Upload Utility for Mobile Phones

Photoshop.com also offers image upload software (in a beta version for Windows only at the time of this writing) for a constantly expanding list of camera-equipped mobile phones. At the time of this writing, Photoshop.com directly supports photo uploads for the Samsung Blackjack I and II, Moto Q 9h and 9m, and Palm Treo 700 and 750; these are phones that use the Windows Mobile operating system. More will be added over time, so if you're interested in using the mobile utility, check back often for updates!

Downloading from Photoshop.com

You can get to the mobile Uploader by way of the Mobile link under New Stuff in the left column of your Photoshop.com window, or if you have not yet uploaded any images, from the main pane of your Photoshop.com entry page after logging in. Clicking either of these links will open the Photoshop.com Mobile page. (See Figure 1.36.)

> ## Tip
>
> If your mobile phone is not on the list of supported devices, Photoshop.com has partnered with ShoZu to allow mobile users to send images to Photoshop.com from many other brands of mobile phones.

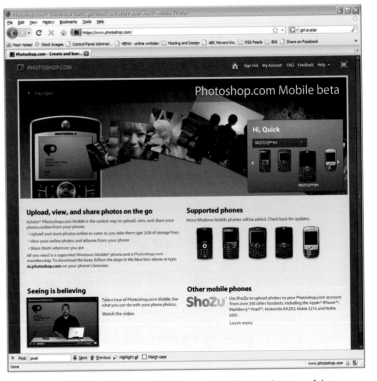

Figure 1.36 The Photoshop.com Mobile page is in beta at the time of this writing. Easily select your mobile device from the selection widget at the top-right corner.

Downloading from Your Mobile Device

Alternatively, you can point your supported Windows Mobile device's browser to m.photoshop.com to grab the download directly from your phone. Follow the instructions provided in the mobile browser window to complete the download and installation process.

Choose Your Device Type

The list of supported devices is small but growing. As with nearly all other Photoshop.com functions, you have multiple ways of selecting your device type.

❶ Look for the device selection widget near the top-right corner of the page.

❷a Select your device either by hovering your mouse over the image that matches your phone, or

❷b Select your device from the drop-down list in the same selection widget.

❸ In the next pane that appears, you must check the box that says "I have read and agreed to the Photoshop.com Additional Terms of Use and the Privacy Policy" (both of which are linked appropriately).

❹ Enter your (U.S. only) phone number in the spaces provided.

❺ Select Send a link to my phone to send the download link directly to your device. The widget will display instructions on what to do next.

❻ Select Download to my PC if your device permits you to install new software from a desktop installer.

❼ Save the resulting file to your device's installation directory (different for each device; refer to your user's manual if you are not certain); then use your device's installation utility to complete the process.

Once the software is installed on your mobile device, you can follow the instructions on-screen to add photos to your Photoshop.com account. (See Figure 1.37.) A brief-but-useful introduction is available from the Photoshop.com Mobile web page. Click on View the video to watch.

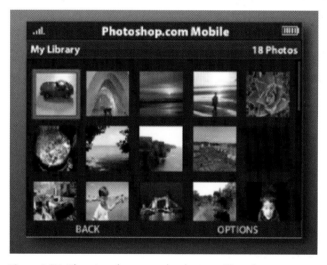

Figure 1.37 Choosing photos to upload to your Photoshop.com account via the mobile Uploader.

Upload Photos

All Photos View (By Newest Date) ▾ Search

Library
All Photos (2)
Most Recent (2)

Albums
⌂ ▾ Gregory's day at the gam...

Other Sites
Facebook **Login**
Flickr **Login**
Photobucket **Login**
Picasa **Login**

IMG_2021.JPG

Add caption

Add tags

Posted: Thu Oct 9 2008 09:12:29 AM

Taken: Sun Apr 15 2007 12:57:08 AM

Albums: Most Recent, Gregory's day at the g...

★ ★ ★ ★ ★

Advanced ▾

Tag	Value
file size	639.5KB
image size	1600 x 1200
camera make	Canon
camera model	Canon PowerShot A70
iso	
fstop	f/3.5
focal length	9.41 mm
exposure	1/250 sec
flash	No

Tag selected photos Apply **Create Album** **Edit** **E-mail** **Remove** **Download** **Prints**

2 Your Photo Library

The developers of Photoshop.com have considered a great many different scenarios in terms of how the average user would want to use Photoshop.com, and have thought of a number of ways of editing and sharing your photos online that might seem new to you. Once you see the possibilities, we're willing to bet that you'll be using them regularly with your own photographic libraries.

Before the advent of online photo storage, physical photo albums (remember those?) were a handy way to keep your pictures organized. You had one for your baby pictures, for your graduation, your wedding, that great trip to the Bahamas, and so on.

In Photoshop.com, you can organize and sort your images in exactly the same way, with *electronic* albums, and with considerably more ease—not to mention the convenience of being able to find them with the click of a mouse button, or the shelf space you've suddenly freed up by having your images on a computer or website instead of in all those bulky books!

In this chapter, we start looking a little more closely at what you can do with your image Library and albums to help you organize and sort your images.

My Photos

When you first land in Photoshop.com after signing in, you are shown a dashboard highlighting your latest activity (new images, albums, etc.), along with the latest news from the Photoshop.com team.

Now it's time to open the door and look inside.

Click on the My Photos icon in the top menu bar to see what's next.

Parts of the Screen

The top menu bar remains the same in the My Photos view, with the difference being that the My Photos text is now blue, showing it as active.

The toolbar just below the main menu is where the action begins. The numbers in Figure 2.1 correspond with the numbers listed below.

Top Menu and Toolbar

❶ **Upload Photos icon.** Anywhere you go within the My Photos views, you have the ability to upload new images from this link.

❷ **Thumbnail size slider.** This permits you to adjust the size of the thumbnail images as they appear in the main pane.

❸ **Sort options.** You can configure how much information you would like to see on the display page, and how you would like it sorted.

❹ **View options.** Similar to the view options in the Windows operating system, you can choose a few ways to view your photos—as a single image, as a grid, or as a sortable table. The default is the grid view.

❺ **Search.** Use the search utility to find photos you have uploaded to Photoshop.com. This will come in handy when you have uploaded a lot of images. Better than a card catalog!

❻ **Refresh.** When you make changes to your images, as when you upload from one of the external utilities, you can use the Refresh button to view your changes.

Left Menu

❼ **Library.** This is the repository for all your images, whether or not they are included in an album.

❽ **All photos.** View all of your images in one place.

❾ **Most recent.** Use this view to look at just the photos you have uploaded recently.

❿ **Albums.** Click here to view your photo album shelf.

⓫ **Album list.** Below the Albums link, all of your album groups and albums are listed. Opening any of them is a simple matter of clicking its title.

⓬ **Other Sites.** If you are a member of any of the listed social networking or photo sharing sites, you can click on its Login link to connect your profile(s) to Photoshop.com. We'll tell you more about signing up for and linking to other sites later in this book.

Main Pane

⓭ **Picture.** In the default grid view, you'll see your images as thumbnails of uniform size.

⓮ **Image name.** This is the filename. It is usually automatically gen-erated by your camera when the image was captured.

⓯ **Rating.** Rate your pictures from one to five stars to add an extra sort-ing option.

⓰ **Date.** This is the date the image was uploaded to Photoshop.com, or when it was taken if that information was stored with the image.

⓱ **Add caption.** Create a caption to add a little more detail to your photos.

⓲ **Add tags.** Think of tags as search terms—the more complete the list, the more likely it is you'll find what you're looking for when the time comes to search through your Library.

Bottom Toolbar

⓳ **Tag selected photos.** You can add tags to multiple images at one time using this handy little feature. Use key words like "vacation," "Spain," or "graduation" to help you search for groups of pictures quickly later on.

⓴ **Create Album.** Along with all the other icons in the toolbar below the main pane, Create Album is grayed out until you select one or more images. Once you do, you can create an album that includes any

images you have currently selected (you can select more than one at a time)—just like selecting tunes for a playlist!

㉑ **Edit Photo.** Selecting this icon, when active, or clicking on an image, takes you to the image editing area, which we'll cover starting in Chapter 6.

㉒ **E-mail Photo.** Send selected images off to friends and family!

㉓ **Remove Photo.** Pretty self-explanatory, this is one of several ways you can delete an image from your Library.

㉔ **Download.** You can download images from Photoshop.com to your local machine. This is useful if you have made changes to your images using any of Photoshop.com's editing features, or if you want to download images to a computer other than the one from which you uploaded the original images, or from phone to Photoshop.com to computer.

㉕ **Order prints.** Order prints of your images through Photoshop.com's partner, Shutterfly.

㉖ **Information.** Blank until a single image is selected, this *very* handy button opens a column on the right side of the window, displaying all the available information for that image, including advanced information such as the camera used to shoot the picture, f/stop, and so on.

Figure 2.1 The My Photos page offers useful features in a frame layout around the main pane.

Viewing Your Library

Now that you know your way around the My Photos window, let's have a look at the ways you can view your images.

Different users have different viewing preferences, and Photoshop.com has tried to accommodate as many of them as possible. You might, in fact, find yourself switching between views fairly often, depending on what you are doing at the time.

◆ **Viewing single images.** When you want to look at a single image in greater detail, you can select the single image view option from the top toolbar. It's the first of the three buttons that live between the View menu and the Search tool.

Similar to the Windows slideshow image view, this option (shown in Figure 2.2) moves things around in the main pane a bit so that you see smaller thumbnails across the top of the pane, with your selected image taking up most of the screen area.

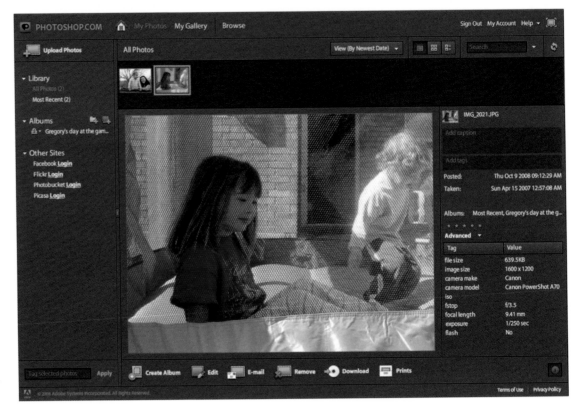

Figure 2.2 Single image view with the information pane open on the right side.

◆ **Viewing by grid.** The second of the three view buttons shows the default grid view (shown in Figure 2.3), which also includes a little more information about the images than does the single view, and shows smaller and therefore less detailed images.

◆ **Viewing in a table.** The third view option (shown in Figure 2.4) shows the smallest version of all the images but displays the most detailed information about each one. In this view, the Information icon at the lower right is disabled, which makes the images larger, filling the entire table.

Figure 2.3 Grid view without the information pane.

Figure 2.4 Table view disables the information pane but shows more information about each image in the main pane.

Viewing All Photos

Under the Library list item in the left pane, you see a link for All Photos and the total number of photos you have uploaded. Clicking that link displays—no surprise—all of your photos at once, regardless of any album or album group membership. Note that when you first sign in, you see a Welcome screen, and won't see All Photos under the left pane unless you click on a single photo, or click My Photos at the top of the screen.

Viewing Most Recent

The second link under the Library list item shows you the images you have uploaded recently. (See Figure 2.5.) So if you want to see, for example, the images you uploaded this past Tuesday but not the images you uploaded two months ago, this would be the place to go!

> ## Tip
>
> Each time you sign in to Photoshop.com, the My Photos area reverts to the default grid view.

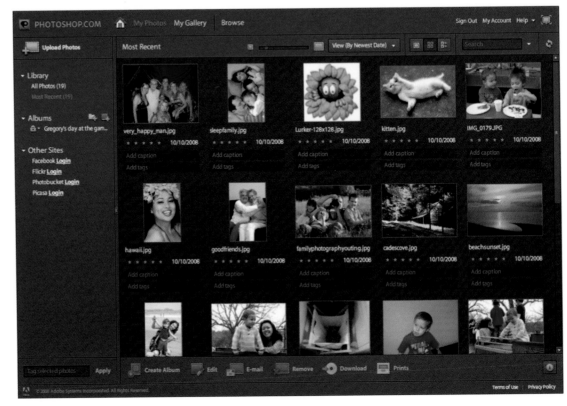

Figure 2.5 The All Photos and Most Recent views show images in the same layouts.

Adjusting Thumbnail Size

In the grid view of the My Photos window, you have the option of adjusting the size of the thumbnail images with the slider bar at the top right of the main pane. As you add images, Photoshop.com automatically adjusts the thumbnail size downward to accommodate more images on the screen.

There are six available thumbnail sizes, but we'll cover the small, medium, and large views.

◆ Moving the slider furthest to the left reduces the thumbnail size to the smallest setting, permitting you to view the most thumbnails at once, but also showing you the least amount of detail in each image. (See Figure 2.6.) Ghost images

under the slider show you the relative sizes of the views you can expect at each position. Just click one of those views to set your display to the size indicated.

◆ With the slider in the middle, you see a moderate number of thumbnails with an equally moderate amount of detail in each image.

◆ Move the slider all the way to the right, and you'll see the largest version of the thumbnail view—hardly a thumbnail any more at this point!—with only a single image in each row of the grid (you must scroll up and down to view the rest of your images). This might be useful if, for example, you want to compare two similar images quickly.

Figure 2.6 Moving the thumbnail slider reduces or enlarges the thumbnail images, changing the number of thumbnails you can view on the screen at one time.

View and Sort

In all three views of the My Photos page, you have options for viewing and sorting images and image information, and each is a little different. The single image view gives you the fewest viewing options (largely because it doesn't display any of the image information) while the table view offers the most flexible sorting ability because it displays the most information about each photo.

View

In the default grid view of the My Photos page, you see information along with the thumbnail images, including the name, rating, date, caption, and tags. Using the View menu, you can adjust which of these you'd like to see by adding/removing checkmarks next to the option. The available options are as follows:

◆ **Name.** This is the name of the image file itself. You may want to hide the filename once you have captioned your images, for example.

◆ **Ratings.** This is the one- to five-star rating bar under each thumbnail. If you choose not to use ratings, or choose to rate but not display the stars, you can remove them from view.

◆ **Date.** Usually, this is the date the picture was taken if your camera includes that information with the photo (most do by default), but if it doesn't, this will appear to be the same as the upload date. In that case, the date might not be useful and you may choose to hide it.

◆ **Keyword tags.** These are the tags you can add to your photos to help improve searching. Even if hidden, the tags associated with each photo are still available to the Photoshop.com search engine.

◆ **Caption.** If you choose not to caption your images (which can be time-consuming if you have a lot of them!), you might choose to hide the caption field.

As the grid view is the only one to display photo information this way, it is the only one in which the full View menu options list is available. In the single image view, you do not see these options in the View menu (all you see are Newest Date, Oldest Date, and Rating), and in the table view, this menu disappears altogether.

Sort

In both the single image and grid views, you have three ways of sorting your images, and you'll use the same View menu to do it. Sorting options appear in a sub-menu at the bottom of the View menu (see Figure 2.7) in the grid view, and are the only items in that menu when using the single image view.

◆ **By Newest Date.** Choosing this option displays your images in reverse chronological order, so that the newest items appear at the top of the list, and oldest at the bottom.

◆ **By Oldest Date.** Opposite of above, this option sorts your images in forward chronological order, displaying the oldest images at the top and newest at the bottom.

◆ **By Rating.** If you are assigning ratings to your images, you can sort them so that the highest ranked images appear first, and lowest or unranked images sink to the bottom.

Sort submenu

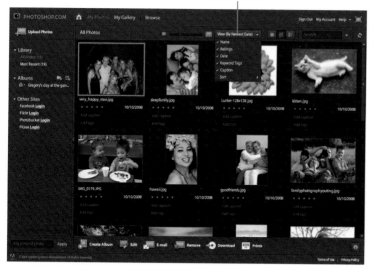

Figure 2.7 Choose the sorting options fly-out menu at the bottom of the list to order images by date or rating.

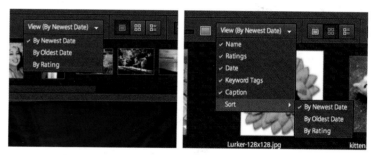

Figure 2.8 The Sort menu appears by itself in the single image view, and as a sub-item of the View menu in grid view. The checkmarks indicate what information will be shown.

Sorting in Table View

Viewing images in the Table view shows the most information about each image—nearly all that is available except for the advanced camera information. (Camera data can be shown in Grid and Single Image view if that information is linked to the file and the Advanced setting is selected.) The View/Sort menu disappears altogether in this view because you can use the table headings themselves to sort your images dynamically using the following fields:

◆ **Filename.** As in the grid view, this is the name of the image file itself, and includes the file extension (.jpg).

◆ **Caption.** If you have added captions, you'll be able to sort alphabetically by the captions!

◆ **Taken.** The date the picture was taken if your camera stores that information with your photos. Otherwise, this is the same as the Posted date.

◆ **Posted.** The date the picture was uploaded to Photoshop.com.

◆ **Rating.** The ranking, if any, that you have given your photos.

You can use the table headings to sort by the above fields in either forward or reverse order (see Figure 2.9). Try it and see how many ways you can list your photos and information!

Sorting by one of the table headings that is not included in the standard View menu will cause a Custom option to appear in the menu.

Tip

The sort order you choose in My Photos will persist across your site views, but it will not persist from one session to the next. Each time you sign in, the sort order defaults back to Newest Date.

Figure 2.9 Using the headings in table view, you have more sorting options than in either single or grid views.

Album Activities

You've uploaded images, sorted them like crazy, and looked at them in every possible permutation, but still you find they need to be further organized. This is where albums come in handy. And it's sure a lot easier than organizing all your paper photos into big, bulky books!

Creating a New Album

We covered album creation in Chapter 1 in the context of uploading new images; now let's put that to use with images already in the Library.

There are so many options for creating a new album, it's almost comical!

◆ As we described in Chapter 1, you can simply click the second green plus sign (+) icon beside the Albums link in the left pane to start a new album.

◆ From the My Photos view, you can select one or more images and drag them over to that same plus sign icon to add them to a new album on the fly. When you drop them, a new album is created.

◆ Select your image(s) and click on the Create Album icon at the lower-left corner of the bottom toolbar.

Moving Photos into an Album

Once you have created and named your album, you can move images in and out of it at will. Let's move a single image to start with.

❶ Go back to your My Photos view by clicking the All Photos or Most Recent link from the left column.

❷ Pick an image to add to the album.

❸ Click *and hold down* the mouse button, and drag your image to the album name link in the left column. A ghost image should follow the movement of your mouse. (See Figure 2.10.)

❹ When you see the small green plus sign appear next to your image, you have found your target. Drop the image by letting go of your mouse button.

❺ Click on the album name to confirm that you dropped the right image in the right place.

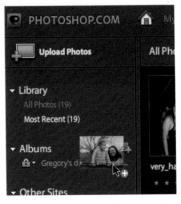

Figure 2.10 Drag and drop a single image into your new album. + marks the spot!

You can do the same thing with more than one image at a time if you have a whole batch of photos you want to file in a single album.

❶ Return to the All Photos or Recent Photos view.

❷ Start by clicking on a single image to select it.

❸ If you have many pictures in a row that will all go in the same place, you can press and hold the Shift key, then click on the *last* image of the series to select the whole series; otherwise, you can Ctrl + click to select multiple non-consecutive images. Your selected images will be highlighted with a colored border around each thumbnail.

❹ Click and drag as before. You should see the same sort of ghost image follow the movement of your mouse; this time with a number across it that corresponds to the number of images you're moving. (See Figure 2.11.)

Figure 2.11 Moving multiple images into an album at one time shows a ghost image that also indicates the number of images you're moving.

❺ When you see the green + sign appear over your ghost image, drop your selection into the album.

❻ Confirm they all landed in the right place by clicking on the album's name and looking at the resulting view.

In addition, unlike your paper photo album, you can drop images into more than one photo album in Photoshop.com, and you don't need multiple copies of the picture to do it!

Album Cover

By default, Photoshop.com sets the first image in each album as that album's cover. However, there may be another image within the album that you like better as the cover. This is easy to set!

❶ Open the album by clicking on its name link in the left column.

❷ Look through the album until you find the image you want, and hover your mouse over it.

❸ The Photo Options menu will appear over the image. Click on the arrow at the right of the menu to display all the options.

❹ Select Use as Album Cover, and presto!—you have a new cover for your album!

Album Views

You have the same image viewing options in the Album view as you do in the Library, with a couple of additions; one of which is that you can set the default Album Slideshow view. This means that when other users view the album in your public gallery, the default slideshow will be the one you set here. We'll discuss this in more detail in Chapter 5.

Publishing Albums

In the left column of your My Photos view, you'll notice that each album link includes an additional icon to the left of the name. This icon changes depending on whether it's public or private; you have several publication options. Clicking on the icon reveals those options. (See Figure 2.12.)

◆ **Available to all.** Selecting this option makes your album available to all users of Photoshop.com through the public Gallery browser.

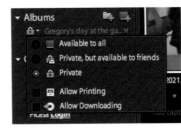

Figure 2.12 You have several publication options for your photo albums.

◆ **Private, but available to friends.** This is the option you'll use when you want to share your album with your own contacts only. They will be able to access the album via an E-mail link, but the album will not be made available on the public Photoshop.com Gallery browser.

◆ **Private.** This is the default setting for all galleries. Photoshop.com assumes that you want to keep your albums private until you've built and configured them to your satisfaction; therefore it requires you to manually publish your albums as a security measure.

In addition to the settings described above, you have two more options for every album, accessed from the same menu.

◆ **Allow Printing.** This setting, when enabled, permits viewers to purchase prints of any image from the album through partner provider Shutterfly. Generally this is fine for family snapshots, but if your images are of higher quality and you want to give viewing access only, you may want to leave this unchecked.

◆ **Allow Downloading.** Enabling this feature will permit viewers to download any image from your album to their local machine for printing or sharing. As with the Printing option, this is probably acceptable for general, casual photos, but if you want to maintain closer control over the distribution of your images, you should leave this option unchecked.

Checking or unchecking these options makes their corresponding icons available or not in the public Gallery view of your album.

Sharing Albums

If you have chosen to publish your Gallery, whether to the general public or just your friends, you can then share the album by sending an e-mail message to the contacts of your choice.

> ### Tip
>
> Note that setting your album to Private and then sharing it will change the publication setting to Private, but available to friends, (See Figure 2.13.)

Share your album by doing the following:

❶ Select the Share Album icon from the bottom toolbar.

❷ A small dialog box will appear. Enter a single e-mail address, or multiple addresses separated by commas.

❸ Enter a personal message.

❹ Choose whether to allow your viewers to download images from the album.

❺ Choose whether to allow printing of any of the images.

❻ Click Share to send the message. You might want to send a test message to your own address first to see how it looks and behaves in recipient Inboxes.

Figure 2.13 Clicking the Share Album icon opens an e-mail window where you can send a personal message with the link to your album.

Describing Images

By now you have probably discovered that images coming directly from your camera don't always have the most elegant or descriptive names. Photoshop.com recognizes this, and gives you a number of different methods for describing your images, making them easier to catalog, search, and recognize.

Adding a Caption

Just as Grandma did with her old paper photo albums with the tidy little notes accompanying each picture (sometimes on the back), you can add captions to your Photoshop.com images, more easily than Grandma's notes. Particularly if you're planning on sharing your images by way of E-mail or the public Gallery, this is a great way to add highly descriptive text—whether you're telling a whole story or just identifying location, event, or characters—adding a caption makes an image much more compelling.

Add captions by doing the following:

❶ In the default grid view, an add caption field should be visible below each image. If not, you'll need to expose it from the View menu, or open the right-hand Information pane and use that. In the single image view, you'll need to open the Information pane to add your caption, and in the table view, the caption will be part of the list of information for each image.

❷ Click inside the add caption field to open it for editing.

❸ Type your caption. (See Figure 2.14.) You can take up to 1,024 characters (including spaces) to tell your story, which gives you room for a long caption, just the length of this section (beginning after the heading, and ending right here) under the photo.

❹ When you're done, hit the Enter key on your keyboard, or just click away from the caption field to see the results.

very_happy_man.jpg
10/10/2008
sleepfamily

Uncle Bob was sure happy to be surrounded by a bevy of beauti...
Birthday party 2008 April

Add capti...
Add tags

Uncle Bob was sure happy to be surrounded by a bevy of beautiful blondes!

Figure 2.14
Hovering your mouse over a captioned image in the grid view shows a flyout of the full caption when thumbnails are smaller.

Adding and Understanding Tags

In addition to adding descriptive captions to your pictures, you can tag them with keywords such as location, event, names, month, year, and so on. The more complete your image tags are, the easier it will be to sort and organize your photos later.

Adding tags is just as easy as adding captions:

❶ In the default grid view, the tag field should appear immediately below the caption field under each image. If it does not, you can expose it from the View menu or in the Information pane to the right. In single image view, use the Information pane, and in table view, it will appear as part of the listed information.

❷ Click on the tags field to open it for editing.

❸ Type your keyword tags. You are limited to 64 characters including spaces; choose wisely. (Note that 64 characters is exactly the length of the sentence before this one, *without* the final period.)

❹ When you're done, hit your keyboard's Enter key, or just click away from the field to see the results.

You can also add tags to a batch of images all at once. Do the following:

❶ Select your photos using Ctrl + click (CMD + click on the Mac) for multiple non-consecutive images, or Shift + click if all the images you want to tag are in one consecutive series (this is where sorting comes in handy—for example, if you took a series of pictures of your child in one day, you can sort by taken date in the table view to bring them all together).

❷ Click into the Tag selected photos field at the bottom-left corner of the window to open it for editing.

❸ Type the tags you want to use. Photoshop.com will suggest tags for you, based on sets you've applied to other photos, as in Figure 2.15. Keep in mind that your tags should apply to *all* your selected images. If you want to tag individual images with additional keywords, you can always go back to the single tag field.

❹ Click Apply next to the field when you're finished.

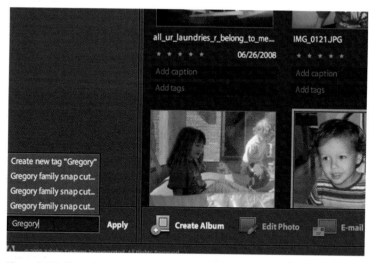

Figure 2.15 Photoshop.com will suggest tags based on sets you have previously applied to other batches.

Searching for Images

The Search field in the top right toolbar includes a drop-down menu that lists several search options. For the broadest and most thorough search, you would leave all these options checked, but there may be times when you want to search within a narrower range for fewer, more specific results. You can, of course, combine search parameters as well. (See Figure 2.16.)

◆ **Search album names.** If you want your search just to include the names of any albums you have created, select this option by itself. This is useful if you are looking for a specific album, but also know that images in albums other than the one you seek are tagged with the same search term, for example.

◆ **Search captions.** When you want to search only within image captions, use this option. Again, this is useful if you know that there are album names or tags that include the same term and you want to narrow your search to exclude those possibilities.

◆ **Search filenames.** This is probably the most difficult search parameter to use unless you are in the habit of renaming your image files after you've taken them. Best used

in combination with other search terms, it *can* be handy if you know precisely what image file you see, e.g., IMG_0331.jpg—in that case, you can search on 0221 and uncover it.

◆ **Search tags.** This is where all that tagging you've done is really useful. Search for a person's name, a location, or an event such as wedding, to find all the images you've tagged with that term.

> **Tip**
>
> If you have not tagged or captioned all your images, using restrictive search parameters may miss some images in your Library.

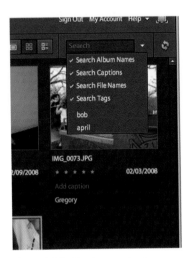

Figure 2.16 Check or uncheck parameters in the search list to broaden or narrow your search.

Figure 2.17 Searching for tags you have associated with your pictures makes it easy to find all the shots that meet certain criteria. For example, a search for the tags "Spain," "outdoors," and "2005" yielded this collection of images located in several different albums.

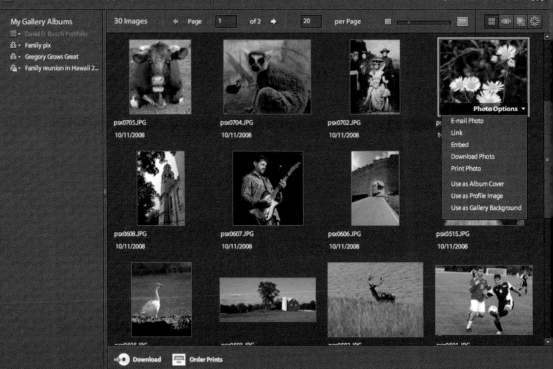

3 Creating Your Gallery

You've tagged your photos, put great captions on them, collected them into albums and album groups, and now it's time to share your prize with the world, or at least with friends and loved ones. Time to create your public Gallery.

Think of your Gallery just like a public art gallery. There are collections of works on different subjects, by different artists, and perhaps each artist has created multiple series of works on different themes. Each collection has its own tone, its own presentation style, its own artistic intention.

How the gallery chooses to present these collections in their best light is the curator's challenge. Photoshop.com acts as your Gallery curator, offering ideas for presentation that will show off any and all of your collections to their best advantage.

In this chapter, we'll learn how to assemble your albums into a Gallery for public viewing, and to manage your Gallery once it's published.

Remember that Personal URL you set when you first signed up for Photoshop.com? Your Gallery is where you see it put to use. Let's have a look.

Parts of the Screen

From the home page of Photoshop.com, you can get to your Gallery two ways:

◆ Click on the link next to My Gallery under your profile picture. This is your Personal URL and also the link to your Gallery.

> **Tip**
>
> When you are signed into Photoshop.com, you can navigate directly to your Personal URL and have access to all your Gallery editing features.

◆ The other way to get to your Gallery, and this is available from all of the Photoshop.com views, is by clicking the My Gallery link in the top menu bar.

As with the other screens in Photoshop.com, the Gallery page is divided into several regions, as shown in Figure 3.1. The labels in the figure correspond to the numbered list below.

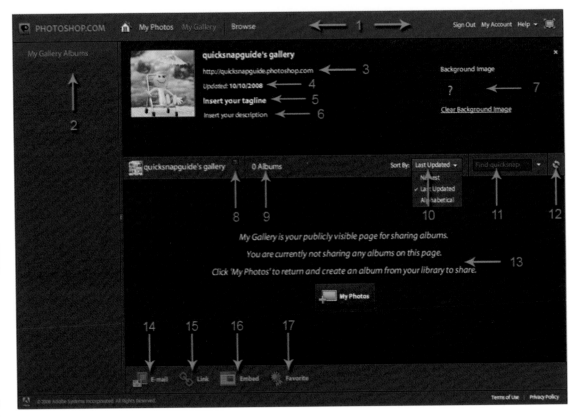

Figure 3.1 The Gallery page.

Top Menu Bar

1 The top menu is your constant friend within Photoshop.com; it is the same in this view as in the others, with the My Gallery text now highlighted.

Left Menu

2 In the Gallery view, the left menu now only lists any photo albums you have created. If you have none yet, this list will be empty. If you have created albums but not published them, they will appear in this list.

Gallery Information Pane

Across the top of the main pane, you'll see a block of information about your Gallery. This information will all be publicly viewable when you're ready to share your Gallery, and this pane is where you can update your details.

3 Personal URL. This is the address you chose when you signed up for Photoshop.com, and it is the public address that people will use to access your Gallery. It cannot be changed.

4 Updated. Photoshop.com keeps track of your Gallery updates and lets you know when you last made changes to your Gallery. This includes activities such as making albums public or private, adding, removing or editing images, and so on.

5 Tag line. This is your Gallery's headline or slogan, and it can be edited when you're signed into Photoshop.com.

6 Description. Longer than the tag line, this is a more detailed rundown of what you are displaying in the albums of your Gallery.

7 Background image. A thumbnail view of the image you have chosen as your Gallery's background. This option appears as a question mark until you set an image as your background. The image you choose will fill the background like wallpaper in the Album display area.

Main Pane

Below the information pane you'll see an open area where you'll carry out a number of album- and Gallery-related activities. Across the top of that area is a second toolbar.

8 Information pane toggle. You can use this button to collapse or expand the upper information pane.

There is also a small X that appears at the top-right corner of the upper pane when it is expanded. You can click either the toggle or the X to collapse the information pane; click the toggle again to expand it.

9 Albums header. This banner shows you how many albums you have chosen to make public. This count does *not* include private albums or those shared only with friends; it only includes albums that are available to everyone.

10 Sort by. As in the Library and Album views, you have a few choices for sort order in your Gallery page. Sort by album creation date, the date albums were last modified, or in alphabetical order.

11 Search. Slightly different from the search module in your other Photoshop.com views, you use the field here to search for Gallery users who have public albums. Search functionality may expand in the future to include tags and captions within images.

12 Refresh. On occasion, when you make changes to your Gallery such as setting or changing a background image, you'll need to refresh the page to see your changes.

13 Album display area. This is the main working space for your Gallery, and will list any albums you have published.

Bottom Toolbar

Active only when you have made at least one album public, the bottom toolbar gives you some great options for sharing your Gallery albums.

14 E-mail. You can send a link for a publicly available album using the E-mail utility. Select an album, then click on the icon to open the E-mail tool. It works the same as the E-mail utility you access from the Albums area.

15 Link. Clicking this link will copy the URL of a selected album to your computer's clipboard. You can then paste it into a file, post the link on a social networking site, and so on, to share an album slideshow with visitors.

16 Embed. Clicking this link copies a tiny script to your clipboard, which you can then paste anywhere that accepts such scripts. An example would be a page on your own personal website where you want to display a slideshow of your album.

17 Favorite. Add albums to your Favorites list in Photoshop.com. You can add your own and those of other Photoshop.com members.

Adding a Tag Line

When you choose albums for your Gallery, you want to make your public area catchy in as many ways as possible; otherwise, why share it? A tag line, like a newspaper headline, is one simple way of grabbing viewers' attention.

Understanding Tag Lines

Limited to only 100 characters, including spaces, your tag line is part of your Gallery's overall first impression. Think of it as a marketing tool—a way to convey you, your specialty, your personality, in a condensed form. If you had to describe yourself in 20 words or less, which is what it boils down to, what would you say? This is the banner across the Art Gallery entrance that brings people in the door.

Example Tag Lines

If you have a favorite phrase, proverb, etc., that you find yourself quoting frequently, it's a good place to start looking for tag line source material. Some examples of tag lines:

◆ "Who sings well prays twice."
 —St. Augustine

◆ Super snaps of super people

◆ It's not enough to aim; you must hit!

◆ Q: What's the difference between a duck? A: One leg is both the same.

◆ The Soul of Civilization

◆ Currently showing pictures of York Hall restoration

Each of these tag lines creates a different mood, and in part establishes the personality of the Gallery owner and the pictures contained therein.

Inserting a Tag Line

Adding a tag line to your Photoshop.com Gallery is simple (see Figure 3.2). The hard part is coming up with it in the first place!

❶ Click on the tag line field to open it for editing.

❷ Type your tag line. Remember that you only have 100 characters. This field only accepts text, so any markup you try to enter will be displayed literally; no fancy lettering, sorry!

❸ When you're done, hit either the Enter key or the Tab key on your keyboard, or just click away from the field to save it.

Tip

Note that Photoshop.com offers other users a way to report content as offensive or inappropriate, so it's best to avoid vulgar language. This is, after all, a family show. When viewing photos in someone else's albums, you'll find a red triangle with an exclamation point that can be clicked to report abuse.

quicksnapguide's gallery
http://quicksnapguide.photoshop.com
Updated: **10/10/2008**

ference between a duck? A: One leg is both the same.

Insert your description

uide's gallery 0 Albums Sort By: Last Updated

Figure 3.2 Inserting a tag line is simply a matter of clicking and typing. Easy!

Adding a Description

Below the tag line field, you'll find the description field. Just as easy to fill out, it's the place where you can describe your overall Gallery in a little more detail. Some Photoshop.com users choose not to use either the tag line or the description field, perhaps because they want to add some mystery, or are lazy, but we think it's a good idea to use both.

Understanding Descriptions

With 994 characters including spaces at your disposal, you have a bit more elbow room to introduce your Gallery. Descriptions can be used many different ways:

- Provide a brief bio of yourself
- Introduce the contents of your Gallery
- Discuss your favorite camera techniques
- Discuss your favorite photography subjects (landscapes, for example, or macro photography)
- Describe the camera equipment you use
- Tell stories about your pictures

The list could go on, and is limited only by your imagination and those 994 characters.

Example Descriptions

Depending on how you choose to use your description field, you might do something like the following, or combinations thereof:

- **Bio.** "I'm not a photographer, but photography occupies most of my free time. By day I work in IT. I've been using cameras since practically before I could talk and although it's not a job, it's definitely a passion."
- **Introduce Gallery contents.** "George Preston Blow's restoration of York Hall. These books were given to the National Park Service by the four brothers in 1969 when the estate was sold to the NPS. Recently, Tony Blow has been able to retrieve scanned photos. We present them here with thanks to Tony—he spent a great deal of time and effort in this endeavor."
- **Food for thought.** "Life isn't about waiting for the storm to pass…

 It's about learning to dance in the rain…

 Life is short, Break the rules, Forgive quickly, Kiss slowly, Love truly, Laugh uncontrollably,

 And never regret anything that made you smile."
- **Equipment.** "We use the best digital equipment possible whether we're shooting, restoring, or printing your images.
 In shooting, we use Nikon cameras.
 In restoring we use Photoshop CS3.
 In printing we use the Noritsu Ddp 421 and Epson."

Again, as mentioned earlier, keep in mind that this is a public site; if you use offensive language, users can report your site to Photoshop.com. Refer again to the Terms of Use if you are uncertain of what constitutes acceptable or unacceptable language or subject matter.

Inserting a Description

As with most of the other information fields on Photoshop.com, filling out the description field is easy (see Figure 3.3).

❶ Click in the description field.

❷ By default you will see "Insert your description" in the field; you'll need to delete that first.

❸ Type in your description.

❹ When you're done, click away from the field with your mouse, or press the Tab key on your keyboard to close the field and save your description.

Figure 3.3 The description field gives you a place to introduce yourself and your photos to the world.

Adding a Background Image

In addition to the interest you can generate with your written introductions, you can also create visual interest—before viewers even peek in your albums—with a background image.

Understanding Background Images

When you set a background image, Photoshop.com will turn it into a watermark—a slightly faded version of the picture—and place it behind the page as a backdrop. All the page features will have a slightly transparent quality, as though you're looking through etched glass or a stage scrim at the background image.

A background offers you another chance to capture your viewers' attention—you can present your best or most dramatic work, or a funny moment, or a compelling image that makes your viewer curious to see more. So, for example, you could:

◆ use a stunning landscape shot

◆ post a close-up (macro) shot of a particularly lovely flower

◆ display a portrait

◆ show off your adorable child

◆ share a funny pet moment

◆ haunt your viewer with a moment of captured drama

◆ make a statement with an illustration

Apply a Background Image

You'll use an image from your own Library as a background image for your Gallery, and setting it is a simple matter.

❶ Navigate back to your Library by clicking the My Photos icon in the top menu.

❷ Browse your Library for the image you want to use.

❸ Hover your mouse over the image to activate the Photo Options menu.

❹ Click on the Photo Options menu to expand it.

❺ Select the Use as a Gallery Background option. (See Figure 3.4.)

❻ Navigate back to your Gallery page to see the result. Example backgrounds are shown in Figure 3.5.

❼ To change or remove the background, just repeat these steps and uncheck the Use as a Gallery Background option.

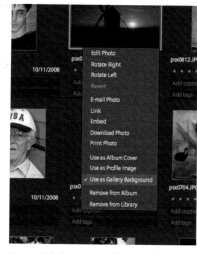

Figure 3.4 Set your Gallery Background from your image Library.

Figure 3.5 A sampling of Gallery Background images from actual Photoshop.com public galleries.

Going Public

Now that you've prepared your Gallery with tag line, description, and background image, it's time to go public with your first album.

As we mentioned in Chapter 2, there are three basic states for your albums. Let's talk about them, and how and why you might use them.

◆ **Private.** It's just for you. While you have been uploading your images, tagging them, and collecting them into albums, they have remained private. This makes sense if you think about it, because you don't really want to show your work in progress until you decide it's ready for prime time.

In some cases you may want to keep certain images and albums strictly private; perhaps because they're just for your own amusement, or you're just using the service to store or keep backups of your images, and you might find that certain ones will always remain private.

◆ **Private, but shared with friends.** It's just for you and your circle of contacts. While still not visible in your public Gallery space, you can send an album link to your E-mail contacts and they will be able to view it. The link includes a fairly complex address and tracking code, making the album nearly impossible to find without that link. This state is useful if you have, for example, family event pictures you'd like to share with family only—the rest of the world doesn't really need to see the look on Uncle Bob's face when he opened that gag gift for his birthday!

◆ **Available to all.** The Full Monty, so to speak: you have decided you *do* want to share your pictures with the whole world. Perhaps you're proud of your work, perhaps you've a bit of an exhibitionist in you and you just want pictures of yourself or your cat posted for the world to see; whatever the reason, this state makes your album viewable to anyone. Photoshop.com users can browse to and find it through your Gallery, and anyone who knows or can guess your Personal URL will be able to see it.

Choosing Photos for Public Albums

Before you open up your albums for public display, you should give careful thought to the choices you make.

◆ **Be kind.** Give consideration to your subjects—if there are other people in your photos, they may not want the image published, particularly if it's embarrassing!

◆ **Be thoughtful.** Consider the other users of Photoshop.com: while art can be thought-provoking, even shocking at times, going too far over the line can end up backfiring in the context of this site. Dramatic is good, hurtful… not so much.

◆ **Be legal.** When you're uploading images, Photoshop.com reminds you that you must have the right to share them. Uploading and sharing images that don't belong to you may constitute copyright infringement. And here's a twist—some public spaces such as museums forbid the use of cameras. And though it's increasingly easy to sneak a picture under those circumstances, doing so is illegal. So is publishing such a photo, so don't.

Making an Album Public

Now, finally, it's time to share the contents of one or more of your photo albums with the world at large. The decisions about what photos to share may have been difficult, but the mechanics of actually sharing them is simple. As you've created albums, they've been appearing in your Gallery page, but marked as Private.

❶ In the Albums list on your Gallery page, click on the album you want to publish. The Gallery will report back to you that This album is not public, and the small icon to the left of the album title appears as a padlock.

❷ Click on the down arrow next to that padlock to expose the menu.

❸ Select Available to all.

❹ Photoshop.com will show you a Privacy Alert to warn you that your album will be accessible to anyone. Click Cancel if you have changed your mind, or Make Public to continue. (See Figure 3.6.)

Once you've done this, the contents of your album will appear in the main pane of the Gallery page, and the padlock icon next

to the album title will become a tiny slide. In addition, your Gallery will go public with your background and profile images, tag line, and description. (See Figure 3.7.)

> **Tip**
>
> Prior to publishing your first album, your public Gallery is not accessible by your Personal URL, so your profile and background images, tag line, and description are all hidden.

Figure 3.6 You'll be asked to confirm that you want to make your Private album public.

Figure 3.7 What Photoshop.com Gallery users see from your Personal URL, before and after publishing your first album.

Managing Gallery Contents

It stands to reason that, as easy as it is to publish an album in Photoshop.com, it would be just as easy to remove it from view. And it's true.

It's also easy to manage the contents of your Gallery albums even after they are published, without taking the whole album offline to do it.

Let's look first at taking the whole album out of your Gallery.

Removing Albums from the Gallery

Somewhere along the way, you might decide it's time to take an Album off your Gallery page. This might be because you want to replace it with a new collection, or rotate in other albums to

keep your Gallery fresh, or you might just be tired of it. Whatever the reason, unpublishing the Album is easy.

❶ From either your Gallery or Library views, click the icon to the left of the album title to expose its menu.

❷ If you still want to share the album with personal contacts only, select the Private, but available to friends option; otherwise, select Private.

❸ A Privacy Alert will appear (shown in Figure 3.8), reminding you that the album will no longer be accessible from your Gallery, and its special URL will be deactivated. Click Cancel if you have changed your mind, or click Make Private to continue.

❹ The album still appears in the list on your Gallery page when you're signed in, but is no longer accessible from the public Gallery, and the icon next to the album name reverts to a padlock.

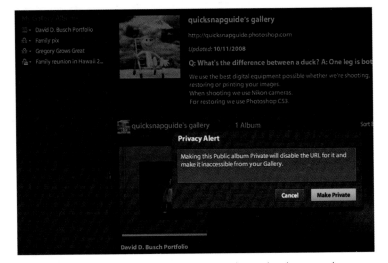

Figure 3.8 Photoshop.com gives you a Privacy Alert and a chance to change your mind before removing an album from public view.

62

Managing and Maintaining Gallery Albums

If you decide you want to add or remove pictures in a public album, you can do so while the album is still public. Perhaps you found another photo or two from that family vacation; perhaps you discovered (as we did during writing) that an uncorrected image got into your album by mistake.

To add more images to a Gallery album, do the following:

❶ You'll need to go back to your Library view first. Do so by clicking My Photos in the top menu.

❷ If you are uploading a new image, go ahead and do so; it will land in your Library.

❸ Add tags and captions to the image if so desired.

❹ Drag the new image over to the album title in the left column to drop it into that album.

❺ Go back to your Gallery view and refresh the contents using the Refresh icon at the far right of the Gallery toolbar.

Removing an image from a publicly shared album also involves navigating back to your Library.

❶ Select the album from the Library's album list.

❷ Navigate to the image you want to remove, and click on it.

❸ Remove it from the album either by using the Photo Options menu and selecting Remove from Album, or by clicking the Remove icon on the bottom toolbar.

❹ Go back to the Gallery and refresh its contents to confirm your action.

Other Public Album Maintenance

Within a publicly shared album, you can make other changes on the fly.

◆ Select a new cover image for that album.

◆ Update your profile image using an image in one of your public albums.

◆ Select a new background image for your Gallery.

All of these tasks can be carried out from the Photo Options menu on any image in a public album, in either the Gallery or Library view (see Figure 3.9).

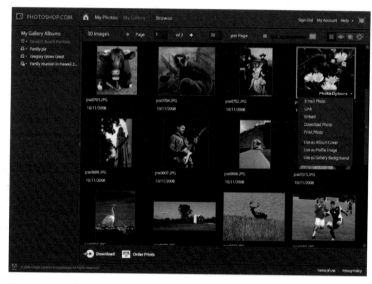

Figure 3.9 Update your public Gallery and Albums from the Photo Options menu.

Browsing Public Galleries

Need some photographic inspiration? Want to see how other users are employing Photoshop.com tools? Need a laugh? There are thousands of public Galleries and Albums, waiting for your perusal.

Click the Browse link at the top of the page to look around and see what other users are up to. There are several ways to browse and sort public Galleries and Albums. Click the left or right arrow at the top of the page to view new or previous albums.

Browsing

Using the links in the left column, you can:

◆ **Browse Galleries.** Look through entire collections that other users have compiled, and see their profiles, tag lines, and descriptions.

◆ **Browse Albums.** If you would rather see albums first and look at Galleries later, you can use this link to see all of the public Albums.

◆ **Favorite Galleries.** While you're browsing Galleries, you can mark them as Favorites and return to them later using this link. Mark a Favorite by selecting it in the Browse window and clicking the Favorite icon on the bottom toolbar.

◆ **Favorite Albums.** Likewise, if certain Albums just jump out at you, you can add them to your Favorites list to visit again later. Keep in mind, though, that if a user decides to unpublish or delete one of your favorites, you won't be able to go back to it from this link. Mark Favorites by selecting an album within the Browse Albums view, or by selecting an Album within a user's Gallery, and then clicking the Favorites icon on the bottom toolbar.

◆ **Recently Viewed Galleries.** Photoshop.com keeps track of Galleries you have viewed, in case you want to go back to them.

◆ **Recently Viewed Albums.** Your Album views are also collected and added to this list so you can return to them later.

Sorting

Because there are already so many user Galleries and Albums, and new ones are being added all the time, Photoshop.com offers some options for viewing, sorting, and searching (see Figure 3.10).

Across the top of the Browse window, you'll see a toolbar similar to those in your own Library views.

◆ **Page.** Move around the Browse pages by clicking the right or left arrows, or by entering a page number into the field. It's fun to enter a random page number just to see what's in the middle of the pile, or to go all the way to the back to see some of the early efforts.

◆ **Per page.** You can choose to view more or fewer Gallery or Album thumbnails per page. If you want to scan quickly, or if you have a large screen, you can increase the number here. Lower it if you want to take your time or see all the thumbnails above the fold (without scrolling around).

◆ **Sort by.** Photoshop.com offers multiple sorting options, including Newest (Galleries or Albums most recently added to Photoshop.com), Last Updated (Galleries or Albums most recently modified), or Alphabetical (A-Z only, not Z-A).

◆ **Search.** The search field currently only permits you to look for Gallery names (i.e., the first part of any Gallery's Personal URL—in our case, "quicksnapguide"). Enter a Gallery name to view it directly; click the X next to the Search field to clear it and show all the Galleries or Albums again.

◆ **Refresh.** As in your own Gallery window, use this icon to refresh the contents of the public Gallery space. New content is added all the time, so click this every so often to see the very latest changes, including your own.

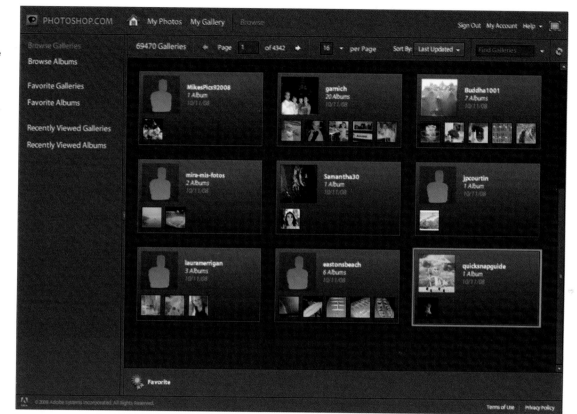

Figure 3.10 Browse public Galleries and Albums to see what other users are doing, or get inspiration for your own images.

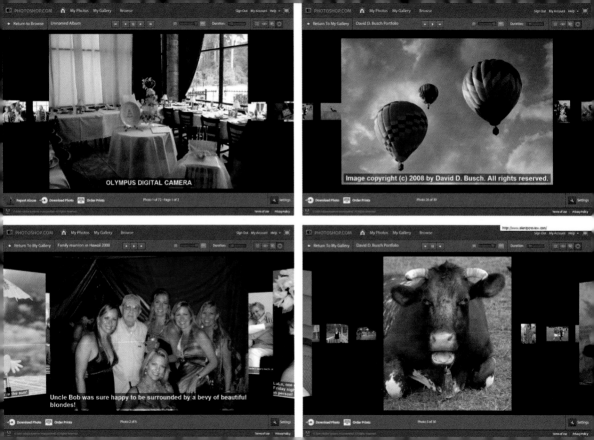

4

Create an Album Slideshow

When you first create an Album and publish it, Photoshop.com creates a slideshow for public viewing with some default settings—and unlike many defaults, this setup is quite nice! You *could* leave your newly published Album exactly as it is, and it would still be quite impressive.

But Photoshop.com has taken it one step—no, *several* steps—further by adding some really nifty extras that help your slideshow stand out even more. Effects, captions, even a music background: these all contribute to the overall effect of your Album slideshow, really sending it over the top!

If you're old enough to remember those family slideshows, in a darkened room, with dear old Dad presiding over the slide projector and waxing poetic about that great fish he caught in 1959, you can imagine how

Photoshop.com offers a vast improvement. It would take an hour to drag out the slide projector, dust it off, get it working, and by the time the show actually started, the kids were up past their bedtime.

And a little closer to the present, you've probably seen your share of picture slideshows at company events—and weren't the ones with the nifty visual effects and exciting soundtrack more memorable and interesting than those bone-dry, unimaginative laundry-list presentations filled with bullet-points?

It used to take a lot of work and time to craft those memorable presentations. But now, Photoshop.com has already done the work. So what are all these features, and how do you add them to your Album slideshows? Read on and find out, and put them to work for you!

Parts of the Screen

Like most of the other major views in Photoshop.com, there are multiple ways to get to your Album Slideshow settings. In this case, however, different entry points dictate how many of the settings you see.

Getting to the Slideshow Settings

◆ **Home Page and My Photos Page.** Clicking on an Album from your Home page or from the Album view in your My Photos page will open up that Album and display the photos in it. From the bottom toolbar, click on the Slideshow link. Your Album's default slideshow will start playing automatically, even those still marked as Private.

◆ **Gallery sidebar.** Your Albums behave a little differently in the Gallery view. Clicking on a Private Album's link only displays a message in the main pane telling you that the Album is not shared. Clicking on a Public Album's link will open the Album's contents in a thumbnail layout first. In the top-right corner, you can start a slideshow by clicking any one of

the three icons furthest to the right (the fourth one takes you back to the thumbnail view).

◆ **Gallery main pane.** To see the Album's current slideshow, you can also click on the center of the thumbnail showing in the Gallery's main pane.

> TIP
>
> Note that not all of your available settings can be accessed or changed from the Gallery page.

In all cases, launching the Album's slideshow will reveal a Settings icon on the right end of the bottom toolbar. Clicking that icon opens a new column along the right side of the screen, and this is where the slideshow fun begins!

Top Toolbar

Where much of the slideshow screen is the same as other views in Photoshop.com, there are a few obvious differences specific to the slideshow. Figure 4.1 shows the key components of the screen, numbered to correspond with the list below.

❶ The top toolbar remains constant as before.

❷ **Return to My Photos.** If you're in the habit of using your keyboard's Backspace key to move back to a previous web page, you'll need to use this button instead. Because Photoshop.com is Flash-driven, hitting the Backspace key will either take you out of Photoshop.com altogether if you had visited a previous page before entering the site, or will do nothing at all.

❸ **Album name.** Just to remind you that you're in the right place, Photoshop.com displays the current Album name.

❹ **Play buttons.** Similar to a CD or mp3 player, you can play, pause, and move forward or backward in the slideshow with these buttons.

❺ **Zoom In/Out.** Increase or decrease the size of the current image with this slider tool. If you have a large screen, you can set the slider to the highest zoom level (furthest right), but keep in mind that if you loaded high-resolution images, they may get cut off a little bit at this setting; the same will be true if a viewer has a smaller screen or one set to display at lower resolution. Moving the slider to the middle is a good place to set the default size if you want to accommodate most viewers' screens—they can always adjust it themselves while they're viewing your slideshow.

❻ **Duration.** Set the default speed for your slideshow display, from 1 second at the far left to 10 seconds at the far right.

❼ **Layout.** Using these settings, you can choose which layout you want your users to see when they first open your slideshow. Select a grid of simple thumbnails, all the way up to a flying ring of images. As with image size and duration, users can change the layout, but the settings you choose here will be the default.

Right Menu

When you click the Settings button at the bottom-right corner to open the right column of tools, you'll see some new items offering you some more choices for your slideshow display. As with

the features in the top toolbar, your viewers can change most of these settings when looking at your slideshow, with the exception of the audio.

⑧ Captions. Choose whether or not to display your image captions.

⑨ Layout. Display your slideshow in two dimensions or with 3D effects using this setting.

⑩ Viewing Settings. You have some options here for how your photos will be displayed within the slideshow.

⑪ Click to Enlarge. Use this setting to determine whether clicking on an image only displays that image, or starts the full automatic slideshow.

⑫ Transition Mode. Do you want users to see your images in a sliding animation, or do you want each image to snap into place without movement? Set that here.

⑬ Audio. Here is where you can select from a list of songs and preview them before adding one to your slideshow. You can pause the sound by locking on the Audio right arrow, which then turns into a Pause symbol. A bar indicates the music's progress.

Bottom Toolbar

Along the bottom of the window, both you and your viewers can see a last little set of tools.

⑭ Download Photo. If you set your Album to permit users to save your images to their local machine, this icon will appear active; otherwise, it will be grayed out and will do nothing.

⑮ Order Prints. As with the Download button, the appearance and function of this button depends on what setting you used when you published your Album.

⑯ Settings. As we already mentioned, this button expands or collapses the right column tools menu.

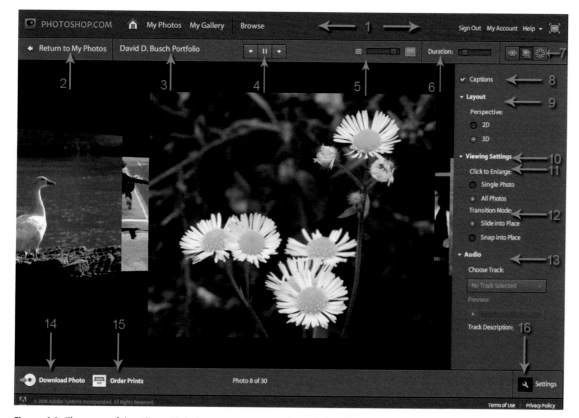

Figure 4.1 The parts of the Album Slideshow screen as seen from the My Photos area.

Zoom, Duration, and Layout

The three settings along the top toolbar might be considered the Function settings, and the right column settings as the Style settings. You'll make choices about those function settings based on your own personal preference, of course, and you'll also want to keep your audience in mind.

Zoom

How large or small you would like your images to appear by default is a choice determined by a number of factors:

◆ **Image size.** The size and resolution of your images will in part dictate the zoom setting you choose. You may want to set a higher zoom level for smaller images, for example, so they fill more of the frame; larger images, particularly very high-resolution ones, should probably be set at a lower zoom level to start with, so that viewers get the overall impact of each picture before zooming in for a closer look. The Zoom control is a slider at the upper right, next to the Duration control.

◆ **Image size uniformity.** It's easier to decide on a zoom level if your images are of consistent size; if it's a mixed bag, however, the decision is a little more difficult. Find a moderate setting so that the smallest images are shown in enough detail to make sense, and the larger images are not cut off, or at least not too badly.

◆ **Image composition.** Because every picture is different, this will also present a small challenge. If your images are generally centered in the frame, with not much detail around the edges, you can probably stand losing a little bit of the edges without damaging the composition, so you can zoom in further. However, images with detail out to the edges should probably be set to stay within the slideshow frame as much as possible, so you might want to set a lower zoom level for these.

◆ **Level of detail.** How detailed are your images, and how much do you want your viewers to see at first? If, for instance, you include photographs of artworks such as paintings, you may want to display the full work to start with, and let users zoom in to see the details. On the other hand, if macro (close-up) photography is your passion, perhaps you want your viewers to see a more intense amount of detail to begin with.

◆ **Screen size.** This might be another small hazard. Although screen size and resolution continues to improve with advances in display technology, not everyone has a 22" (or larger) screen that displays 1680x1050 (or higher) resolution. In fact, it's pretty safe to assume—at least this year—that most users don't; if you do, reduce the size of your browser window to something closer to a normal screen (1024x768 is a good middle ground) and set your zoom so it fits best in a screen that size. Remember also that some users—perhaps those who have some visual impairment—set their screens at even lower resolution.

> **Tip**
>
> Remember that viewers of your Public Gallery can change these settings as well, so even if you choose a zoom level that doesn't work for all screens, users can make changes to suit their preferences.

Duration

How long or brief a time you want to display individual images in your Gallery, set with the Duration control found to the right of the Zoom slider, is also a decision that can be influenced by a number of factors. Again remembering that users can change this setting according to their own preferences, how the contents of your Gallery are best displayed can be helped if you keep the following in mind:

◆ **Number of images.** With fewer images in your Album, you can afford to display each one for a longer period of time without losing your audience to impatience. You may want to spin a larger collection a little faster to keep your viewers' attention. (You can always pause an individual slide by clicking on the center arrow in the top toolbar.)

◆ **Level of detail.** If your shots are particularly detailed or artistic, you might want to set a longer duration to encourage your visitors to spend some time on each image. Of course, if they want more time, they can always pause on an image to examine it in detail. Simple snapshots generally don't require as much individual attention, so you can speed them up a little.

Layout

When Photoshop.com users first open your slideshow, you can choose a few different layout possibilities, from very simple to quite complex, using the last three tools on the upper tool bar (see Figure 4.2).

◆ **Filmstrip.** Remember those? Decades ago, before computers were in such widespread use, a filmstrip was often used in the classroom to illustrate concepts, or sometimes as part of a story, and was exactly what it sounds like: a strip of static images which, like slides in a slide projector, were displayed one at a time.

Photoshop.com has enlivened the original concept and brought it to the computer display in animated form (at least, it advances by itself). The images move across the screen, showing the left-most first, and moving along to the right.

◆ **Grid.** Your images start out in either a 2D or 3D grid (we'll talk about those in the next few pages), and one image at a time is enlarged and displayed, then put back into the grid to make room for the next.

◆ **Ring.** Perhaps the most visually complex (and cool, if you're into visual effects), your images begin in a ring, and as an individual image is displayed, the ring rotates in a fashion similar to those old slide projector carousels, having no real beginning or ending.

Figure 4.2 Examples of slideshow layouts. Within those layouts, you can set additional style variations.

71

Captions: On or Off?

In Chapter 2, we showed you how to add captions to your images, and gave you a few examples of how they could be used. One good reason to spend time creating good captions is here, in your Public Gallery.

All about Captions and What They Have to Say

When you're viewing your own images from inside your Library, it's hard to get a sense of what impression captions will convey when other people view your images. You see them as little text fields below or beside your images; public viewers see something quite different.

Ask yourself some questions when choosing whether or not to use captions:

- ◆ Do my pictures require explanation?
- ◆ Is there a story I'd like to tell, with each picture a step along the way?
- ◆ Do I want my viewers to know who's in my pictures? Or where and when they were taken?
- ◆ Does my camera equipment affect the result of a shot? If so, do I want to include a note about what I used?

And finally, because captioning does take time:

- ◆ Is it worth all the time it takes to add captions?

> **Tip**
>
> You can use captions to place copyright notices on your images if you want to protect them; be sure to disable Downloading and Printing functions as well to control distribution.

There's one other factor to consider as well: if some of your images are captioned, but not all, will it drive you nuts? Will it drive your viewers nuts? Does it matter?

As to that last, the good news is that Photoshop.com doesn't leave a gaping hole if a caption isn't present; it just shows the picture with no fuss.

Figure 4.3 Too long of a caption will obscure your image.

If you do choose to use captions, then, you could use them for the following:

◆ **Location**—e.g., "Killarney Castle, Ireland"

◆ **Date**—e.g., "March 2008"

◆ **Event**—e.g., "The Wedding of Jamie and Fred"

◆ **People**—e.g., "Betty and Judy at the family reunion"

◆ **Title**—e.g., "Stillness at Sunset"

◆ **Equipment**—e.g., "Nikon D90, natural light"

◆ **A line of poetry**—e.g., "Ist dies etwa der Tod?"

◆ **Copyright notice**—e.g., "Image copyright (c) 2009 by David D. Busch. All rights reserved."

◆ **One-liners**—e.g., "Uncle Bob was sure happy to be surrounded by a bevy of beautiful blondes"

Although you have up to 1,024 characters to play with in the caption field, you should know that using all 1,024 characters covers your entire image with text in the Gallery Slideshow! (See Figure 4.3.)

Figure 4.4 Examples of images in Gallery Slideshow view, with and without captions. Some images require no explanation.

Layout Controls

While the Contact Sheet and Filmstrip layout views are only available in 2D, the Grid and Ring layouts can be displayed in either 2D or with 3D effects. Because your Gallery slideshow display is, in the end, a combination of all these features and effects, you might choose 2D or 3D because it works better for your album size or in combination with some other settings you've chosen.

How 2D Looks and Works

As you might imagine, setting your layout to 2D aligns the picture thumbnails as though they're moving around or across a flat surface (see Figure 4.5).

◆ **Grid layout.** All of your image thumbnails are laid out in rows and columns as though on a table.

◆ **Ring layout.** Thumbnails are set out in a flat circle, again as though on a table.

While it's tempting to reach automatically for 3D because it's so cool looking, you might find that 2D works better if your album only has a few pictures. It looks great if you set a lower zoom level so that users can keep an eye on the progress of the slideshow presentation; 2D also makes it easier for users to click back over previously viewed images if they want to go back to a specific one.

How 3D Works and Looks

When you enable the 3D style, your Album thumbnails are stood up on end and stacked from front to back so that they appear layered in—you guessed it—three dimensions. It's an exciting addition to the visual style of your

Figure 4.5 Grid and Ring layout views in 2D. You can see an equal amount of detail in the background image thumbnails that are within view.

Figure 4.6 The 3D effect works well with larger Albums.

Gallery Albums, but not always the best choice.

◆ **Grid layout.** Thumbnails now appear in rows, like soldiers in formation, waiting to step forward.

◆ **Ring layout.** Now even more closely resembling the carousel of a mechanical slide projector, image thumbnails are stood up on end and moved around in a circle as viewers progress through the Album.

The 3D view makes sense if your Album has a lot of pictures; the stacked effect brings more thumbnails into view at one time, though a little of the detail might be lost in the stack. The Grid layout in 3D looks best if your album has 24 or more pictures in it (see Figure 4.7). The Ring layout in 3D works well for Albums with at least 10 images as in Figure 4.8; otherwise, the effect is lost behind the front image.

Figure 4.7 For Grid layout, the 3D effect is lost in smaller Albums, even with the zoom level at its lowest setting.

Figure 4.8 In Ring layout, the 3D effect is lost at higher zoom levels, and distracting at lower zoom levels.

Viewing Settings

Further down the style list, you have a couple more visual choices that can enhance or detract from the selections you have already made, and affect how much impact individual images have on the viewer. Again, depending on personal preference, your exploration will lead you to your own styling decisions, but as with the features we've already introduced, factors such as album size and style combinations will result in more or less effective outcomes.

Click to Enlarge

By default, the Click to Enlarge setting for new Gallery Albums is set to Single Photo, which shows off some other layout settings to good effect. You have two choices, though, and you might be surprised by the overall result when choosing one over the other.

◆ **Single Photo.** Whether 2D or 3D, the Single Photo setting zooms in on and enlarges the current image and leaves the waiting thumbnails in the background at a perceived distance.

◆ **All Photos.** This setting moves your entire array of image thumbnails forward so that the current image and next and previous images appear to be nearly the same visual depth and size.

Both Click to Enlarge settings can be applied to all three of the Slideshow layouts (see Figure 4.9).

◆ **Filmstrip layout.** The Single Photo selection shows the current image in the center of the screen with waiting images in a line of smaller thumbnails in the back; All Photos lines up all the images at the same distance from the viewer at whatever zoom level you set.

◆ **Grid layout.** In 2D, Single Photo is like picking up a sheet from the table to examine it, and All Photos is like leaning in close to the table without picking up a sheet. In 3D, the Single Photo setting brings one image forward, like a soldier stepping forward out of his formation; the All Photos setting is like stepping up close to the entire formation.

◆ **Ring layout.** The combination of Single Photo or All Photos and the previous features has perhaps the most significant difference in the Ring layout. In 2D, the effect of Single Photo is rather like that of a clock with the numbers each leaping forward in turn; All Photos is more like looking closely at a Ferris wheel as it moves. In 3D, the ring of thumbnails floats in space behind and slightly below the current image when using the Single Photo option, and All Photos brings the whole ring up to eye level.

Figure 4.9 Filmstrip layout and the effect each Click to Enlarge setting has on the overall Album.

Tip

Note that in Filmstrip layout, the images move across the screen from right to left. The first image you view is at the left end of the row. Using the Next and Previous play buttons above the display can be confusing because the images appear to move in reverse order.

Transition Mode

The final visual effect has to do with the transition from one image to the next, and this really is a matter of personal preference. Some users love lots of animation, others find it irritating and distracting. (See Figure 4.10.)

◆ **Slide into Place.** The default transition setting for new Gallery Albums, this setting animates the movement of your thumbnail array and the current image as it switches in and out of view. It really shows off the more complex style settings of the album.

◆ **Snap into Place.** Selecting this option effectively disables the animation of your album, so that each image instantly takes the place of the one before without any motion.

While the effect of animated movement is visually interesting in itself, you may find that it doesn't work as well as the snap effect in some instances; additionally, too much movement may distract and detract from your photos if they are highly detailed or artistic in nature. (See Figure 4.11.)

Figure 4.10 The same image has more impact or less in the slideshow depending on the combination of features.

Figure 4.11 Combinations of effects work to enhance either a single image or the overall Album. Some features get lost with certain combinations; note that combining 2-D and All Photos brings the image forward and completely loses the waiting images.

Adding Audio

Like animation, audio is diffi-cult—okay, impossible—to demonstrate in a book made of paper. But let's think about sound and music for a moment. For many of us, our lives have a soundtrack: we listen to our mp3 players, have the radio going in the background, play the car stereo while we drive around. Movies have soundtracks, and the right music can send a movie over the top from good to truly great.

Why not add music to your Album's slideshow presentation? Music puts a final layer of polish on what (we hope!) is an already spectacular show.

Choosing Tracks

While still a fairly short list, Photoshop.com offers music to go with your Album slideshow. The songs listed offer a range of moods and styles, from country to electronica to party to emo and more.

❶ Click the arrow below Choose Track to show the menu of available songs.

❷ Select a song to read its descrip-tion, which will appear in the Track Description field at the bottom of the Settings pane (see Figure 4.12).

❸ You'll probably want to listen to the songs as you browse through them; you can hear short snippets of each by clicking the play button on the Preview widget. Naturally, you'll need headphones or speakers! Click the arrow under Preview to pause the music. The bar indicates where in the song you are.

Figure 4.12 Choose from a list of songs offered by Photoshop.com to accompany your Album slideshow.

Enabling an audio track adds an extra tool to the Gallery Album in the public view. In the top toolbar, users will now see a volume control icon for adjusting the sound while they view your Album (see Figure 4.13).

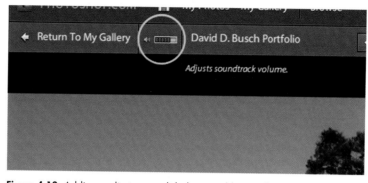

Figure 4.13 Adding audio to your slideshow enables a volume control tool in the public Gallery view of your Album.

Although it seems logical to assume if you can upload photographs, you should be able to upload the audio of your choice as well, this is not so. Because of potential (really tricky!) copyright infringement issues, Photoshop.com has chosen to limit the audio selections to those that they provide for you. In Photoshop.com forums at the Adobe website, several users have asked to be able to upload their own songs, but until the folks at Adobe can find a way to work within music copyright laws, users will be limited to the songs provided.

Your photostream 4 items / 0 views

Slideshow 🖵 Share This ⤷

Sets Tags Archives Favorites Popular Profile

psx0503

click here to add a description

ⓒ ⓞ Anyone can see this photo (edit)
Uploaded on Oct 13, 2008 | Delete
0 comments

psx0503

click here to add a description

ⓒ ⓞ Anyone can see this photo (edit)
Uploaded on Oct 13, 2008 | Delete
0 comments

Great Smoky Mountains
4 photos | Edit

psx0611

Cades Cove, Tennessee

Cades Cove, in the Great Smoky Mountains

5 Photoshop.com and Other Photo Sharing Sites

The web is an amazing place. There are sites for social networking, music, images, games, recipes, socks, pet clothing; you name it, you can probably find it on the web. And it grows larger and more complex by the minute!

As web technology continues to improve, and the concept of Web 2.0 gains a firmer foothold in virtual space, users have demanded more ways to connect, and more ways to link their memberships on various sites. You can sync your e-mail contacts with several of the major networking sites now, for example, and the list of ways in which you can share data between social networking sites is far too long to enumerate here. Facebook talks to LinkedIn, which talks to Plaxo, which talks to LinkedIn and to your computer, which talks to Google… the list goes on.

With all this in mind, the creators of Photoshop.com have built connection methods right into the service. If you have existing accounts (or want to create new ones) on any one of several networking and photo sharing sites, you can now keep them synchronized with Photoshop.com, further expanding your ability to share photos with friends and family, and the world at large.

In this chapter, we'll take a look at how Photoshop.com integrates with the four largest networking and photo sharing sites: Facebook, Yahoo!'s Flickr, Photobucket, and Google's Picasa.

The Login Process

Back in the My Photos area of Photoshop.com, it's time to look at the Other Sites component in the left menu area as shown in Figure 5.1 (you can expand or collapse any menu item by clicking the small arrow to its left).

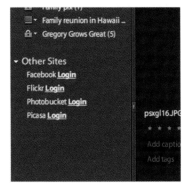

Figure 5.1 Expand or collapse the Other Sites menu item using the arrow to its left.

Currently Photoshop.com supports integration with:

◆ Facebook

◆ Flickr

◆ Photobucket

◆ Picasa

Assuming you already have an account with one or more of these services, the login process is quite simple (signing up for a new account is also easy, but you'll need to go to your chosen service first and let them walk you through the process).

Let's start with Facebook.

> **Tip**
>
> Photoshop.com assumes that you already have an account with the Other Service that you're selecting, so you'll be taken directly to a login page.

Logging into Facebook

To link Photoshop.com with your existing Facebook account, carry out the following steps:

❶ Click the Facebook Login link under Other Sites.

❷ Your web browser will open a new window or tab (depending on your browser and its configuration settings). This is a special Facebook login screen. (See Figure 5.2.)

❸ Enter your Facebook account information (the e-mail address and password you use to access your Facebook account).

facebook

Adobe Photoshop.com
Login to Facebook to enjoy the full functionality of Adobe Photoshop.com. If you don't want this to happen, go to the normal Facebook login page.

Email: quicksnap@shetech.com

Password: *******

Forgot your password?

Security Note: After login, you should never provide your password to an outside application. Facebook does not provide your contact information to Adobe Photoshop.com.

Login Cancel

Figure 5.2 The Facebook login screen will open in a separate browser window or tab.

④ Click Login to continue.

⑤ The first time you access Facebook through Photoshop.com, you will be asked to allow Photoshop.com access to your Facebook profile and other information. Click Allow to continue.

⑥ When those steps are complete, you can close the window or tab to return to Photoshop.com.

⑦ Back at the Photoshop.com page, you'll see a dialog box asking you to click OK when you are done logging in. It's now safe to do so.

You'll see that the Facebook link in the Other Sites menu now has its own expand/collapse arrow, and shows a link to your photos on Facebook.

Logging into Flickr

The Flickr login and setup process is similar to Facebook's. Do the following to login and attach your Flickr account:

① Click the Flickr Login link in the Other Sites menu.

② As with the Facebook link, a new window or tab will open, this time showing you the standard Yahoo! Login widget (and a place to sign up for a new account if you don't have one).

③ Enter your Yahoo! User ID and password.

④ Click Sign In to continue.

⑤ Flickr will ask you to confirm that you want to merge with Photoshop.com (or Photoshop Express, which was the previous name for the service). Click OK, I'LL ALLOW IT to continue as shown in Figure 5.3.

⑥ When the integration is complete, you'll see a success message telling you that you can now close the window or tab to return to Photoshop.com.

⑦ Photoshop.com will be waiting with a dialog box asking you to click OK once you have logged in. Click OK to complete this final step.

⑧ The Flickr link now changes, expanding to include a link to your Flickr photos.

Figure 5.3 Logging into Flickr for the first time generates a confirmation screen to authorize the integration process.

Logging into Photobucket

Photobucket is another major player in the photo sharing arena, so if you have an account there, you too can link it to Photoshop.com. To get started, do the following:

❶ Click the Photobucket Login link in the Other Sites menu.

❷ Unlike the first two services, this one opens a login dialog within Photoshop.com, rather than sending you to an external page or opening a new browser window or tab.

❸ Enter your Photobucket user name or e-mail address and password (see Figure 5.4).

❹ Click Sign In to continue.

❺ The Photobucket link will expand to include links to your photo collection on that service.

Logging into Picasa

Picasa is Google's photo sharing service, and it has grown at an amazing rate. If you have a Google account, you will automatically have access to a Picasa account; however, you must completely set it up first in Google before you can access it through Photoshop.com. To link Picasa and Photoshop.com, do the following:

❶ Click the Picasa Login link under Other Sites to start the process.

❷ Photoshop.com will open a new browser window or tab with a message from Google telling you that Photoshop.com is requesting access, and includes a login form. (See Figure 5.5.)

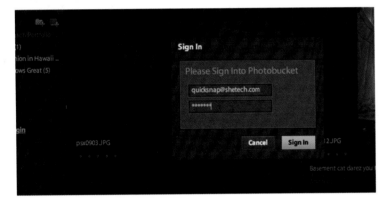

Figure 5.4 The Photobucket login routine differs from that of Flickr or Facebook.

Figure 5.5 To access Picasa, you'll need to use the Google login page.

❸ Enter your Google/Picasa login ID and password, and click Sign In to continue.

❹ You may see a message alerting you that Photoshop.com has not registered with Google to establish a secure connection for authorization requests. As long as you reached this page directly from Photoshop.com, it is safe to continue. Click Grant Access. (See Figures 5.6 and 5.7.)

❺ The Google sign in window should close automatically and return you to Photoshop.com, where you'll now see a link to your Picasa images in the Other Sites menu.

quicksnap@shetech.com | Google Home | Help | My Account | Sign Out

Google Accounts Access Request

The site **www.photoshop.com** is requesting access to your Google Account for the product(s) listed below.

◯ **Picasa Web Albums** - http://picasaweb.google.com/

If you grant access, you can revoke access at any time under 'My Account'. www.photoshop.com will not have access to your password or any other personal information from your Google Account. Learn more

⚠ **This website has not registered with Google to establish a secure connection for authorization requests.** We recommend that you continue the process only if you trust the following destination:

https://www.photoshop.com/express/picasa_auth_response.html

[Grant access] [Deny access]

Figure 5.6 You may see an alert telling you that Photoshop.com has not yet registered with Google for secure access.

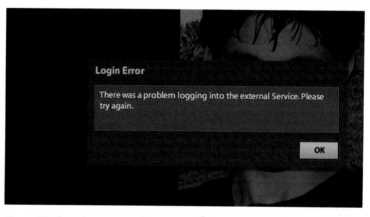

Figure 5.7 If you have a Google account but have not set up the Picasa service within Google, Photoshop.com will show an error when attempting to log in.

Integrating Photoshop.com with Facebook

Once you have logged in to your Facebook account through the Photoshop.com integration component, you'll see links to any photo albums you have created in Facebook, and the photos you previously uploaded to those albums will be collected here the same way they are in your Photoshop.com Albums. But logging in to the Facebook component does not mean that your Facebook albums automatically become Photoshop.com Albums; they really just sit next to each other.

The good news about that is you have just expanded your overall storage space between the two services if you keep them separate. The bad news is that you won't be able to share your Facebook albums as they are through the public Photoshop.com Gallery.

So what do you do if you want to share these pictures as well?

Moving Photos from Facebook to Photoshop.com

The answer to that question is that you actually need to move images over from your Facebook collection into the Photoshop.com area, and it couldn't be much easier!

❶ Log into your Facebook account through the Photoshop.com component if you have not already done so (you need to log back in every time you close and come back to Photoshop.com).

❷a Select an album from which you want to move photos, and then select the image(s) you want, OR

❷b Select a photo from the All Photos—Facebook link. Like the Photoshop.com Library, your images are listed both in a general library and in their respective albums.

❸ As with moving images around inside Photoshop.com, you can drag an image or images *from* Facebook into the Photoshop.com Library, where they will simply be stored, or you can drag into a new or existing album. Drag the pictures over the link you want to use. When the + appears, you can drop them.

❹ You'll see a Download Approval dialog the first time you do this. Click Do not show if you don't want to be reminded every time, then click Agree to continue.

❺ Your picture is now part of your Photoshop.com Library, and part of an album if you chose one. Note that your Facebook captions are lost in transit; you'll need to rewrite your captions in Photoshop.com.

You might notice that the images from Facebook have really long, confusing filenames—in the end, that may help you keep them straight! More on that in a moment...

> ### Tip
>
> Note that you cannot move entire albums across from Facebook to Photoshop.com or vice versa; however, you can move multiple images at one time.

Moving Photos from Photoshop.com to Facebook

Moving photos across services works in reverse, too! You've done a lot of work tagging, captioning, and organizing your images in Photoshop.com, and now you can very easily copy them to your Facebook photo collection. Here's how:

❶ Select the photo you want from either your general Library or an Album within Photoshop.com.

❷ Drag it to an Album link under the Facebook menu, or to the Add icon to create a new album.

❸ The first time you copy a photo into Facebook, you'll be asked by Photoshop.com to authorize the upload (see Figure 5.8). Click the Facebook Extended Services button to continue.

❹ Facebook will also ask you to authorize the upload in a separate window (see Figure 5.9). This will look familiar to you if you have ever added any applications to your Facebook profile. Click Allow Photo Uploads to continue.

❺ You can then close the Facebook window to return to Photoshop.com, where you'll see your newly copied image in the Album you chose or created.

❻ Photoshop.com automatically creates a caption for the picture in Facebook if you did not have one on the image in Photoshop.com; or it will carry an existing one over and place it in the Comments field in Facebook (see Figure 5.10).

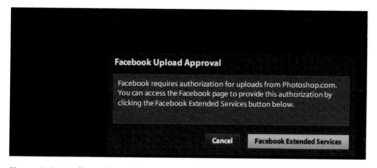

Figure 5.8 You'll need to authorize Photoshop.com to upload images to Facebook the first time you move images.

Figure 5.9 Facebook asks you to allow the image upload the first time you copy one from Photoshop.com, as it does with all new add-on applications.

Figure 5.10 Your existing Photoshop.com image captions get uploaded to Facebook along with your photos.

Managing Multiple Copies and Locations

One thing you'll encounter along the way as you move images back and forth between Photoshop.com and Facebook is that you will have multiple copies of your images; one on Photoshop.com and one on Facebook. And if you do any editing of your Facebook images in Photoshop.com, those edited pictures will be saved as separate files—and you can't remove them from within the Facebook component on Photoshop.com.

Not only can this be confusing, but you'll use up space quickly—and since Facebook permits a limited number of images in each album, duplicate copies will make you hit that limit sooner (see Figure 5.11).

It's best to clean up as you go along.

> **Tip**
>
> Staying on top of your housekeeping will save you from piling up too many image duplicates between services.

To clean house on Facebook, you'll need to log into your account in a separate window.

❶ Open a new browser window or tab and navigate to www.facebook.com.

❷ If you're logged in to the Facebook component in Photoshop.com, your account should open automatically; otherwise, you'll need to log in.

Figure 5.11 Saving edits in the Facebook component within Photoshop.com creates a new copy of the image that you can see in both Photoshop.com and Facebook.

❸ Click on Photos from the Applications block on your Facebook home page.

❹ Select My Photos from the top Photos menu.

❺ Open the album you want to clean up by clicking on its title.

❻ Click on Edit Photos to see a table layout of all the photos in that album (it's easier to compare versions in this view).

❼ Select the Delete this photo checkbox on any photos you want to remove. You can select more than one at a time (see Figure 5.12).

❽ Click Save Changes at the bottom of the page.

❾ Go back to your Photoshop.com window and click the Refresh button at the far right of the top toolbar. The duplicate images you just removed should disappear from view.

Keeping Track of What's Where

It's fairly easy to tell which images are from Facebook and which are from Photoshop.com.

◆ Photoshop.com image filenames are retained from your original upload, or if you renamed them from within Photoshop.com.

◆ Facebook image filenames are very long strings of letters, numbers, and underscores, even after moving them into Photoshop.com (see Figure 5.13).

Tip

If you're planning on doing a lot of moving around of your images between services, it's best to leave the filename in view rather than hiding it from the View menu in Photoshop.com. The filenames do not appear in the Public Gallery view, but they will help you keep images straight in your Library.

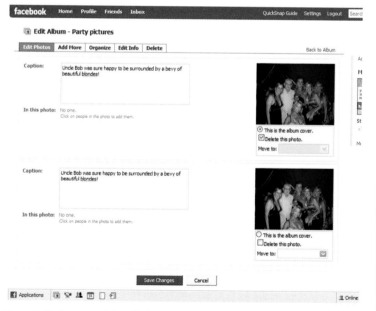

Figure 5.12 You must delete duplicate images from within your Facebook account; they cannot be deleted from the Facebook component on Photoshop.com.

Figure 5.13 Facebook filenames are long strings, easily distinguished from your original Photoshop.com uploads.

Integrating Photoshop.com with Flickr

Through its partnership with an online editing service called Piknik (an online image editing toolset somewhat similar to Photoshop.com's), Flickr offers photo editing, captioning, and tagging capabilities. Chances are, if you've spent much time on Flickr at all, you've also spent time carrying out some or all of these tasks. Piknik's tools (www.piknik.com) can be used in all image sharing sites, and work on both Macs and PCs.

Having done so, you probably want to share your photos, and through Flickr you likely already have. Now that you have a Photoshop.com account, you may want to share them in your Photoshop.com Gallery as well. Doing so gives your images a chance to be seen in more places, by even more people, as the Photoshop.com subscriber list grows by the minute.

Once again, though, logging into Flickr through the Photoshop.com component does not mean that your Flickr collection is automatically made part of your public Photoshop.com Gallery. What it does do is give you access to the Photoshop.com editing tools, which, if you chose not to use the Piknik tools, offer you an incredible range of editing capabilities. Even if you do use Piknik, while some of the editing tools overlap, there are some things you can do with Photoshop.com that you can't in Piknik—so your toolbox just got larger!

We'll get into Photoshop.com's editing tools in later chapters, but first let's talk about sharing your photos between the two services.

Moving Photos from Flickr to Photoshop.com

Photoshop.com makes it very easy to move images back and forth between services. More precisely, it gives you the ability to seamlessly import and export images (see Figure 5.14). Here's what you do:

❶ Log in to your Flickr account if you have not already done so (each time you log out of Photoshop.com and back in, you must also log back in to Flickr).

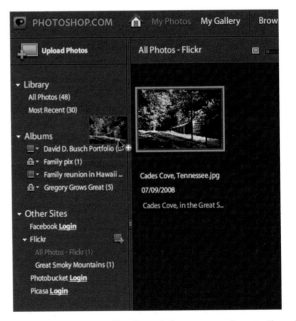

Figure 5.14 Moving files from Flickr to a new album in Photoshop.com is just as easy as it is within Photoshop.com—a matter of clicking and dragging.

❷ Select a picture from within a Flickr album or from the All Photos—Flickr link. Like Photoshop.com, your Flickr images are listed both in their sets (which is how Flickr refers to albums) and in a general library. You can select more than one image at a time.

❸ Drag your selected image(s) into an existing Photoshop.com Album, into your general Photoshop.com Library, or create a new album by dragging them across the Add icon next to the Photoshop.com Albums link.

❹ Unlike the Facebook tool, Flickr does not request additional permissions once you have gone through the initial integration process; your image(s) will simply be copied to their chosen destination.

❺ Although the Flickr filenames are retained, the captions are not, so you will need to re-enter captions once your images are placed in Photoshop.com.

> **Tip**
>
> Flickr handles filenames differently than Facebook does, basing them on titles you assign when uploading files, or retaining the original filenames if you choose not to title your images.

Moving Photos from Photoshop.com to Flickr

When you want to share your Photoshop.com images in Flickr, moving them is just as easy in this direction. Keep in mind that

doing so *will* have an impact on your monthly bandwidth limit on Flickr if you have a free account, so choose wisely, or limit yourself to smaller/lower resolution images if you want to conserve, particularly if you're only sharing images for web viewing (see Figure 5.15).

❶ Select an image or multiple images from within your Photoshop.com Library or an Album.

❷ Drag your selection to an Album link under the Flickr menu, or to the Add icon to create a new album, or to the All Photos – Flickr link if you don't want to add it to any sets at all.

Figure 5.15 Copying an image from Photoshop.com to Flickr is also a simple matter of click-and-drag.

❸ In this direction, Photoshop.com retains the original filename and any caption you created, or leaves the caption field blank if you did not create one. If you want to have the same caption in both services, it's best to create the caption first in Photoshop.com before exporting it to Flickr.

Managing Multiple Copies and Locations

If you have copied an image more than once to Flickr by mistake, you cannot remove it from within the Flickr component on Photoshop.com; instead, you need to log into your Flickr account separately to do your maintenance (see Figure 5.17).

❶ Open a separate browser window or tab and navigate to www.flickr.com (see Figure 5.18).

❷ You should be taken directly to your account, unless you are not signed in to the Flickr component in Photoshop.com, in which case you need to log in first.

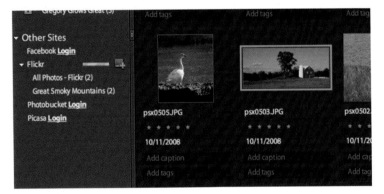

Figure 5.16 You'll see a small progress bar if you're uploading a large image.

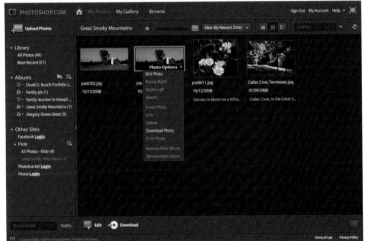

Figure 5.17 Many of the Photo Options to which you normally have access in Photoshop.com are disabled in the Other Services components, including the ability to remove an image from a Library or Album.

③ Click on Your Photostream to view your images.

④ Select the Delete link for any images you want to remove.

⑤ Flickr will show you a dialog box asking you to confirm the deletion. Click OK to continue.

⑥ Go back to Photoshop.com and click the Refresh button in the Flickr area to view your changes.

Keeping Track of What's Where

Because Flickr bases its filenames either on your photo's original filename or on a title you created when you uploaded it, it's not quite as easy to tell Flickr and Photoshop.com images apart as it is Facebook images.

One good way to distinguish them is by assigning titles within

Flickr before importing them into Photoshop.com—that breaks down, however, if you use the same sorts of names when you save edited files within Photoshop.com.

If you want to be able to easily tell your Flickr and Photoshop.com images apart, there are two simple ways to do it:

◆ Keep your Photoshop.com and Flickr images in separate albums, even when importing them.

◆ Use different naming conventions for your Flickr and Photoshop.com services.

If you're not sure where you've put your images, you can always use the search tool in Photoshop.com (see Figure 5.19). Keep in mind that it won't search across both Photoshop.com and Flickr images at the same time—which may actually come in handy! You may end up doing some hunting until you come up with a system that works for you.

Figure 5.18 You must sign into your Flickr account in a separate browser window to delete duplicate images.

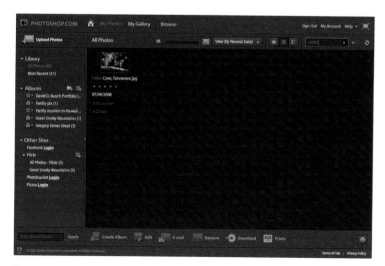

Figure 5.19 Searching in the Photoshop.com Library turns up results only within the Library; searching other site components will likewise only turn up results within each component.

Integrating Photoshop.com with Photobucket

Similar to Photoshop.com, when you add images to Photobucket's website, you can upload without adding them to an album, or you can create albums to keep them organized. Many of the other photo sharing services behave the same way, but Photobucket automatically creates a separate album to hold your uploaded photos, based on your name (firstname_lastname).

That being said, you can integrate these, as well, in Photoshop.com.

Like Photoshop.com, the free Photobucket service limits your storage (though Photoshop.com offers twice as much!), and limits your monthly bandwidth as Flickr does (the Photobucket bandwidth limit is higher than that of Flickr).

Given Photobucket's stricter limits (and—let's face it—Photobucket's ads can be a little too much), it may be that you're integrating Photobucket and Photoshop.com to either increase your effective storage space, or you're switching services altogether.

Moving Photos from Photobucket to Photoshop.com

Here's how to share images from Photobucket to Photoshop.com:

❶ Log in to the Photobucket component in the Other Services menu if you have not already done so (you must log in again each time you close and reopen Photoshop.com).

❷ Select an image (or multiple images) from an album within the Photobucket component or by selecting from the All Photos—Photobucket area. The Photobucket component displays images both in their respective albums and in a general uncategorized album area, making it easier to select images from multiple albums at one time.

❸ You can move them to your general Photoshop.com Library by dragging them to the All Photos link under Library; add them to an existing Album by dragging them to an album link and dropping them when you see the + icon appear; you can also create a new album with your selected images by dragging them to the New icon next to the Album link.

❹ Photobucket does not require additional permission to export images into Photoshop.com, so your images are moved easily to their destinations.

❺ Photoshop.com retains the file-name but not the tags or captions—Photobucket calls captions Descriptions and uses them a little differently than Photoshop.com does. So you will need to recaption your images once they're in Photoshop.com (see Figure 5.20).

> **Tip**
>
> In Photobucket, the combination of both Titles and Descriptions function as two-part image captions in the slideshow display. Neither field carries over into Photoshop.com when images are moved from Photobucket to Photoshop.com.

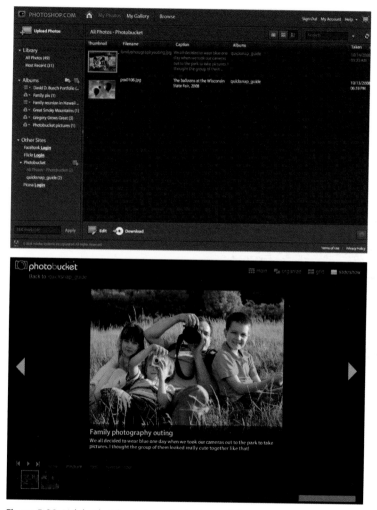

Figure 5.20 While Photobucket uses both titles and descriptions in the slideshow display, only the description carries over as a caption in the Photobucket component, and it is not retained at all when moving images into Photoshop.com.

Moving Photos from Photoshop.com to Photobucket

There may be times when you want to move images from Photoshop.com into Photobucket—for example, if you have edited an image using the Photoshop.com toolset, you may want to copy it into your Photobucket account so you can share the updated version (see Figure 5.21).

❶ Select the image(s) from your Photoshop.com Library.

Click to add title
Basement cat darez you to taek hs blu bottl (edit)

Click to add tags

Figure 5.21 Captions in Photoshop.com are retained as the Description in Photobucket; Photoshop.com leaves the Photobucket Title field blank, and any tags are lost in transit.

95

❷ Drag your selection directly to an existing album or to the New album icon beside the Photobucket menu item. You cannot drag images to the All Photos—Photobucket link.

❸ Filenames and captions are retained in the move, and the caption becomes the Description in Photobucket. Tags are not retained.

❹ If you want to add or update titles, tags, or captions/descriptions on images in your Photobucket Library, you'll need to log directly into your Photobucket account in a separate window.

Managing Multiple Files and Locations

Because the Photoshop.com Other Sites tool allows you to copy files both to and from each service, you may find yourself with duplicate copies. While this may not necessarily be a bad thing (more ways to share your images, after all!), we have already discovered that some information gets lost in transit, and you must duplicate efforts such as tagging and captioning.

If you find yourself with duplicate copies by mistake when moving files from Photoshop.com to Photobucket, you will not be able to delete them from within Photoshop.com. Instead, you must sign directly into your Photobucket account. Likewise, you'll need to edit tags and titles directly from Photobucket.

❶ Open a new browser window or tab.

❷ Even if you are logged into the Photobucket component within Photoshop.com, you may need to log in to Photobucket in the new window, unless you set the Remember Me flag in Photobucket somewhere along the way.

❸ You'll be taken first to Photobucket's main page. Access your account by selecting either My Albums from the top Photobucket menu, or by clicking on your account name in the top right.

❹ You'll see your images below the center advertisement and upload blocks.

❺ Click the Delete link for any images you want to remove.

❻ Photobucket will ask you to confirm the deletion. Click OK to continue.

❼ Select the Click to add title link above any images missing titles, and click OK when you've added each title.

❽ Click the tag link for any images missing tags.

❾ When you're done making all your changes, return to the Photobucket area within your Photoshop.com browser window and click the Refresh button to view your changes (you may occasionally find that the Photobucket area is not completely refreshed the first time you do this, so you may need to hit Refresh more than once).

Keeping Track of What's Where

You may find yourself getting confused about which images are where, and which is the most current. There are a few methods you can use to keep them straight.

◆ **Date.** The Photobucket component does display the upload date but not the date of the most recent modifications. A way to check which is the most current image is to actually copy your Photobucket images back into Photoshop.com—you can then do a side-by-side eyeball comparison. The Last Updated date will show as the date and time you moved the image into Photoshop.com, so using the date fields might serve to confuse the comparison.

◆ **Album.** You might consider creating separate albums for images from Photobucket once you import them into Photoshop.com to help you distinguish which is which.

◆ **Search.** You can search for images within either Photoshop.com or the Photobucket component, but not across both. This might actually be useful if you're not certain whether a particular image is in Photoshop.com or in Photobucket or both (see Figure 5.22).

Figure 5.22 Searching within Photoshop.com reveals images only in your Photoshop.com Library; searching within the Photobucket component will only uncover images in the Photobucket library.

Integrating Photoshop.com with Picasa

Picasa is the Google version of online photo sharing, and like Photoshop.com, offers a downloadable utility for your PC. The free service offers 1GB of storage, and it does not impose a bandwidth limit. Higher storage limits are available by subscription, also similar to Photoshop.com (but at considerably higher cost!).

If you have both Picasa and Photoshop.com, it makes sense to link them for the expanded storage that Photoshop.com offers—and Photoshop.com offers advanced editing tools that Picasa does not.

Moving Photos from Picasa to Photoshop.com

Let's first look at moving images from Picasa into Photoshop.com:

❶ Log in to the Picasa component in the Other Services menu if you have not already done so (you must log in each time you close and reopen Photoshop.com).

❷ Select an image (or multiple images) from an album within the Picasa component or by selecting from the All Photos—Picasa area. The Picasa component displays images both in their respective albums and in a general uncategorized album area, making it easier to select images from multiple albums at one time.

❸ You can move them to your general Photoshop.com Library by dragging them to the All Photos link under Library; add them to an existing Album by dragging them to an Album link and dropping them when you see the + icon appear; you can also create a new album with your selected images by dragging them to the New icon next to the Album link.

❹ Picasa does not require additional permission to export images into Photoshop.com, so your images are moved easily to their destinations.

❺ Photoshop.com retains the filename but not the tags or captions, even when displaying them in the linked Picasa component, so you will need to add captions to your images once they're in Photoshop.com (see Figure 5.23).

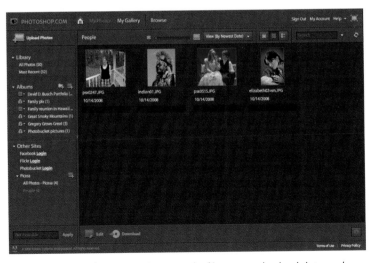

Figure 5.23 Photoshop.com only retains the filename and upload date, and no captions even when displaying images within the Picasa component.

Moving Photos from Photoshop.com to Picasa

There may be times when you want to move images from Photoshop.com into Picasa—for example, if you have edited an image using the Photoshop.com toolset, you may want to copy it into your Picasa account so you can share the updated version.

Doing so is quite easy:

❶ Select the image(s) from your Photoshop.com library.

❷ Drag your selection directly to an existing Album or to the New album icon beside the Picasa menu item. You cannot drag images to the All Photos—Picasa link.

❸ Filenames and captions are retained in the move, and the caption becomes the Description in Picasa. Tags are not retained (see Figure 5.24).

❹ If you want to add or update tags or captions on images in your Picasa library, or remove unintentional duplicates, you'll need to log directly into your Picasa account in a separate window.

Figure 5.24 The Picasa component retains filenames and captions when images are moved into it from Photoshop.com, but tags are left behind.

Managing Multiple Files and Locations

Because the Photoshop.com Other Sites tool allows you to copy files both to and from each service, you may find yourself with duplicate copies. While this may not necessarily be a bad thing (more ways to share your images, after all!), we have already discovered that some information gets lost in transit, and you must duplicate efforts such as tagging.

If you find yourself with duplicate copies by mistake when moving files from Photoshop.com to Picasa (as we did for this demonstration by copying in the wrong image the first time around), you will not be able to delete them from within Photoshop.com. Instead, you must sign directly into your Picasa account.

Likewise, you'll need to edit captions and add tags directly from Picasa (see Figure 5.25).

❶ Open a new browser window or tab.

❷ Even if you are logged into the Picasa component within Photoshop.com, you may need to log in to Picasa in the new window, unless you set the Remember Me flag in Picasa somewhere along the way.

❸ You'll be taken first to Picasa's main page. Access your account by selecting the Picasa Web Albums link under either the Download Picasa button or the Share area.

❹ You'll see your albums in the resulting window. Select an album, then click on an individual image to work with it.

❺ Click the Delete this photo link to the right of an image you want to remove.

❻ Picasa will ask you to confirm the deletion. Click OK to continue.

❼ Select the edit link beside captions you want to edit, and click Save Caption to save your changes.

❽ Click the Add icon next to Tags at the right for any images missing tags.

❾ When you're done making all your changes, return to the Picasa area within your Photoshop.com browser window and click the Refresh button to view your changes (you may occasionally find that the Picasa area is not completely refreshed the first time you do this, so you may need to hit Refresh more than once).

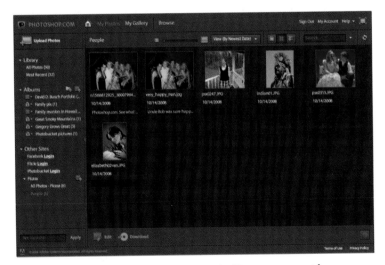

Figure 5.25 Copying the wrong images into the Picasa component from Photoshop.com results in confusing duplicates; you need to remove them directly from your Picasa account.

Keeping Track of What's Where

You may find yourself getting confused about which images are where, and which is the most current. There are a few methods you can use to keep them straight.

◆ **Date.** The Picasa component does display the upload date but not the date of the most recent modifications. A way to check which is the most current image is to actually copy your Picasa images back into Photoshop.com—you can then do a side-by-side "eyeball" comparison. The Last Updated date will show as the date and time you moved the image into Photoshop.com, so unfortunately, using the date fields might serve to confuse the comparison.

◆ **Album.** You might consider creating separate albums for images from Picasa once you import them into Photoshop.com to help you distinguish which is which.

◆ **Search.** You can search for images within *either* Photoshop.com or the Picasa component, but not across both. This might actually be useful if you're not certain whether a particular image is in Photoshop.com or in Picasa or both (see Figure 5.26).

Figure 5.26 Searching within Photoshop.com reveals images only in your Photoshop.com Library; searching within the Picasa component will only uncover images in the Picasa Library.

6 Simple Photo Editing: Basics, Crop, and Rotate

When you take photographs, whether with a snapshot camera or a fully featured Single Lens Reflex (SLR) camera, you may discover that what you see in the viewfinder is not always what you get in the picture. For example, if you're taking a picture of your mom—say, standing next to a fountain on the Via della Appia in Rome—you might find that you held the camera a little crooked, so now your fountain more closely resembles the Leaning Tower of Pisa. Or all the people in that picture you took at your best pal's birthday party suddenly look rather diabolical because the flash you used made their eyes glow an ominous red.

Basic Tools

It's time for Photoshop.com to leap in and save the day.

Let's first have a look at the Basic Tools we'll be using in these next three chapters.

When you're ready to edit an image, just do the following:

❶ Click on the image.

❷a From the bottom toolbar, click the Edit icon, OR

❷b Hover your mouse over the image and select Edit Photo from the Photo Options menu that appears at the bottom of the image.

You may briefly see a dialog box and progress bar telling you that Photoshop.com is preparing the photo for editing. This might take a moment, depending on the size of the image.

The Basics of Basic Photo Editing

The editing screen is another new view we haven't yet explored. We're just looking at the Basics block to start with, and we will cover its contents over the next three chapters; we'll work our way through the rest of the screen in later chapters.

❶ **Crop & Rotate.** These tools will help with the most basic layout of your picture: if it's on its side (you took the picture with your camera turned up on its side to get a long, tall look), rotating will turn it right side up; if there's too much background and not enough subject, the cropping tool trims away the excess to better frame your subject.

❷ **Resize.** Too big? Too small? Use the Resize tool to adjust the size of your photo.

Figure 6.1 Each function in the left menu column opens its own specific toolbar across the top of the editing area.

❸ **Auto Correct.** Photoshop.com can analyze your picture and automatically correct it with its own smart combination of the four tools below!

❹ **Exposure.** If your picture is too dark, or washed out, use this tool to correct it.

❺ **Red-Eye Removal.** Fix those pesky glowing eyes, generally the result of a built-in flash that hits the person head on.

❻ **Touchup.** If there's a blemish on the skin or a scuff on the wall, Touchup helps you cover it.

❼ **Saturation.** Too much color or not enough can be corrected using this tool.

Selecting any of the items in this menu block will open that tool and show you another toolbar across the top of the main editing window with functions specific to that tool (see Figures 6.1 and 6.2).

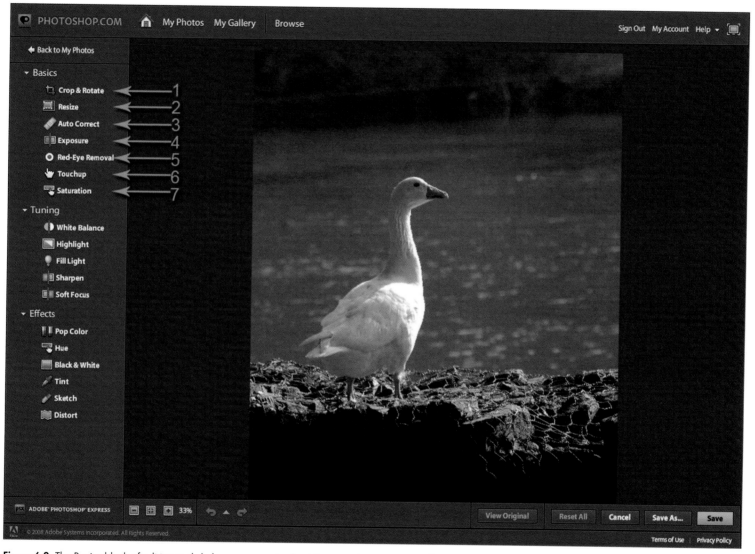

Figure 6.2 The Basics block of editing tools helps you correct color, trim your photo, resize, and more.

Basic Editing Tools Overview

Over the next three chapters, we'll be working with tools that help you correct or change the basic composition and layout of your photographs. But just using the tools is not enough without an understanding of what they are or can do. Let's have a quick look and then we'll get into the details.

Crop & Rotate

Cropping an image can do a lot for it, in ways that might surprise you. You can use it to fill a frame with your subject, or completely change the focal point of an image (see Figures 6.3-6.6).

From simple trimming…

Figure 6.3 Cropping this picture brings focus to where it should be: on Kristin!

...to complete change of focus... ...cropping is a powerful tool! Likewise, rotating an image can be as simple as turning it upright...

Figure 6.4 Trimming an image like this can make it a completely different composition!

Figure 6.5 Shooting a picture with the camera sideways results in a sideways image, until you rotate it.

...or making a subtle change to line up background features.

Figure 6.6 Cropping can improve the composition of a photo.

Resize

Not to be confused with cropping, resizing doesn't trim the photo itself; instead, it changes the scale of the whole image, from larger to smaller or from smaller to larger. (See Figure 6.7.) Resizing an image will also affect the size of the image file, so you can use it to optimize your images for specific uses, or just reduce its size from print resolution for smaller printed images, or to produce a really tiny version for sharing between mobile phones.

Figure 6.7 Resizing changes the scale of an image, reducing the file size as well as the standard print size made from that image.

Auto Correct

Photoshop.com can analyze an image and automatically correct it for a number of factors at once. So if you're not sure what to do to fix a picture, Auto Correct can do the work for you, and make a typical snapshot, like the one with multiple problems shown in Figure 6.8, into something worth saving and sharing (see Figure 6.9).

Figure 6.8 This snapshot has multiple problems with exposure, saturation, and color balance.

Figure 6.9 Auto Correct can fix these problems, creating a sparkling new version.

Exposure

Shooting in bright sunlight or low light can cause a picture to be over- or underexposed, resulting in a washed-out appearance or loss of detail. The Exposure tool offers a great way to correct lighting (see Figure 6.10).

Figure 6.10 Adjusting exposure downward helps deepen color and contrast to show more detail in this brightly lit beach photo.

Red-Eye Removal

One of the challenges of flash photography, particularly when using a snapshot camera where the flash is integrated into the body of the camera, is that it sets eyes aglow—and not in a good way. Many snapshot cameras now come equipped with a red-eye setting to mitigate the effect, but it's not always perfect. This is where Red-Eye Removal can be handy (see Figure 6.11).

Figure 6.11 Red-Eye Removal: gets the red out.

Touchup

Nobody's perfect, much as we might strive. Blemishes appear on school picture day, or that really cute shot of your kid shows you how much your walls are in need of cleaning. Luckily, Touchup can clean your walls more quickly than you can by hand.

Saturation

On television screens, particularly the old tube variety, you'd often see issues with the color being off—sometimes *way* off. Color Saturation, too much or too little, can make the difference between garish, dingy, or realistic color (see Figure 6.12).

Figure 6.12 Too much color can make an image garish and distracting, so toning down the saturation helps.

The Crop and Rotate View

Each time you select one of the tool links from the left column in the editing screen, you'll see the main editing pane change a bit. The top toolbar displays the functions specific to that tool, and the image itself may show an extra widget or two.

Parts of the Screen

In the case of the Crop & Rotate view, both are true. The top toolbar offers button tools, and the main pane gives you a way to do the same tasks with grab controls. Figure 6.13 corresponds to the following numbered list:

1 Aspect manager. This is a very handy little tool that helps you with some automatic settings so you can crop images to fit specific photo print sizes—5"x7", 8"x10", and so on.

2 Rotate clockwise. If your image is lying on its left side, a click of this button sets it straight.

3 Rotate counterclockwise. When your image starts out on its right side, this button stands it upright.

4 Straighten. This Slider tool helps you rotate an image incrementally right or left for finer corrections.

5 Reset crop rectangle. Not happy with the changes you made? Set it back to how you started using this reset button.

6 Cancel changes. If you want to cancel *any* changes you've made to the aspect or rotation of your image (before saving it), this will take you out of the Crop & Rotate view and back to the main edit screen.

7 Save changes. When you're satisfied with the cropping and/or rotating you have done, this will apply the changes and take you back to the main edit screen. Note that it does *not* save the image yet.

> **Tip**
>
> Save changes applies the changes you have made in this particular view only, and applies them to the image in your working space, but it does not save the image back to Photoshop.com yet.

8 Auto-hide. If you like your workspace to remain tidy, you can select this option, and the toolbar will tuck itself away when you're not using it.

9 Grab controls/crop. If you prefer to use grab controls and manipulate your image by "hand" you can grab the corner controls within the workspace and crop the image precisely the way you want it.

10 Grab controls/rotate. Having the same incremental effect as the rotation slider bar above, you can arbitrarily turn your image this way and that with grab controls in the workspace.

11 Zoom. Along the bottom of the screen is another specialized toolbar that applies to all of the editing tools. With the zoom controls, you can move in for a closer look, step back to see the overall picture, or make the image fit the screen.

12 Undo/redo/view as tiles. Like the software version, Photoshop.com keeps track of your changes so you can compare results or undo errors. The view as tiles option displays a row of thumbnail images across the bottom of the workspace so you can see an overview of your change history.

13 View Original. If you want to see how your changes compare to the original version, you can do a quick check by selecting this button.

14 Reset All. Back to the drawing board, so to speak—if you want to just scrap it all and start over, the Reset All button lets you do that.

15 Cancel. This will abandon *all* changes you have made and take you out of the editing area altogether, returning you to your Library without saving any changes.

16 Save As... This lets you save your changes to a new file instead of overwriting your original image. It's the choice to make if you want to preserve the original.

17 Save. This will save all your changes to the original file. Make sure that you really want to scrap the original before saving a file this way!

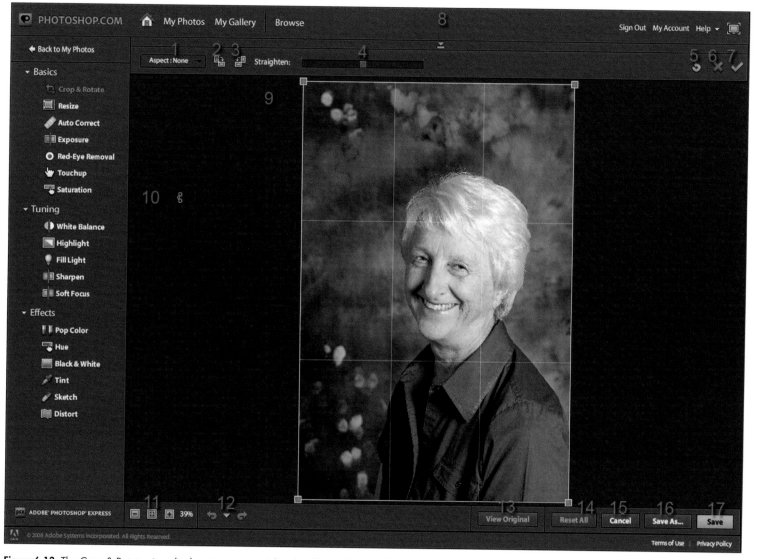

Figure 6.13 The Crop & Rotate view displays its own specialized toolbar at the top of the work area.

Cropping

When you crop a photograph, you're making a decision about what's most important in that photograph and leading the viewer's eyes to it. When you crop an image well, the viewer knows right where to look; if not, he might hunt around for something to settle on and, dissatisfied, lose interest and move on.

What Cropping Should Do for Your Photoshop.com Images

When you took your picture, you had in mind a subject, generally referred to as a *center of interest*. Even if you're shooting a panorama, there are one or two objects in the frame that capture the viewer's interest. Cropping helps strengthen that focal point so that the eye is not distracted by less important features.

There are a number of purposes that cropping serves:

◆ **Trimming excess.** Too much blank space above, below, or to the side(s) of an image can make it feel a little lost.

◆ **Centering.** A large object or portrait subject can be centered in a picture.

◆ **Exclusion.** If something in the background is distracting, cropping it out brings the focus back to where it belongs.

◆ **Creating a sense of motion.** Cropping a picture so that the subject is off-center can encourage a feeling of motion in images with suitable subjects, such as race cars, sailboats, or your great-grandmother competing in her first 10K.

◆ **Changing the subject.** If you find that a secondary object is just as interesting as your original subject, a proper crop will bring that object forward.

◆ **Light and dark.** A photograph with prominent fields of light and dark can be cropped to emphasize one or the other, dramatically changing the feel of the picture.

◆ **Emphasis.** Very tight cropping can be used to focus on a particular aspect or feature of a larger object.

Because this isn't a book on photography, we won't go into much more detail about cropping technique (besides, much of that is personal artistic choice!), but we'll show you how it works, as well as some examples to give you some ideas about how it can be used.

Use the Cropping Tool

There are two ways to crop images in Photoshop.com: using the Aspect manager to fit images within print dimensions, or with the work area's grab controls.

Let's look at the Aspect manager first, which has the ability to retain a specified print size within the cropped area. This is the simplest way to make sure your photos will look their best when being printed on standard sizes of photo paper, or if you want to make your images a uniform size (see Figure 6.14).

Different applications dictate different aspect ratios—for example, a 1:1 ratio, while not common for printed images, is handy for web profiles; 8:10 is still the standard for entertainment industry headshots; and 2:3 matches the proportions of 4 x 6-inch prints that most people prefer for their snapshots.

To use the Aspect manager:

❶ Click on the small arrow to the right of the Aspect manager menu in the top toolbar.

❷ A drop-down menu will appear, showing you a fairly complete list of standard ratios; select one.

❸ The Aspect manager places the crop marks in the center of the image by default; if your image gets cropped incorrectly as a result, you can move the crop frame around until it's placed where you want (see Figure 6.15) or use the corner grab handles to adjust the crop. The areas outside the crop are grayed out to highlight your chosen subject matter.

❹ When you're satisfied with the results, click the Apply icon (the green checkmark in the top-right corner) to apply your changes.

❺ The cropped version of your image will appear, and the Crop & Rotate tool will close.

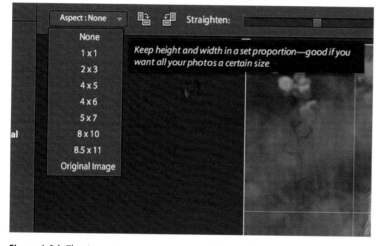

Figure 6.14 The Aspect manager presents a list of ratios, helping you match your picture to standard sizes.

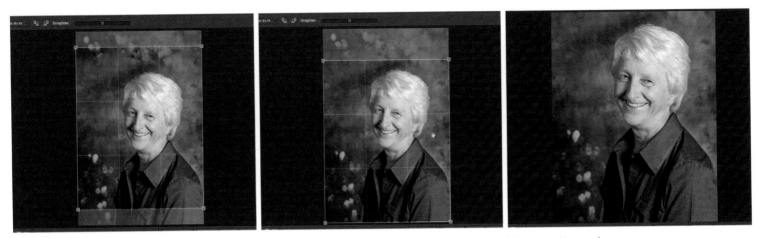

Figure 6.15 The Aspect manager applies crop dimensions to the center of your image. Move it by clicking and dragging the crop frame.

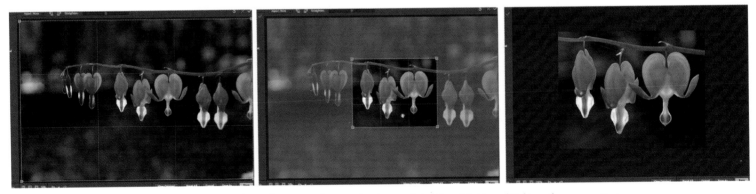

Figure 6.16 Cropping this photograph of bleeding heart flowers emphasizes the drama of detail and light, and tightens the composition.

Custom Crop

Sometimes the aspect manager isn't enough to achieve the effect you want. When that's the case, you can use on-screen drag controls to crop the image precisely the way you want it, even though your customized cropping may not completely fill a specific print size (leaving white areas at top/bottom or sides).

❶ Each corner of the crop frame has a small square over it. Click and drag the squares to change the size and shape of the frame.

❷ Move the whole crop frame around by clicking anywhere within the frame (your mouse cursor turns into a little hand when you're over the area you can move) and dragging it where you want. (See Figure 6.16.)

❸ When you're satisfied with the cropped image, click the Apply (checkmark) icon to apply your change. Figure 6.17 shows another image cropped in a creative way.

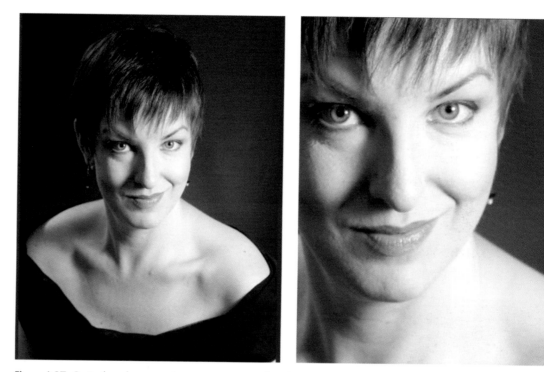

Figure 6.17 Go to the edge: cropping a portrait can make it look edgy and hip.

Rotating

The most obvious use of rotation is when you have taken a picture with your camera turned on end—to capture a tall monument or building, for example—and need to stand it upright.

There are other, more subtle (and fun) uses for image rotation.

What Rotating Should Do for Your Photos

Digital cameras are smarter and smarter, and some of them are smart enough to figure out when to automatically rotate images back to horizontal orientation after shooting a vertical image. But, Photoshop.com has given you not one, not even two, but *three* ways to easily rotate those recumbent images.

◆ The first way is available without even going into the editing area: hover your mouse over the image in your Library to expose the Photo Options menu, and select either

Rotate Right or Rotate Left. (See Figure 6.18.)

◆ Once you're in the editing area with the Crop & Rotate tool open, you can use the top toolbar buttons to rotate your images right or left in 90 degree increments.

◆ Finally, if you trust yourself to "eyeball" the rotation, you can grab the crop frame in the main work area and drag it around by hand, which can be difficult (see Figure 6.19). With a grid of guidelines to help, it's clumsy, but doable.

But there's another use for the slider and hand rotation tools: to correct weird angles, or even to create some of your own for an "edgy" look (remember the old 1960s "Batman" series on television? The villains' scenes were inevitably filmed about 30 degrees off of square, having a rather unsettling effect on the viewer).

Let's look at the easy one first, because chances are good you'll be seeing a lot of it.

Figure 6.18
Because the need to turn your images 90 degrees is so common, Photoshop.com made it part of the Photo Options menu in the image Library.

Figure 6.19 Dragging an image around by hand to rotate it 90 degrees can be cumbersome.

Rotating 90-Degrees Clockwise

When aiming for "tall" shots, most people turn the camera so that the shutter release (the "trigger") is at the bottom or top of the camera, which has the effect of putting the top of the subject on the left or right side of the final image. When you upload it from your camera, you'll need to turn it 90 degrees to set it straight.

❶ The Rotate Clockwise and Rotate Counterclockwise buttons are at the top toolbar in the Crop & Rotate view, with the arrow curving right/left and down (clockwise, and counterclockwise, respectively).

❷ If your image was zoomed to fill the window, Photoshop.com will automatically zoom out to fit the full image in the window.

❸ If you're happy with the result, click the green Apply checkmark icon at the upper right to apply your change and return to the main edit view. (See Figure 6.20.)

❹ If you turned your picture the wrong way, you can either click the Rotate Clockwise button two more times, or click the Rotate Counterclockwise button twice, or click the Undo icon at the top right, then click the Rotate Clockwise button. Choices, choices! Photoshop.com is thorough about giving you multiple ways to carry out many tasks.

Figure 6.20 Rotating this image sets it upright.

Straighten

Sometimes, even when you think you're shooting head-on, the effect of lens curve or perspective causes visual elements to appear crooked. The Straighten and grab control tools offer finer control over the rotation of your image. We'll use Straighten first.

❶ In the Crop & Rotate view, click on the square in the middle of the Straighten slider bar, and slowly drag it left and right to see the angles it produces in your picture.

❷ While you're moving it around, Photoshop.com projects a *very* helpful grid over the image so you have reference lines with which to align the picture. A degrees counter appears above the slider tool. If you click on the slider tool, it will reveal the number of degrees the image is tilted.

❸ When you're happy with your corrections, click the green Apply checkmark icon to apply the rotation (see Figure 6.21) and take you back to the main edit view.

> **Tip**
>
> The Straighten tool only goes up to 44.9 degrees in either direction. For deeper angles, you need to use the work area grab controls.

Figure 6.21 A little extra lean doesn't do kitty any harm, but it does straighten up the background.

Using the grab controls in the work area itself gives you an even finer—and wider—range of control over rotation. The Straighten tool only lets you rotate an image up to 44.9 degrees in either direction, but with the work area grab controls, you have 360 degrees to play with! (See Figures 6.22 and 6.23.)

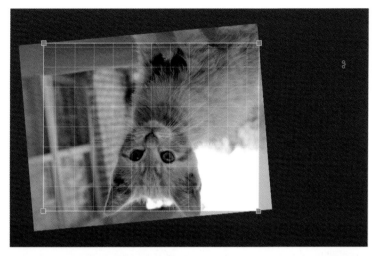

Figure 6.22 Something you should never do to the actual kitten, you can turn him upside down in the picture, making him a cute version of "ceiling cat."

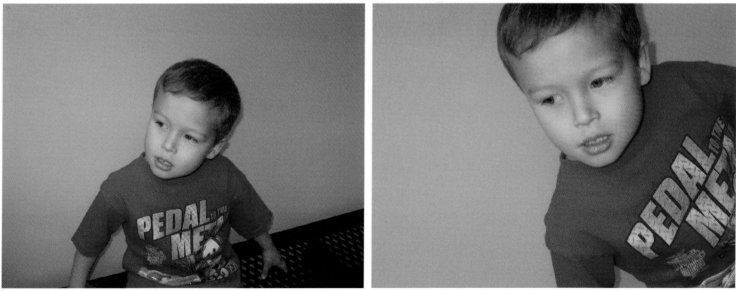

Figure 6.23 Rotating deliberately adds an element of edginess or playfulness—or both, in this case—to an image.

7 Simple Photo Editing: Resize, Auto Correct, Exposure

Correcting photographs can sometimes be a little more involved than simply upending or trimming them, and Photoshop.com includes some pretty powerful tools to make those corrections. Sometimes, for example, your image might be cropped correctly, but you need it to be a different size. The super-duper high-resolution picture you took on your zillion-megapixel camera is just too darned large for your blog: it takes forever to load, and then takes over the whole screen, shoving everything else aside and wrecking your page design.

Or perhaps you have a photograph that you see is not quite right—maybe colors are a little skewed—but you're not sure how exactly to fix it. Or you've got a great action shot of your dog catching that Frisbee in midair on the beach, but everything looks washed out because it's a typical bright Southern California day.

In this chapter, we'll introduce you to the tools that will help you fix up these problems and a few more besides. These are still fairly basic editing techniques (which might explain why they're included in the Basic tool block), but you still need a good eye and a few guidelines to get things right.

Resizing Photos

When you take pictures from a digital camera, even the snapshot type, the resolutions of the images is generally fairly high by default, until you adjust the setting; professional-model SLR cameras often make higher-resolution images; even camera-equipped smartphones and PDAs can take pictures at pretty impressive resolution these days.

But what happens when the image is *too* big? Displaying images on mobile phones, for example, is still limited to relatively low resolution by definition—there's just so much you can do with a 3-inch (or smaller) screen—and websites also necessarily limit image resolution. Can you imagine, for instance, trying to load a 2500 x 3500 pixel image through a *dialup* connection (yes, as crazy as it sounds, some people still use those—you might even be one of them)?

Size Really Does Matter

No matter what you might have heard to the contrary, size really does matter. But you might not have heard that under certain circumstances, smaller is better.

Hey, I don't know what *you're* talking about—I'm talking about the size of your photographs, and those lovely high-resolution images are overkill in some cases. Fortunately, Photoshop.com offers some great options for both automatic and manual size adjustments.

What You See in the Resize View

Most of the edit screen remains the same when you activate any of the individual tools, except for the top toolbar, and in the case of the resizing tool, a Picture-in-Picture tile at the bottom left of the work space.

When you click on the Resize option, the photo jumps to full editing screen size if it is a large file. Then, the Picture-in-Picture tile pops up at the bottom left and the following tools, shown in Figure 7.1, and numbered 1 through 9, appear at the top of the editing pane if you have clicked the tool display option in the top center of the screen. Note that the width and height panels change to reflect the automatic size selected and the picture changes size for each option selected.

You'll see some new buttons and features in this view.

❶ **Profile.** Specific to Photoshop.com and any site that provides a space for your profile picture, this function automatically optimizes your image to match the dimensions of your Photoshop.com profile image space.

❷ **Mobile.** Another automatic setting, Mobile resizes your image for optimal compatibility with mobile phones.

❸ **E-mail.** The third automatic setting scales your image to work best as an e-mail attachment.

❹ **Website.** The resolution of a computer screen is a lot lower than print. Use this automatic option to scale your image for best use on the web.

❺ **Custom.** If none of the automatic settings meets your needs, you can set your own sizes.

⑥ Width/Height. Selecting the Custom option opens the width and height fields so you can assign values by hand. Photoshop.com maintains the proportion automatically, so you don't have to worry about making an image 5 pixels wide by 750 high by mistake.

⑦ Swap default. When using the automatic settings, you can swap the height and width definitions to reorient the proportions of your picture.

⑧ Undo/Cancel/Apply. As with all of the edit functions, you can step back and undo what you've just done, back out of the tool, or apply your changes and move on.

⑨ Picture-in-Picture. When your picture is larger than what is recommended for web use (the largest automatic setting), or one of its sides fits outside those of the default settings, you'll see a small Picture-in-Picture tile at the lower left of your work area. Use this to match the scale of your image to the recommended size settings.

All of the edit tools give you a way to compare the original, undo everything, cancel, or save your changes.

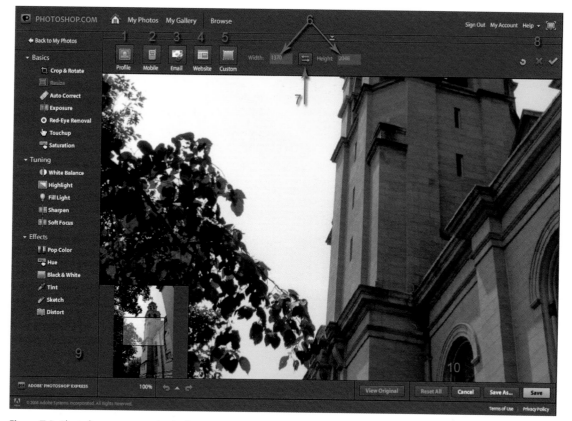

Figure 7.1 Photoshop.com provides both automatic and manual resizing modes.

Using the Resizing Tool

When you first open a photo for resizing, you might observe that one or more of the automatic settings is disabled. That's because Photoshop.com measures the size of your file, and if it already fits within the recommended dimensions for one of the automatic settings, recognizes that there would be no need to resize it.

You'll see in Figure 7.2 that when you first open the image, the Website option is disabled. But wait—if you use the swap button, suddenly it's enabled again. That's because swapping the height and width numbers now puts the image just outside the range that Photoshop.com thinks is optimal for a web image.

The other variable on the screen is the Picture-in-Picture view at the bottom left. If you open an image in the edit view and the P-in-P appears, it's because the image is larger, along one side or the other, than is recommended for web viewing; the limit is 609 pixels high.

Now it's time to try out the tool. If you have one, start with a high-resolution image to see all the available options (see Figure 7.3).

Figure 7.2 This old-time amusement park portrait already fits within web scale, so Photoshop.com disables the option.

Figure 7.3 Photoshop.com shows you in the P-in-P how much you'll need to reduce your image to fit to web scale.

Let's look at the functions from left to right.

◆ **Profile.** The default automatically sets the width at 150 pixels. Swapping that measurement with height moves the 150 pixels definition to the height field and either increases or decreases width proportionally, depending on whether your image is portrait or landscape layout (see Figure 7.4).

◆ **Mobile.** Given that screen resolution on any mobile phone is by definition limited, Photoshop.com assumes a default width of 320 pixels. Swapping width into height will then increase or decrease the width of the image proportionally, as it does with the Profile setting.

◆ **E-mail.** The e-mail setting is a little more generous, but still sets a fairly low default width of 640 pixels. You don't want to e-mail an image much larger than this unless it's for a special purpose and your recipient knows about it—many e-mail providers place strict limits on the size of an e-mail message, and sending a very large message is quite likely to exceed that limit and cause the message to be rejected, unless the recipient has a broadband Internet connection to match yours.

Tip

Many (most) e-mail and internet service providers place strict limitations on the size of individual e-mail messages, so reducing your images for e-mail also reduces the chance of your message being blocked.

◆ **Website.** Computer screens have an actual resolution of between 72 and 96 dpi (dots per inch)—much better than television, not as good as print. So when you prepare images for website use, Photoshop.com sets the width to 800 pixels by default. Keep in mind, though, that many websites require even smaller images because an image as wide as 800 pixels may take up too much usable space—many sites impose a maximum width of 400 or 500 pixels. Note, too, that a thumbnail image (a small placeholder image) is typically between 100 and 150 pixels wide. Make your choices with those things in mind.

◆ **Custom.** Photoshop.com also offers a way to scale your image to a custom size. Click the Custom button to open up the Height and Width fields and enter the value you want. Changing one field causes the other to be automatically updated—the proportions are locked to prevent you from distorting your image by mistake.

Figure 7.4 The automatic Profile resize button sets the width by default to 150px and scales the height according to the orientation (portrait or landscape) of your photo.

Resizing Examples

Figure 7.5 This image is quite tall and narrow, and we don't want to lose that scale or we'd wreck the impact of that perspective, so first we select web, then swap the width, then custom scale the image until the whole thing fits within the web guidelines.

Figure 7.6 This picture is just too good not to use as a profile picture.

Figure 7.7 This high-resolution picture would look great on your mobile phone!

Figure 7.8 Grandpa Joe might want to see the picture you took at his birthday party, but he's in Wisconsin, and you're back in Seattle, so you'll e-mail it to him.

Figure 7.9 You have the pictures from the last high school play, and you want to post them on the school's website, but the camera shot them at pretty high resolution, so they'll need to be reduced.

Figure 7.10 This great shot of your favorite musician goes on your Facebook page, for sure! Problem, though: his guitar is cut off on the default web setting, so you make it a custom size to make sure everything fits.

The Auto Correct Feature

Occasionally you will find that there is a combination of factors affecting a photograph's quality, and sometimes it's difficult to know where to begin. Is it saturation or color balance; exposure or white balance?

What Auto Correct Does, and Why It Helps

Photoshop.com has provided the Auto Correct feature, combining a number of auto correction tools used in the Photoshop software version. It analyzes an image, searching shadows, midtones, and highlights for color, and finding the darkest and lightest points to adjust contrast. It generally results in a good, balanced picture in terms of color, exposure, and contrast.

In the Web tool, you are offered several choices at once, so you can decide which works best for your particular picture.

What You See in the Auto Correct View

Like the other editing tools in Photoshop.com, it's the view across the top and in the main work area that changes. There are a few key differences. Instead of tool icons across the top, you see thumbnails of your images in the Auto Correct view, altered in various ways (see Figure 7.11).

❶ **Original.** A thumbnail of your image in its original state gives you a way to step back if you don't like your changes. Note that the undo symbol now appears over this thumbnail, rather than further to the right as in previous views.

❷ **Suggested changes.** Use any one of the remaining thumbnails for one-click adjustments to lighting, color, and contrast in various combinations. The options will be more or less dramatic, depending on the relative intensity of your original image. In Figure 7.11, the changes are pretty widely varied because the original is so strongly lit, with broad washes of similar colors.

❸ **Cancel changes.** As in all the editing tools, you have the opportunity to back out all your Auto Correct changes and return to the main editing screen.

❹ **Apply changes.** When you're happy with the results, you can apply your Auto Correct changes to the working image.

❺ **Zoom.** Lean in or pull back to see how the various Auto Correct options affect the details of your image.

Looking at Auto Correct Images

Looking at just the thumbnails above the working area may not be enough to tell you what the best option is for your picture, so you can preview the possibilities before applying any changes.

❶ In the Auto Correct view, move your mouse over each of the thumbnails in turn, leaving it to hover for a moment.

❷ Photoshop.com will project a preview of that Auto Corrected option in the main work area so you can see how it looks.

❸ Move your mouse away without clicking the thumbnail to leave the image alone.

❹ If you're happy with one of the Auto Correct options, clicking on that thumbnail will keep it active in the main work area.

❺ Using the Zoom tools, check your image detail close up, and back away to view the effect as a whole.

❻ Click the green Apply checkmark to apply your changes, or to return to the original, click on the leftmost thumbnail to undo your changes.

Figure 7.11 Auto Correct offers several options in one view for correcting light, color, and contrast.

Auto Correct Examples

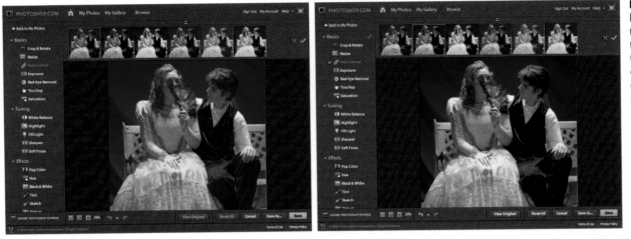

Figure 7.12 Stage lighting affected both the color and contrast in this image, but selecting the first Auto Correct option deepens contrast and makes the colors both richer and more realistic.

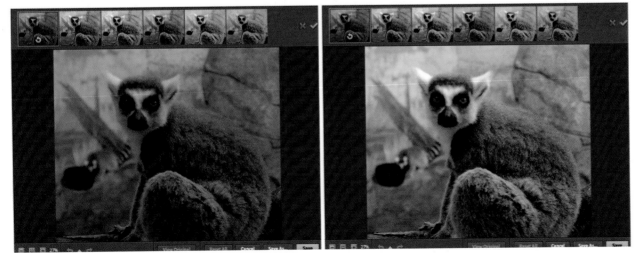

Figure 7.13 Because the background color is so bright in this image, Auto Correct might not be the right solution, but the first option adjusts contrast and color balance, helping the critter in the foreground stand out a bit more, and fades the background to look at least a little less garish.

Figure 7.14 Flash photography can often be helped a great deal with Auto Correct by improving exposure and color. In this case, a subtle shift in skin tone warms this young actor's appearance.

Figure 7.15 Because the natural light was filtered through all that green (beautiful!), the water looks a little green, too, and the overall atmosphere feels a little overgrown. Color and contrast changes make the whole scene look a little more appealing.

Figure 7.16 This beautiful casual family portrait needs help with color, contrast, and exposure. Auto Correct deepens the shadows, warms skin tones, and fixes the light (photo courtesy of Theresa Saxon).

The Exposure Feature

Photography is, at its core, about the capture and use of light. Without light—in *some* spectrum—there would be no photography. The subtleties of light and shadow are part of what makes a photograph interesting to the eye.

What Exposure Means, and How It Changes Everything

Bright light, dim light, sunlight, flash, fluorescent lights, night shots, stage lighting—all offer unique opportunities for creativity. And all present their own set of unique challenges.

One of these challenges is exposure—that is, how much time the camera spends "looking" at an image with its shutter open. Bright light requires a shorter look, dim light a longer one. And it's difficult to strike just the right balance between longer and shorter exposure so that you capture your subject completely, leaving enough shadow to show texture and prevent it from looking "flat."

Most digital cameras can be set to automatically judge how long a picture should be exposed, but there are so many variables in any given shot that the automatic settings are not always satisfying. And if you're into night shots with long exposures, for example, you must generally set a manual exposure. The art is in getting it right, as much as it is in composing the picture itself. Expose a picture too long, and it washes out; not long enough, and the details are dim.

Fortunately, Photoshop.com offers an Exposure correction tool that lets you boost or reduce exposure after the fact. It's one of the things that the Auto Correct Feature does, but Exposure by itself can reveal amazing results.

What You See in the Exposure View

In Auto Correct, your Undo button was at the far left, embedded in the original reference thumbnail; now your reference is in the middle, offering you samples in a progression from darkest to lightest.

❶ **Undo/Cancel.** The Undo icon is your middle ground in the Exposure view, with your original image as the center point of a graduated scale.

❷ **Thumbnails.** The left thumbnails show you what your image looks like under lower exposure; the right thumbnails offer brighter versions with longer exposures.

❸ **Scale.** The slider below the thumbnail images offers finer control over exposure levels.

❹ **Cancel/Apply.** The Cancel and Apply buttons are back in their familiar spot at the upper-right corner.

❺ **Zoom.** The Zoom tool at the bottom of the editing pane again gives you a way to lean in to examine details or pull back to take in the full effect.

Looking at Exposure Images

When your image is a little too dim, as in Figure 7.17, moving the Exposure scale to the right reveals more detail; the left side darkens an overexposed image, deepening shadows and enhancing texture. Let's look at how it's done.

❶ In the exposure view, move your mouse over each of the thumbnails in turn, leaving it to hover for a moment. To darken a too-bright picture, move gradually to the left; move to the right to lighten a dim picture.

❷ Photoshop.com will project a preview onto the work area of each option as you hover over it.

❸ Move the mouse off the thumbnail without clicking to leave the image as it is.

❹a Click on a thumbnail to keep that option active in the main work area OR

❹b Click and drag the slider below the thumbnail images for smaller changes in exposure.

❺ Zoom in to examine details, and out to view the overall effect.

❻ Click the green Apply checkmark when you're happy with an exposure level to apply the change to your working image and return to the main editing area. Click Undo if you want to scrap the changes and keep your original image.

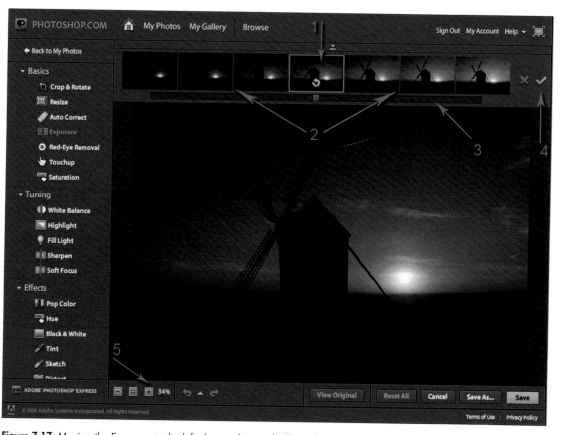

Figure 7.17 Moving the Exposure to the left plunges this windmill into darkness, while moving it to the right brightens the sun and reveals detail in both the windmill and the landscape not otherwise visible—hey, that's water!

Exposure Examples

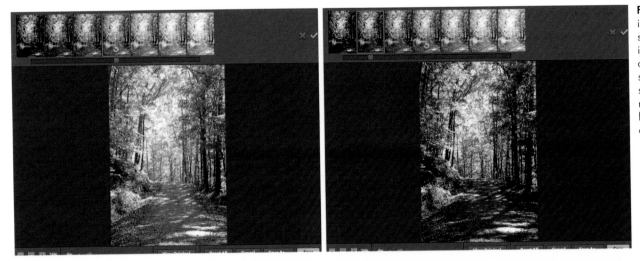

Figure 7.18 While this image is lovely and may seem right to an inexperienced eye, it's overexposed and could stand reduction. Doing so makes the scene more pleasant and less harsh (image courtesy of Theresa Saxon).

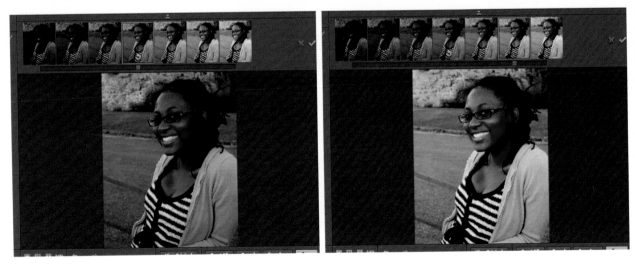

Figure 7.19 Raising the exposure level in the portrait shows off beautiful skin and a bright smile; a previous crop also removed much of the background, which might have looked overdone at this setting (image courtesy of Theresa Saxon).

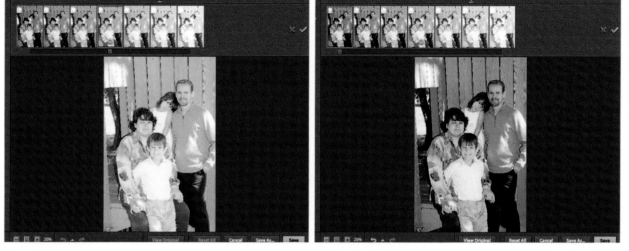

Figure 7.20 Bright sunlight caused this family portrait to look a little overexposed, but reducing the level turns hard light into interesting shadow and texture (image courtesy of Theresa Saxon).

Figure 7.21 This beautiful wedding scenario benefits from lifting the exposure level; it will also need some Highlight help, covered in Chapter 9 (image courtesy of Theresa Saxon).

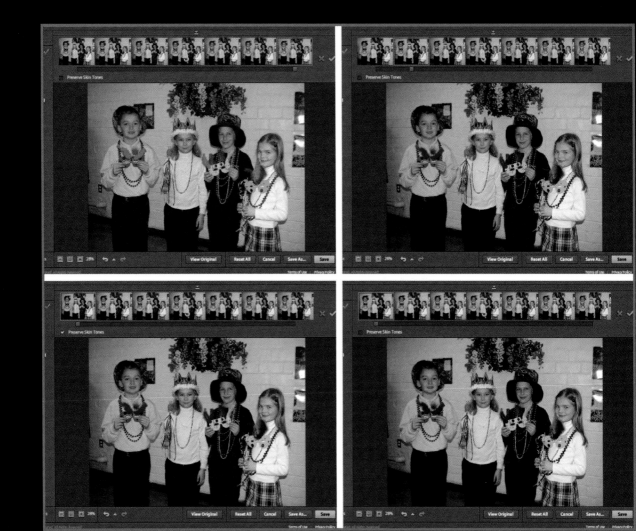

8 Simple Photo Editing: Red-Eye Removal, Touchup, Saturation

Image editing didn't begin with software; we've been altering photographs practically since photography began. First done in the camera through the use of filters or exposure alterations; then in the darkroom with processing and printing manipulations; and, finally, by hand with a paintbrush, a keen eye, and a steady touch. Through the years, our alteration techniques improved as the industry matured and technology became available (airbrushing used to be done with a real airbrush, on a real paper photograph—and often still is).

Now we can fix and alter and manipulate with the click of a mouse button (or two). Remember that Photoshop.com keeps track of your changes so you can compare results or undo errors. The View as Tiles option displays a row of thumbnail images across the bottom of the workspace so you can see an overview of your change history.

There are a few more simple editing tasks in the Basics block of Photoshop.com that help with common problems. As annoying as these problems are, they're simple to fix in Photoshop.com, which is a good thing because they happen a lot!

Those red eyes that always seem to show up when you're taking that nice group photo; the circles under the eyes or the cat hair you didn't notice on your favorite black sweater; the gloomy day that drained everything of color—these are all simple issues, easily fixed, and we cover them in this chapter. Read on…

Red-Eye Removal

In flash photography, especially when you're using a camera with built-in flash in low ambient light, you have probably come across the red-eye phenomenon more than once. It's nearly unavoidable because the flash unit is so close to the lens.

Many camera models now come with a Red-Eye flash mode that fires the flash quickly before taking the picture, and then flashes again during the picture. While not a faultless solution, it does help.

Where Does Red-Eye Come From?

So what is it that causes red-eye, anyway? There's a great Wikipedia article on the subject if you search for "red eye" and "photograph," but what it boils down to is this: flash happens so quickly that the pupils don't have time to contract, and the light of the flash reflects off the back of the eyeball. It happens in humans and some animals because of the color of the material in the back of the eye, and it's more pronounced in those with lighter-col-

ored eyes. When you use a built-in flash, the angle of the flash is close to the camera lens, thus shining almost directly into the eyes. A way to avoid red-eye, besides using the camera's Red-Eye Flash mode, is to diffuse the flash by pointing it somewhere else (not always possible) or covering it with thin fabric (not always practical).

But sometimes it's unavoidable. So Photoshop.com has come up with a way to fix it. Let's look at the Red-Eye Removal work area first (see Figure 8.1).

❶ **Click on the red eyes to fix them.** Good instructions, and that's the only thing that changes in the top toolbar in this view.

❷ **Undo/Reset/Apply.** The usual suspects are back at their station in the upper-right corner.

❸ **Zoom.** In this particular tool, the zoom controls will definitely come in handy!

❹ **Picture-in-Picture.** When you're zoomed in, the P-in-P will help you home in on the eyes.

❺ **Crosshair cursor.** Your standard mouse pointer turns into targeting crosshairs as you search out red eyes.

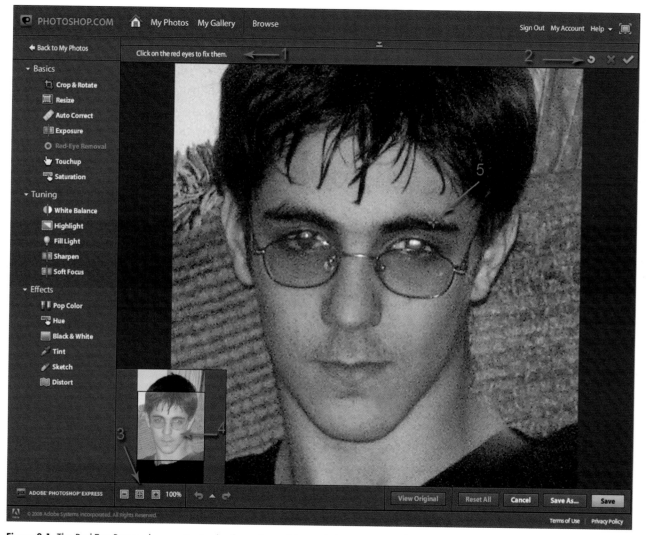

Figure 8.1 The Red-Eye Removal screen is simpler than other editing tools because its single task is so straightforward.

Zoom In on Those Eyes!

In the case of the Red-Eye Removal tool, the Zoom function is much more than just a nifty observation gadget; it's a useful tool that helps your precision.

When you want to work on the red eyes, zooming in *first* is very helpful for aiming your target crosshairs. In close-up pictures, the eyes are easier to work with so zooming is less necessary, as in Figure 8.1, but when you have a number of people at some distance, as we see in Figure 8.3, zooming in is very helpful.

Let's give it a try...

❶ Activate the Red-Eye Removal tool in the Editing area, then click the + button in the zoom toolkit to move in closer.

❷ A Picture-in-Picture tile will appear at the lower-left corner as you zoom in. Click and drag it around to change the active view and home in on the eyes in your work area.

❸ Move your mouse cursor over the red area of the eye and click once.

❹ The red glow will be replaced with normal, darker color so that the pupil appears black as it should. You may need to click a second time if any red still appears, as we did in Figure 8.2.

❺ Move your target screen around to the other eye (or eyes, if there's more than one set of eyes all aglow), and repeat the process.

❻ Zoom back out to see the full effect.

❼ Click the green Apply checkmark when you're done, to return to the main editing area.

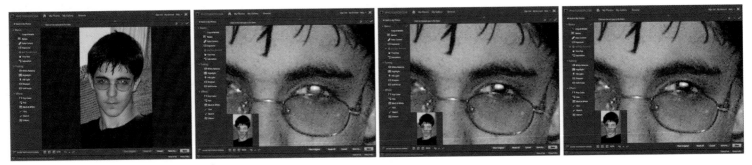

Figure 8.2 Zooming in first helps home in on your target—those red eyes—more easily. We had to click in two areas on the left eye to completely fix it.

Choosing Likely Candidates

The red-eye phenomenon is more pronounced in some pictures than in others; the choice to fix the obvious ones is simple. But even in group shots, where the effect may be less apparent, fixing the red eyes helps the photo look more finished. Use the Undo/Red tool (the orange arrows at the bottom) to compare the before and after at each step.

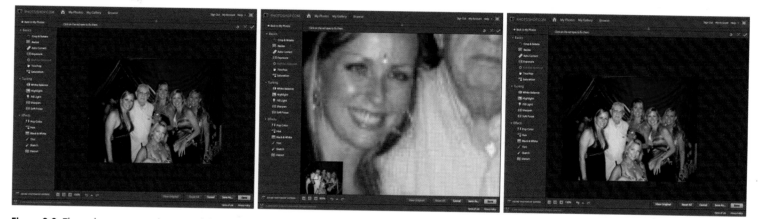

Figure 8.3 The red eyes are much more subtle in this snapshot, but fixing them made the girls look a little more angelic than devilish.

The Touchup Feature

The day you're supposed to have your special senior portraits done is—of course—the day you get that monster on your chin. You get the CD of your pictures, and there's a pose you want to share with your friends—except for that monster on your chin.

You take a really beautiful picture of your Aunt Mabel, but you didn't notice that she still had a cookie crumb (the cookies were sure tasty, though!) on her blouse.

The sky is perfect one day, an amazing and flawless Wedgwood blue, so you grab that landscape shot you've been waiting for three weeks to capture. D'oh! There was an airplane coming into view just as you snapped the photo, wrecking that pristine stillness.

Photoshop.com has the solution for all these scenarios in the form of the Touchup tool. Here's how it works (see Figure 8.4):

❶ Click and drag on the photo area you want retouched. Instead of a single click as in the Red-Eye Removal tool, you will mark a larger or smaller area by clicking and dragging your mouse. The cursor changes into a crosshair, which you can move over the areas that need fixing and note the green target and red sample area. Click in a selected area, and like magic, the problem is fixed.

❷ Retouch size. Having the same effect as dragging your mouse over an area, this determines the size of the area you want Photoshop.com to use to retouch your spot. Changing this setting enlarges or shrinks the size of *all* your retouches, where clicking and dragging changes the size of the current retouching area you're working on.

❸ Reset/Cancel/Apply. As before, you can use the tools to start over, cancel out of the Touchup area, or Apply your changes and go on.

❹ Zoom. Again more than just a nifty magnifying glass, the Zoom tool helps you aim precisely at your target marks.

❺ Picture-in-Picture. With the Zoom tool in use, the P-in-P tile gives you a way to navigate around your image when looking closely.

❻ Step back/forward. Compare your changes by stepping back and forth to see the difference.

❼ Target crosshairs. Giving you a way to center precisely on your target spot, the crosshair is easier to place than a standard cursor arrow is.

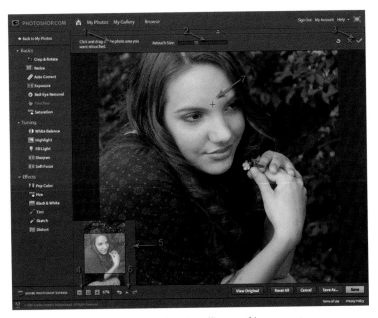

Figure 8.4 This lovely teenager suffers the affliction of her age: zits. Photoshop.com will zap 'em!

Using Touchup

Aside from the more obvious uses of the Touchup tool that have been previously covered in this book (such as to fix skin blemishes and wrinkles), there are some applications that might surprise you. For example, in Figure 8.5, Gregory is really cute but the scuff marks on the wall are distracting, so out they go.

Touchup can also be used to soften lines and dark circles around the eyes, right along with the blemishes (see Figure 8.6).

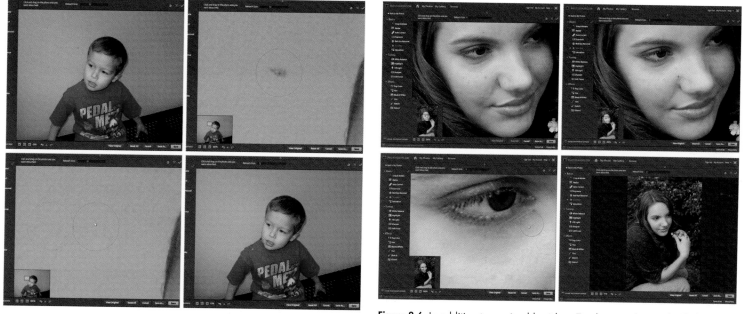

Figure 8.5 Scuff marks on the wall may not be as obvious in real life, but they distract from our subject in the photograph. Using Touchup eliminates them. Amazing what a little virtual scrubbing can do.

Figure 8.6 In addition to erasing blemishes, Touchup can be used to lighten dark circles and even out skin tone.

Using Touchup is generally pretty simple, but it may require a little practice and trial and error, depending on the level of detail at which you want to work. Here are the steps:

❶ In the Touchup view of the Editing area, zoom in on the region you would like to smooth out. Use zoom (+) to lean in, and the Picture-in-Picture frame to move around the image.

❷ Click and drag your mouse over the area. Drag a *very* short distance to begin, as you get a feel for how the tool works. You'll see a green target ring around the spot, and a red sampling ring nearby.

❸ The tool will sample an adjacent area and airbrush those pixels into the marked area.

❹ Move your cursor away from the area for a moment to examine the results.

❺ If you are not satisfied, move your cursor back into the target area. You'll notice the target and sampling rings reappear. You can move the target ring to see if another position works better (see Figure 8.7).

❻ Hover your mouse over the edge of the target ring to resize it.

❼ Move the sampling ring to another region to grab other pixels if the original sample didn't work.

❽ When you're satisfied, move on to another spot, or click the Apply checkmark if you're done.

When it takes those samples, Photoshop.com copies pixels from the sampling area, rotates them a little bit, and replaces most of the pixels within the target area as if with an airbrush.

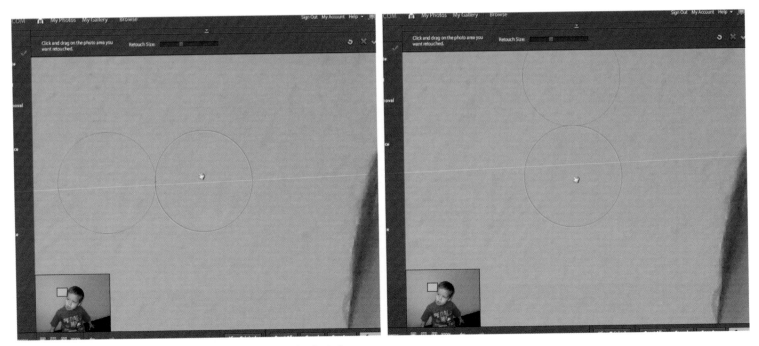

Figure 8.7 You can move the target or sampling rings to see what looks better on your target spot.

Touchup Examples, Before and After

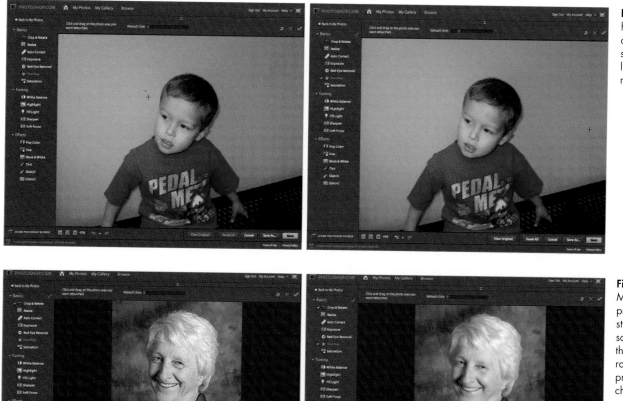

Figure 8.8 Gregory and his bright yellow wall look considerably tidier sans spots (and his face looks a little tidier without the remains of lunch on it).

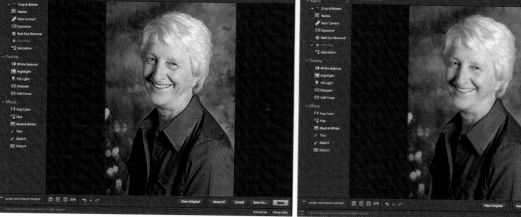

Figure 8.9 While Aunt Margaret is and should be proud of her years, the studio light emphasized some wrinkles and spots that she would probably rather not see. Wrinkles present a special challenge when touching up (image courtesy of Theresa Saxon).

The Saturation Feature

On days when gloomy skies make the light dim, photographs tend to look dim, too. In that case, it may not be a problem of exposure, but of saturation—that is, the richness of the color. While increasing exposure has the effect of adding some color, it also increases the light effect. Increasing saturation, on the other hand, enhances the color without adding extra light.

Saturation can also be used as an effect, to over-exaggerate color or, when lowered, to create a softer, pastel effect.

The Photoshop.com Saturation tool gives you the ability to either increase or decrease color saturation on a sliding scale. Here's what you see when it's activated (see Figure 8.10).

❶ **Reset.** Across the top you see thumbnail images as you do in some of the other Basics tools; the center thumbnail is the home of the Reset icon, as it is with the Exposure tool. The Cancel and Apply buttons are in their usual seats.

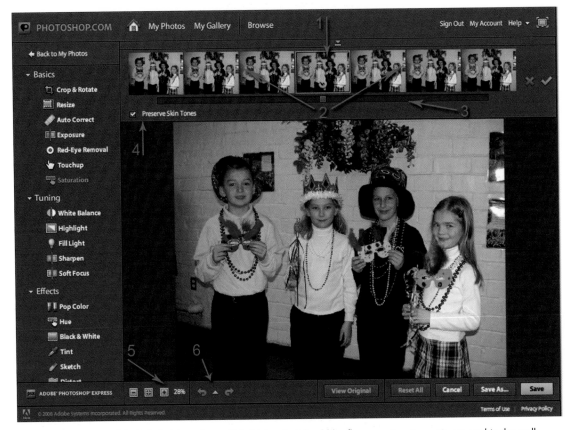

Figure 8.10 The use of flash faded the colors a little bit in what should be fluorescent costume pieces, and in the wall behind the kids. Adding saturation will help.

❷ **Increase/Decrease.** The thumbnails to either side of the center show samples with higher or lower saturation levels.

❸ **Slider.** The slider bar below the row of thumbnails gives finer control over saturation levels.

❹ **Preserve skin tones.** Very important when you're working with human subjects, this keeps skin looking like skin and not something out of a comic book—unless that's what you want! Remove the checkmark if you don't want to use this feature.

❺ **Zoom.** Move in or out to observe the effect your changes have on detail and on the whole picture.

❻ **Undo/Redo.** Step backward or forward one step at a time to compare versions.

Working with Saturation

As a corrective, adding or reducing Saturation helps bring colors to realistic levels. As an effect, it can be used either slightly or extremely to change the viewer's perception of the image. Here's what you can do with it:

❶ Activate the Saturation tool within the Editing area, and start with your image zoomed out to fit the screen. It's helpful to observe the effect your changes have on the whole picture first.

❷a Move your mouse to one of the thumbnail images to either side of center, and let it hover for a moment, OR

❷b Click and drag the slider below the thumbnail row for finer changes in saturation.

❸ When you've settled for a moment, Photoshop.com will project a preview of the alteration in the main work area.

❹ Zoom in closely to observe the effect the changed levels have on detail (see Figure 8.11).

❺ Zoom out again to view the whole picture.

❻ When you're satisfied with your changes, click the green Apply checkmark to accept them; otherwise, clicking Reset will scrap your changes and set you back to center.

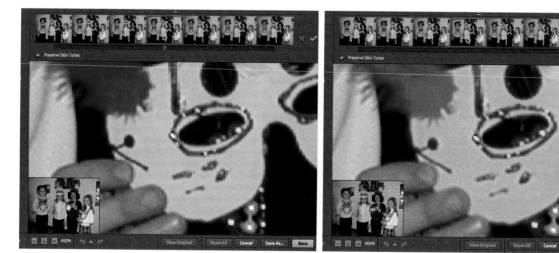

Figure 8.11 Zooming in very closely shows you the effect changed saturation levels have on individual pixels. Note how the shadows around the fingers fluoresce a little when the saturation is too high.

Choosing a Saturation Image

Photos that are taken in dim light (e.g., overcast conditions outdoors) tend to be good candidates for increasing saturation levels; you can also increase saturation to enhance the color of, for example, that beautiful cherry cordial or that beautiful crimson car; or go further and exaggerate the colors as an effect.

Reducing saturation is not often required as a corrective measure unless your camera's saturation levels are set too high when shooting. Otherwise, reducing saturation produces a faded or pastel effect; the subtle remainder of color has the effect of making a picture look hand-colored and old-fashioned, or even black and white if you take out skin tones, too. You can see the effects of reducing and increasing saturation in Figures 8.12 and 8.13.

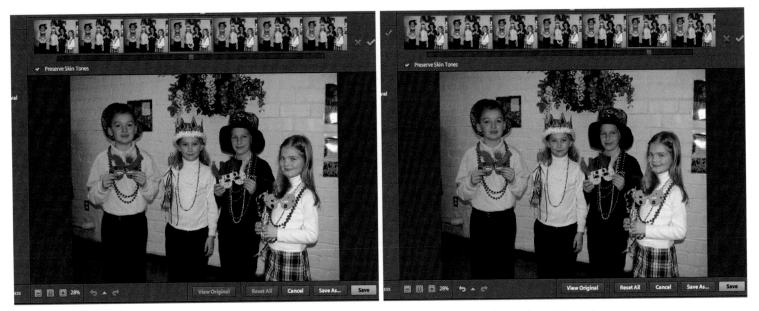

Figure 8.12 Back to our Mardi Gras children, boosting saturation while leaving skin tones brings out the brilliant colors of the masks.

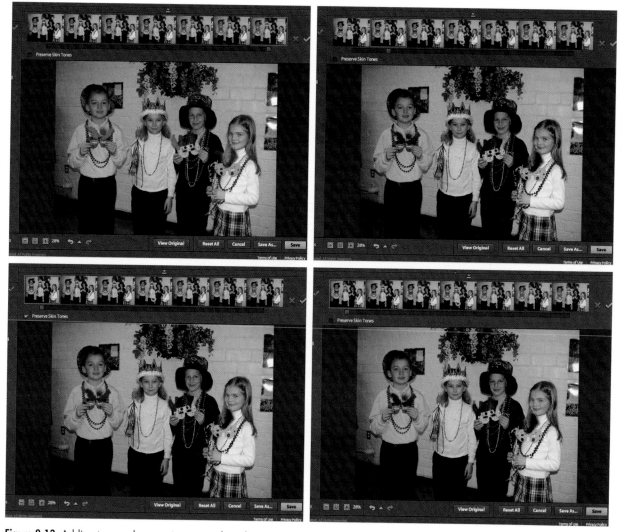

Figure 8.13 Adding too much saturation can make colors unrealistic; not enough, and the colors fade away. Note the effect when reducing saturation completely and preserving skin tones vs. not preserving.

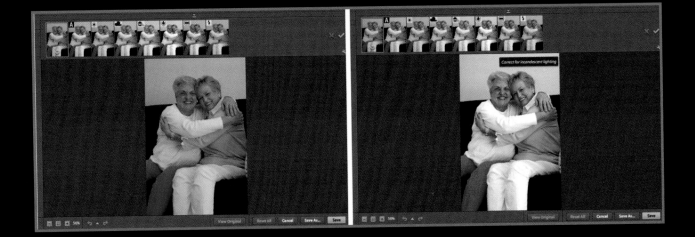

Advanced Photo Editing

The Basics tools in Photoshop.com offer relatively simple ways to make corrections to your photographs when you see things that detract from the picture's overall effect. What if it doesn't have any obvious flaws, though, yet still seems to be… off… missing something… not quite right? Or even if it is right, it still wants something that will really lock it in.

This is where tuning comes in. Think of the dial on an analog stereo or ham radio: you can make big moves to find your station's neighborhood, and then it takes smaller, finer moves to locate the strongest signal.

Here's a photographic example: fluorescent lighting can be unpleasant, don't you agree? The light is cold and unnatural and, unless you have the far more expensive full spectrum lamps (which still aren't perfect), it tends to cast a faint yellow-green glow over everything. Unfortunately, cameras don't always detect fluorescent lighting's particular color cast, and your pictures may turn a little green.

While you're thinking about that, think about all the subtle possibilities for what should be plain white paint: winter white, eggshell, antique, and so on. On a wall, it's white. But if you put the different paint chips next to each other, they are distinctly different.

This is White Balance, and Photoshop.com helps you tune it, among other things, with the tools available in the Tuning block of the Editing area.

As we go through this chapter, we'll also learn about Highlight, which helps enhance detail by boosting the lighter colors in a photo; Fill Light, which can brighten up subjects that are partially lit and need a bit of a boost, and enhances detail in shadows without brightening blacks (helping with silhouettes, that you don't want to be 100 percent black, for instance); Sharpen and Soft Focus, which are just what they sound like.

White Balance

You might remember discussions from your elementary school days about the color spectrum, and how the white that we perceive is a balanced combination of all the colors of the visible spectrum. If any one or more of the colors in the spectrum is stronger than others, your white will lean faintly in the direction of that color (I recall trying to make a color wheel which, when spun, was supposed to turn white—mine was always kind of purple).

What Is White Balance, and Why Does It Matter?

In photography, differing light conditions result in differing whites. Those variations are called "temperature" and "tint" in photography, referring to the relative "warmth" of color in the former, and the balance of magenta and green in the latter. Fluorescent lighting is one example of white variation, and the condition of the sky in outdoor photography, whether clear or cloudy, is another. The resulting picture might have a slight green tinge, or blue or blue-gray.

The White Balance tool in Photoshop.com helps you tune those various shadings back to center by adding a touch of the missing color or reducing the overblown one. Here's what the screen looks like (see Figure 9.1):

❶ **Reset.** Once again, the Reset icon now appears over a thumbnail image to the far left across the top of the work area.

❷ **Full Auto.** Let Photoshop.com do the balancing for you: like all fully automatic modes, the results are sometimes great, and sometimes miss the mark.

❸ **Correct for sunlit conditions.** Bright sunlight, believe it or not, can add a blue cast to photographs, making the white temperature lean toward cool. Use this setting to warm your colors.

❹ **Correct for cloudy conditions.** A cloudy day can also add a little bit of blue, though less than full sunlight; this setting corrects that.

❺ **Correct for shady conditions.** Like cloudy conditions, shooting in the shade, even on an otherwise bright day, can also result in a photograph whose whites lean toward the cool side. This warms the colors even more than the cloudy setting does.

❻ **Correct for incandescent lighting.** Taking pictures lit only by incandescent light bulbs—the kind you generally find in table lamps and overhead lights in homes—can turn the white temperature too far toward "warm," thus giving you a photograph with lots of yellow in it. This automatic setting adds a bit of blue and magenta to compensate.

❼ **Correct for fluorescent lighting.** As we have noted, much fluorescent illumination is deficient in red and some other tones, which often makes the apparent color temperature too warm and with a little green in it. This setting replaces some green with magenta and the yellow with blue to correct.

❽ **Correct for flash lighting.** Flash lighting is a little on the cool side, adding a little blue to photographs and flattening warmer colors. This setting corrects it.

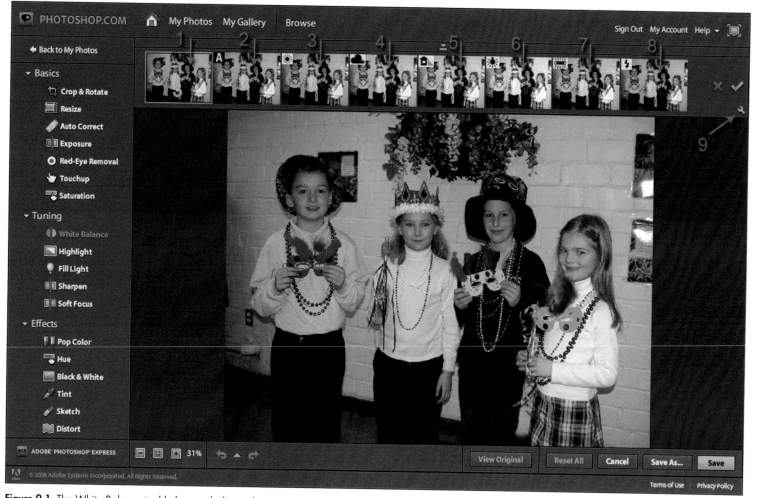

Figure 9.1 The White Balance tool helps you balance the proportions of color in your photograph by shifting the red/green/blue sensitivity.

⑨ Advanced controls. Clicking this icon will close the row of thumbnails and replace them with two slider controls, one for Tint and one for Temperature. See Figure 9.2.

The White Balance screen also shows the same standard functions that the other editing tools include: Reset, Apply, Zoom, Undo/Redo, View Original, Reset All, Cancel, Save As, and Save.

Selecting any one of the automatic settings is simple, and adjusts the image according to preset compensation levels.

❶ In the White Balance view of the Editing tool, move your mouse over each one of the thumbnail images in turn.

❷ Leaving your mouse to hover over any one of the thumbnails causes Photoshop.com to project a preview of that setting in the main work area.

❸ If you're not satisfied with the results, simply move your mouse without clicking. Moving completely away from the thumbnail row restores the original image; moving to another thumbnail replaces the preview image with that of the setting over which you're now hovering.

❹ When you find a setting that satisfies your eye, click on it to set that adjustment level.

❺ Click the green Apply checkmark to accept the setting and return to the main Editing view.

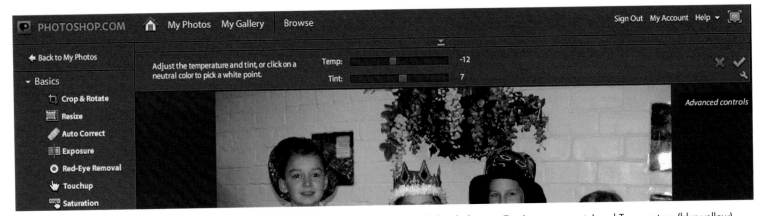

Figure 9.2 The Advanced Settings view offers finer control over white balance with the two sliders balancing Tint (green-magenta) and Temperature (blue-yellow).

Full Auto

Selecting the Full Auto option permits Photoshop.com to select a good color balance for your image. It will find spots that are supposed to be pure white and change the color mix so that white really is white. Generally, this is a sufficient choice and results in a good, balanced image, as in Figure 9.3.

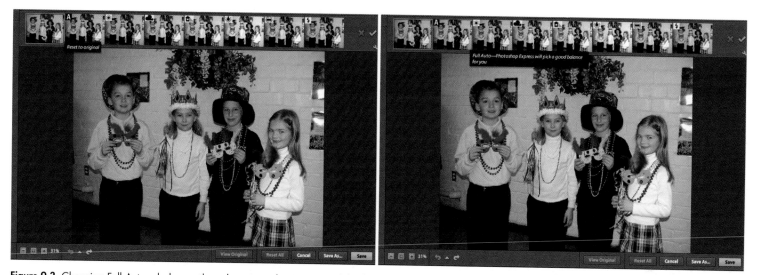

Figure 9.3 Choosing Full Auto rebalances the color mix so that you see subtle changes in the yellow wall and white shirts. This image presents a balancing challenge because it's a flash picture taken in fluorescent ambient light.

Correcting White Balance for Outdoor Conditions

The color of outdoor light tends to be on the cool side even on those lovely warm days (light temperature and atmospheric temperature are two different things). The result, if your camera does not compensate for it, can be pictures that have a little too much blue in them.

Correct for Sunlit Conditions

Bright sunlight has a color temperature that leans toward cool, adding a faint blue cast to pictures if your camera does not have a color balance setting that compensates (many do; some do not). Choosing the Correct for sunlit conditions adds a little bit of yellow to balance the blue, very slightly warming the overall effect of the photo (see Figure 9.4).

Correct for Cloudy Conditions

Even on cloudy days, outdoor light tends toward cool as well. The picture in Figure 9.5 is a great example of what White Balance can do in that case.

Correct for Shady Conditions

Shooting on bright days with your subject in the shade also causes color temperature to be on the cool side, and it often presents the additional challenge of exposure levels, as we saw in Chapter 7. In Figure 9.6, we have already corrected the exposure, but the colors are still a little cool. Using the automatic Correct for shady conditions setting results in a much warmer picture (see Figure 9.6).

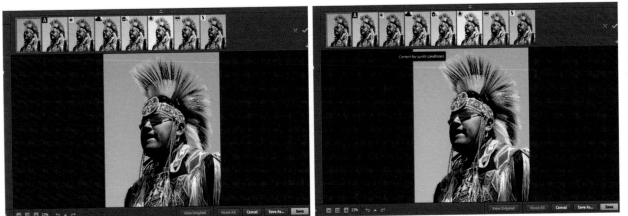

Figure 9.4 While it's true that the sky is very blue and there's a lot of blue in this ceremonial costume, the whites are also a little too blue. Applying the sunlit setting rebalances the colors back toward neutral, and the costume is no less brilliant for it.

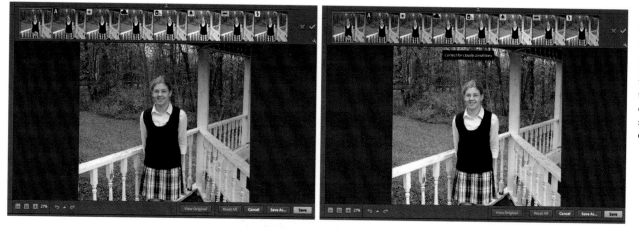

Figure 9.5
Compensating for cloudy and/or shady conditions significantly improves the color of the picture, especially the girl's skin—the atmosphere no longer seems chilly, but warm and comfortable.

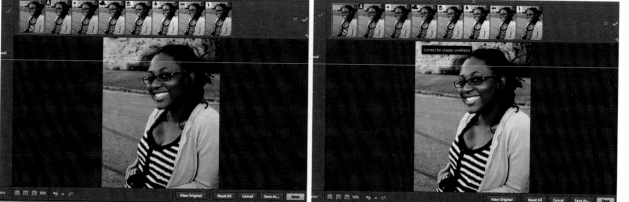

Figure 9.6 While adjusting exposure helped enhance details such as her excellent skin and teeth, adjusting White Balance resulted in warmer skin tones on both the model's skin and in the shade around her.

Correcting for Indoor Conditions

Where natural light outdoors tends toward "cool," indoor light presents a different palette of colors. Artificial light is lower in intensity and can skew the color balance in the opposite direction, with too much yellow and/or green in photographs.

Fortunately, different kinds of artificial light put out light whose color balance is fairly predictable, so Photoshop.com provides some automatic settings that cover most common conditions.

Correct for Incandescent Lighting

If your camera does not have a correction setting for incandescent light (the kind put out by standard light bulbs, not the compact fluorescent variety), you might notice that all your pictures are coming out yellow (see Figure 9.7). That's because the light that even high-wattage bulbs put out is still a fairly low color temperature. It's also pretty common, so Photoshop.com's automatic setting generally does a good job of balancing it.

Correct for Fluorescent Lighting

While fluorescent light doesn't have a true color temperature, it nevertheless affects white/color balance in photographs. Cool white light is kinder to the resulting image, but standard fluorescent lamps that are not cool white have a tendency to make everything look a little green. Not very appealing (see Figure 9.8). Photoshop.com has a setting for that, adding magenta for balance.

Correct for Flash Lighting

Though not as intense as full sunlight, the light of an electronic flash can still skew a picture toward the cool end of the spectrum. Other ambient light will influence the color balance as well, but the flash is, of course, generally the strongest light source, so has the most influence (see Figure 9.9).

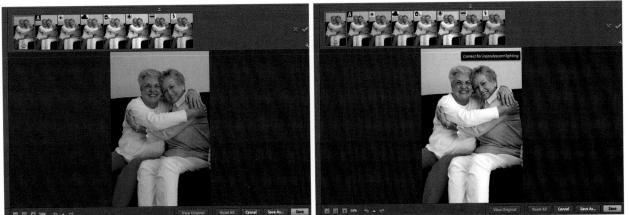

Figure 9.7 The ambient room light in this reunion photo was a bright overhead fixture and a table lamp, which made the overall image a little too yellow.

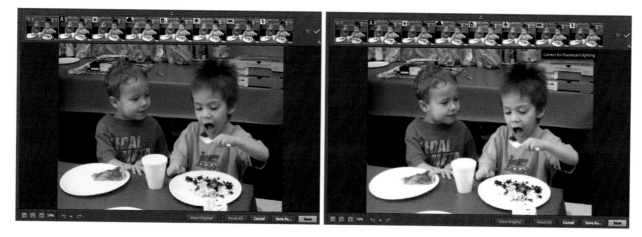

Figure 9.8 That bit of chocolate birthday cake would be more appetizing if it weren't lit by overhead fluorescent light.

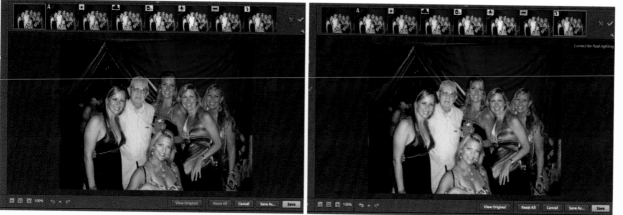

Figure 9.9 Uncle Bob is even happier surrounded by warm-blooded women.

How the White Balance Tool Works Best

When none of the automatic settings balance your photo exactly right, the Advanced tools might do the trick. Here's how (see Figure 9.10):

❶ Click on the little wrench icon below the Reset/Apply icons to open the advanced settings view. The row of thumbnails across the top will be replaced by two slider bars marked Tint and Temp.

❷ Experiment with dragging the sliders from one side to the other to see how they affect your image.

❸ You can try "eyeballing" the balance; however, it's difficult to get the balance just right between both Tint and Temperature, with the two offering nearly infinite combinations of possibilities. There's a better way: if there's even a single pixel of color that should be neutral, that is, white or gray or black (there usually is), Photoshop.com can calibrate the whole image so that the colors are balanced based on that neutral pixel. To do so, zoom in on a neutral area. The closer you zoom, the more precise you can be.

❹ Click on the neutral pixel.

❺ Photoshop.com will adjust the Tint (green/magenta balance) and Temperature (yellow/blue balance) until that neutral pixel is balanced. The result is that the whole picture is balanced, as Photoshop.com adjusts the whole image to match the corrected neutral pixel.

❻ Zoom out to see the results over the whole picture, and toggle the View Original button to compare your results to the original image.

❼ In the unlikely event the image needs further adjustment, you can still do so by moving the Tint and Temp sliders yourself.

❽ When you're satisfied with the result, click Apply to accept the change and return to the main editing screen.

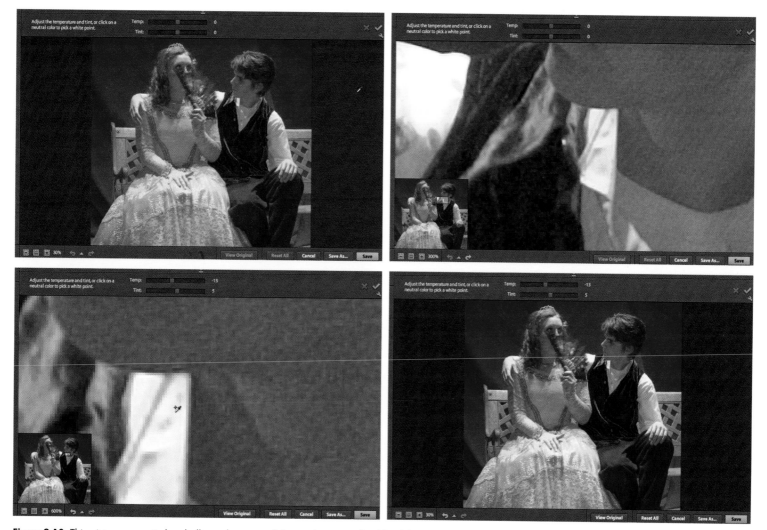

Figure 9.10 This picture presented a challenge because of the combination of red backdrop, yellow dress, and yellow gels in the stage lights. Using the Advanced tools and calibrating to the bright white of the young man's collar (we chose a pixel that showed a little too much yellow to give Photoshop.com something to work with) resulted in a much better color balance than any of the automatic settings. Note that both Tint and Temperature were adjusted.

Highlight

Highlight is exactly what it sounds like: the highlights of an image—that is, the colors that are brighter. For printing and photography, color shading is divided into 256 gradations from dark to light with 0 being the darkest (black) and 255 being brightest (white). The highlights are the colors on the high/bright end of the scale.

The Highlight tool in Photoshop.com gives you a method for raising and lowering the relative intensity of the brightest parts of a picture. Similar to the Exposure setting, which adjusts the intensity of *all* light in a picture, Highlight only lightens or darkens the lighter-colored pixels in relation to their surrounding darker neighbors.

This is what you see in the Highlight view (see Figure 9.11):

❶ **Reset to original.** The reset function is back in the middle of the thumbnail row, because Highlight is a plus or minus function.

❷ **Reduce highlights.** At the left end of the thumbnails will be highlight reduction, where center is zero (0) and the far left is -32.00. Each thumbnail represents a decrement of 10.66 points (on that 256-point scale).

❸ **Increase highlights.** At the right end are the thumbnails representing increases in highlight in the same proportions, but on the positive side: 10.66, 21.33, and 32.00.

❹ **Slider.** Below the thumbnails you once again see a sliding scale for finer tuning of the highlight levels. Click and drag to move it up or down the scale.

As before, the screen also includes the other useful tools available in any of the Editing functions: Cancel, Apply, Zoom, Undo/Redo, View Original, Reset All, Cancel, Save As, and Save.

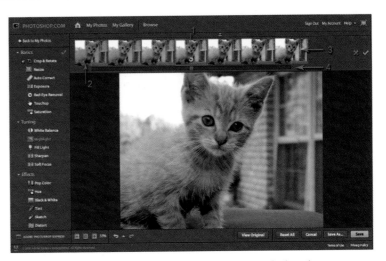

Figure 9.11 Enhancing or reducing highlights changes only the relative intensity of the lightest pixels in an image.

Choosing Images for Highlight Help

If an image seems to have the right amount of color, but still appears a little flat, enhancing the highlights can wake it up a bit (see Figure 9.12).

It's as easy to boost or reduce highlights in a picture as it is to carry out most other Editing tasks in Photoshop.com (see Figure 9.13).

❶ In the Highlight view of the Editing window, move your mouse cursor over one of the thumbnails to the left of center to reduce highlights, or to the right to boost them.

❷ Leave your mouse to hover for a moment, and Photoshop.com will project a preview of the change in the main work area.

❸ It's possible that one of the suggested settings will meet with your approval; if so, click on that thumbnail.

❹ If not, click and drag the slider below that thumbnail to the right or left in small movements for a more refined adjustment.

❺ When you're satisfied with the setting, click the Apply checkmark to approve the change and go back to the main work area.

Figure 9.12 Boosting highlights made the details in the kitten's fur stand out better, and heightened his ginger markings.

Figure 9.13 While reducing kitten's highlights made him look bizarrely two-dimensional, the same reduction helps soften the very high contrast light and shadow on this woodland path.

Fill Light

Adjusting Fill Light is a way to enhance detail in shadows by adjusting the relative dark pixels in relation to the even darker neighbors, without making black pixels any brighter (see Figure 9.14).

What this means is that details which might otherwise be lost in shadow can be tweaked a little to bring them forward. This is helpful if your picture seems to show nothing but black in areas where you *know* there's detail, as in silhouettes. Here's what the Fill Light screen looks like:

❶ The Reset icon is now back at the left end of the row of thumbnails; Photoshop.com assumes that you would only ever need to enhance fill light, not reduce it.

❷ The thumbnails suggest relative levels of fill light, from 0 (your original) to +10 at the far right.

❸ A slider bar below the thumbnail row offers finer control over fill light intensity, so you can make fractional adjustments.

Using Fill Light

For certain images, the need to enhance Fill Light levels is fairly obvious; a silhouetted image often needs enhancement to brighten up dark shadows, for

example. In some cases, the solution is actually a combination of tools, as in Figure 9.15, where we used both Exposure and Fill Light to reveal details otherwise hidden from view.

Figure 9.14 Although we already enhanced the exposure on this photograph, we are certain that boosting fill light will enhance more details.

There may be some trial and error on your part in getting the adjustments, or blend of adjustments, just right. Here's how to get started:

❶ In the Fill Light view of the Editing window, begin by moving your mouse over the thumbnail image immediately to the right of the original.

❷ Let your mouse hover there a moment, and Photoshop.com will project a preview onto the main work area.

❸ Move your mouse away from the thumbnail row without clicking.

❹ Compare settings by moving your mouse back and forth over the thumbnails, or for finer control by moving the slider back and forth. Click a thumbnail or leave the slider when you're satisfied with the result.

❺ Toggle the View Original button to compare your changes with the original image.

❻ Zoom in to see the effect the Fill Light enhancement has on image details.

❼ When you're satisfied with the result, click Apply to accept your changes and return to the main Editing area.

Fill Light Examples

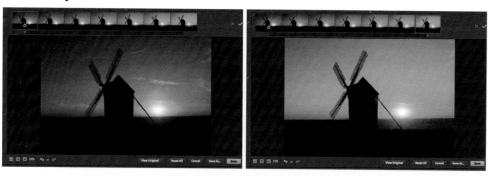

Figure 9.15 Enhancing the Fill Light setting on our windmill, having already boosted the Exposure, suddenly reveals a window, shingles, and details of the town in the valley below! The dark areas, such as the roof and the ground in front of the windmill, remain dark as they should.

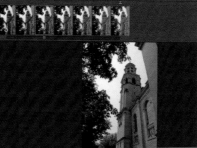

Figure 9.16 A more subtle increase in the Fill Light reveals a real copper downspout and enhances the color of the brick on this beautiful church, while leaving intact the intense shadows cast by bright sunlight.

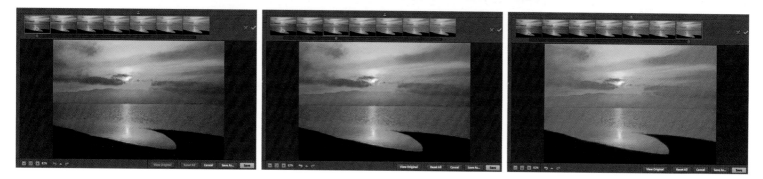

Figure 9.17 Unlike our silhouetted windmill, increasing the Fill Light actually reduced the quality of this seemingly similar image. Time to hit the Reset button!

Sharpen

The Sharpen tool does what its name implies: it sharpens edges in a photograph. Edges, as Photoshop.com sees them, are the boundaries between colors and color families in an image. Photoshop.com finds those boundaries and makes them more distinct by matching blurred pixels more closely with neighboring colors in the same family, thereby enhancing the definition *between* colors.

While the Photoshop.com Sharpen tool can't fix a severely blurred image, it can greatly enhance a mildly blurred image, and even in images that already seem sharp it can increase contrast and clarity.

Most pictures taken by a digital camera—even higher quality ones—or scanned pictures, can benefit from sharpening, but note that if there's image "noise" (graininess because of low light and long exposure, or poor reproduction in the case of a scanned image), sharpening will also enhance the noise.

Here's what you see in the Sharpen tool (see Figure 9.18):

❶ **Reset.** Our friend the Reset icon lives at the left edge of this row of icons, because Sharpen is a positive action only (if you want to blur an image, we'll be looking at Soft Focus next).

❷ **Thumbnails.** Thumbnails in this row show you samples of what your image will look like at various Sharpen levels. Rather than showing a thumbnail of the whole image, however, as we see in other tools, it shows you a detail selection instead, so that you can pick a reference point for changes you make.

❸ **Slider.** If the suggested settings available with the thumbnails are not right, you can make finer adjustments by clicking and dragging the slider.

❹ **Detail frame.** Because the thumbnails are details, not the whole image, Photoshop.com gives you a way to change focus so that you can build out from a specific detail. Click and drag this frame to move it around the work area.

❺ **Picture-in-Picture.** When zooming in on a detail, the Picture-in-Picture tile gives you a way to move around to center on a specific area. Use the zoom focus in combination with the detail frame to center your view on a very specific detail.

Using the Sharpen Tool

Using Sharpen in Photoshop.com is as much an aesthetic choice—no surprise there—as a technical one. While even the sharpest digital images have a little bit of blurring around the edges (partly due to the way the .jpg file format handles color and data compression), you might find that the Sharpen tool does not always produce the result you expect.

It sharpens edges and detail, and if there's noise in the picture, it sharpens that, too. Sharpen *too* much, and the picture may end up looking unrealistic. You'll very likely need to experiment with different sharpen settings in each image. Let's get a feel for how it works.

❶ In the Sharpen view of the Editing tool, zoom first on a detail area, and move both the Picture-in-Picture focus frame and the detail from the main view over to that detail area, so that it appears in the thumbnail views.

❷ Move your mouse cursor slowly over each thumbnail from left to right.

❸ As you come to rest on each thumbnail, Photoshop.com will project a preview image on the main work area so you can observe your results.

❹ If the thumbnail images' suggested settings aren't quite right, try dragging the slider bar right or left for finer tuning.

❺ When you have found a setting that works best for your image, zoom all the way back out to see the results over your whole image.

❻ If that works, click on the Apply checkmark to accept the setting and return to the main editing window.

Look carefully at both the details and the overall image before you decide on a setting. And you can always go back and change or undo it altogether if you change your mind later.

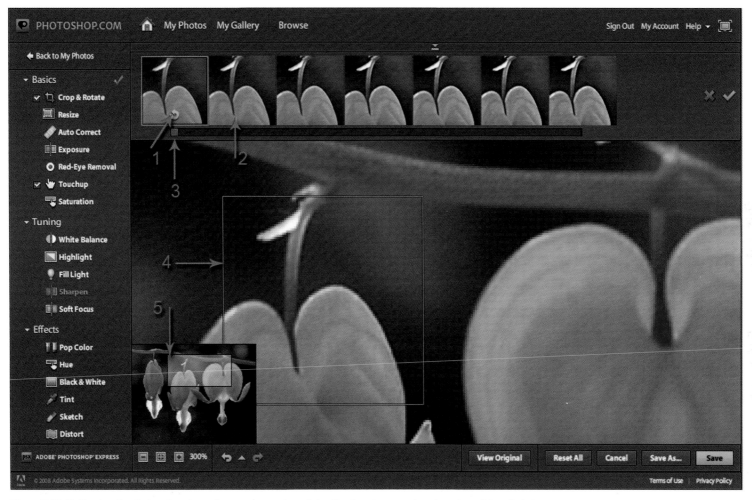

Figure 9.18 Unlike thumbnails in other views, here you see selected detail rather than a reduced version of the whole image.

Sharpen Examples

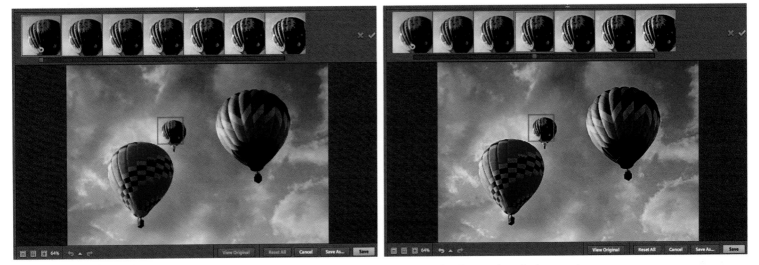

Figure 9.19 The distinct definition between the colors on these bright balloons stands out intensely when moderately sharpened.

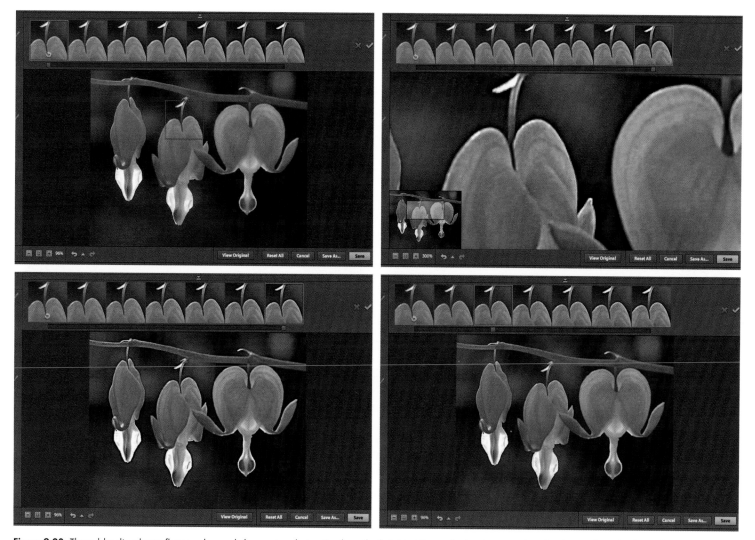

Figure 9.20 These bleeding heart flowers do need sharpening, but notice how the brightest flower looks almost as though it has a drop shadow effect behind it, because of the high contrast. So a more subtle change would be better (image courtesy of Theresa Saxon).

Soft Focus

If you're a Star Trek fan as I am, you might remember a particular phenomenon from the original series: whenever the women were filmed close up, they were always slightly blurred. In ST:TOS, with Yeoman Janice Rand (played by Grace Lee Whitney) it was always particularly noticeable, perhaps because her hair styles were so elaborate, or perhaps because of her very blond hair.

Part of the reason for doing this is that it's quite flattering to one's face—it reduces the appearance of any irregularities in skin and softens the atmosphere around the face.

Soft focus is a popular technique in photography, often used to create that sense of softness in an image, especially portraits involving subjects with aging or poor skin. Photoshop.com provides the feature as part of the Tuning tool set. Let's have a look (see Figure 9.21).

❶ **Reset.** Our friend the Reset icon lives at the left edge of this row of icons, because like Sharpen, Soft Focus is a positive adjustment only.

❷ **Thumbnails.** Thumbnails in this row show you samples of what your image will look like at various Soft Focus levels. Rather than showing a thumbnail of the whole image, however, as we see in other tools—except Sharpen—it shows you a detail selection instead, so that you can pick a reference point for changes you make.

❸ **Slider.** If the suggested settings available with the thumbnails are not right, you can make finer adjustments by clicking and dragging the slider.

❹ **Detail frame.** Because the thumbnails are details, not the whole image, Photoshop.com gives you a way to change focus so that you can build out from a specific detail. Click and drag this frame to move it around the work area.

❺ **Picture-in-Picture.** When zooming in on a detail, the Picture-in-Picture tile gives you a way to move around to center on a specific area. Use the zoom focus in combination with the detail frame to center your view on a very specific detail.

Using the Soft Focus Tool

Most often used in portraiture, Soft Focus can be applied to any number of images to very slightly blur and therefore soften the overall atmosphere in the picture. In landscapes where the light is on the harsh side, the judicious application of Soft Focus can take the edge off.

Let's have a look at this final tool in the Tuning set.

❶ In the Soft Focus view of the Editing tool, zoom first on a detail area and move both the Picture-in-Picture focus frame and the detail from in the main view over to that detail area, so that it appears in the thumbnail views.

❷ Move your mouse cursor slowly over each thumbnail from left to right.

❸ As you come to rest on each thumbnail, Photoshop.com will project a preview image on the main work area so you can observe your results.

❹ If the thumbnail images' suggested settings aren't quite right, try dragging the slider bar right or left for finer tuning.

❺ When you have found a setting that works best for your image, zoom all the way back out to see the results over your whole image.

❻ If that works, click on the Apply checkmark to accept the setting and return to the main Editing window.

Look carefully at both the details and the overall image before you decide on a setting. And you can always go back and change or undo it altogether if you change your mind later.

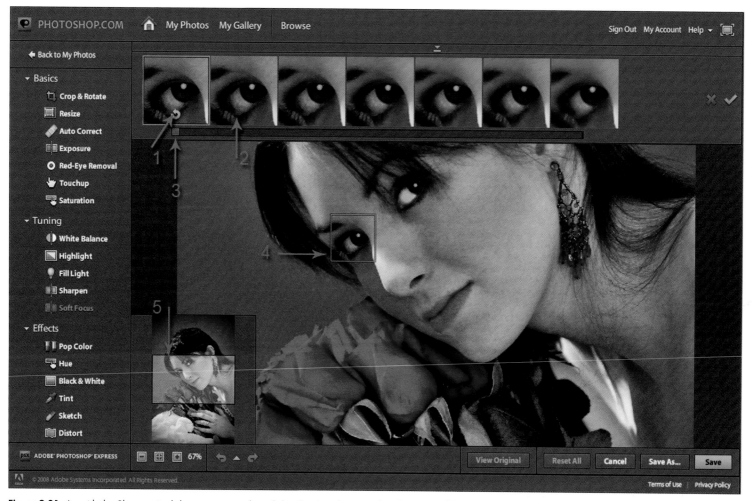

Figure 9.21 As with the Sharpen tool, here you see selected detail rather than a reduced version of the whole image.

Soft Focus Examples

Figures 9.22-9.24 show examples of soft focus at work.

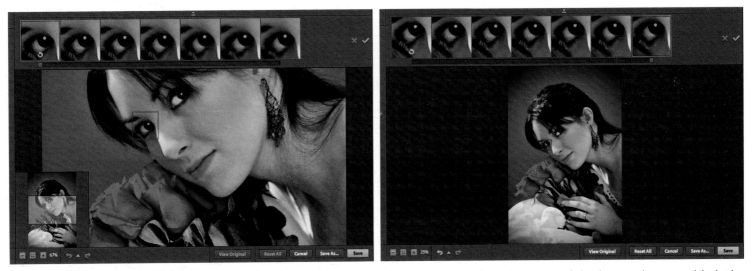

Figure 9.22 A frequent application of the Soft Focus technique is in wedding portraiture: it smoothes the skin and creates a soft, lovely atmosphere around the bride.

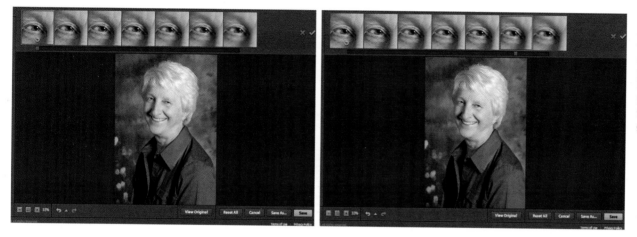

Figure 9.23 Adding soft focus to the touchup we already did to Aunt Margaret's portrait further softens both the wrinkles and the freckles, and adds to her lovely, grandmotherly appeal.

Figure 9.24 Softly! Baby's sleeping... and adding the fullest amount Soft Focus that Photoshop.com offers turns this child into a porcelain doll, without changing the texture of his hair or his sweater.

10 Advanced Photo Editing: Effects

Now it's time to have some fun! (Or, I hope, even *more* fun!)

We've done a lot of corrections, tweaking, and fine-tuning, and now it's time to get a little more adventurous with Photoshop.com. In addition to the very powerful retouching and tuning tools we've already covered, the site offers some great special effects that are simple to apply yet yield eye-popping results!

In this chapter, we'll cover the remaining block of tools in the Editing area: those that cover special effects. We've talked about tuning color to get it just right, but how about sending it way *outside* the expected into just plain crazy? Have you thought about making that fabulous portrait into a black and white, or better yet, sepia tone? Or turning it into a charcoal drawing? Or turning your dog's nose into a balloon? Photoshop.com has the tools; now it's up to you to provide the imagination.

Pop Color

Pop Color allows creating some interesting color effects with a few clicks of the mouse. Pop Color is the first of the Effects tools in Photoshop.com, and it allows you to highlight one particular color in your photo and selectively replace it. With this tool, you can turn the whole picture shades of that color, or just replace a narrow range of color shades. With it, you can turn grass purple, hair green, or the sun magenta.

What You See in the Pop Color View

When you first open the Pop Color view in the Editing area, you'll see your image plus a couple of simple buttons across the top, as shown in Figure 10.1.

❶ **Reset to original.** The Reset icon is a small button, not a thumbnail image, in this view.

❷ **Button color guides.** These buttons show the predominant color or colors in an image. Clicking one or the other of them opens an additional row of thumbnails as in Figure 10.2.

❸ **Eyedropper.** Moving your mouse over the image shows an eyedropper in place of the standard mouse cursor. This allows you to select a color other than the ones shown in the color guide buttons.

❹ **Show All Colors.** In the secondary view that appears when you click one of the color guide buttons, or select a color from the image with the eyedropper, you will see an additional checkbox where you can opt to show all colors or just the one you're highlighting. It is unchecked by default.

❺ **Reset to original.** In this view, you can undo your secondary selections with this button, which leaves the thumbnail row open, and displays your image with the first color choice you made highlighted.

❻ **Color choices.** The color you chose is replaced selectively in a series of thumbnails from left to right, with your original image at the left end.

❼ **Slider.** Below the thumbnails, you see a slider that gives you finer control of the color replacement.

❽ **Picture-in-Picture.** When you zoom in on an image, you will see the now-familiar P-in-P tile in the lower-left corner of the work area, which you use to focus on a specific region of your image.

The results you see differ according to which color you chose to highlight, and whether or not you choose to Show All Colors.

◆ **Unchecked (default).** Leaving Show All Colors unchecked—off—renders your image in black and white first and then replaces the color you selected with the highlight colors.

◆ **Checked.** Selecting this option leaves all the colors of your image intact except for the one you choose, which gets replaced with the Pop Color choices.

Figure 10.1 The first view in Pop Color offers you color choices in the form of buttons, and displays different results based on your choice.

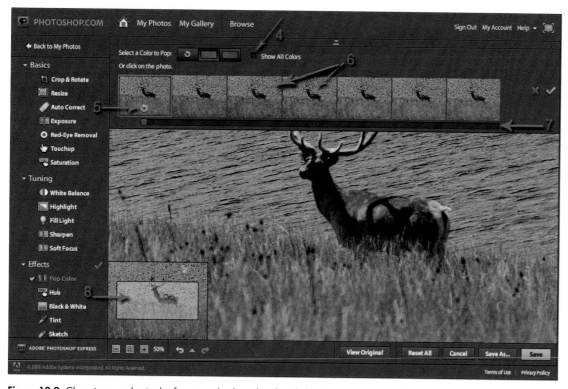

Figure 10.2 Choosing a color in the first step displays thumbnails highlighting and transforming your color choice.

Working with Pop Color

The Pop Color tool is a little more complex than most of the other Editing tools in Photoshop.com because choices you make along the way lead you down different paths, and those choices can end in vastly different results.

Let's look at the kinds of choices we can make and where they lead us.

❶ In the initial Pop Color view, let your mouse hover over each of the buttons in turn to see in the main view what gets highlighted.

❷ If you want to choose a color other than the ones offered, zoom in on an area containing the color you do want. With the Eyedropper tool, select exactly the color you want to highlight.

❸ When you select your own color rather than one of the color buttons, you will see a Fuzziness slider, as in Figure 10.3. Use that to expand or contract the range of color shades you want to pop.

④ Making a selection, either with one of the color buttons or with the eyedropper, will open the second row of thumbnails.

⑤ Move your mouse across the top color buttons to compare the results when one color or another is highlighted.

⑥ As we have noted, Show All Colors is unchecked by default, which reduces all colors to black and white except the one you chose. Selecting

Show All Colors restores all the other colors except the one you chose to highlight.

⑦ Click on one of the thumbnails or move the slider to the Pop Color choice you want.

⑧ Zoom out to see the resulting change in your image.

⑨ Toggle the View Original button below the work area to compare your changes with the original image.

⑩ When you're satisfied with the Pop Color options you choose, select Apply to accept those choices and return to the main Edit window.

Because there are so many choices you can make, and variables within those choices, the best thing to do is experiment with combinations to see what yields the best results. Every image is different, with different color palettes and details, so Pop Color choices that you make in one image may not work the same in another. Play with it, see what it does, and have a great time!

Figure 10.3 This bull just tickles my funny bone, and he's just as silly-looking when he's bubblegum pink. We picked the color to highlight, which shows us the Fuzziness slider; moving it increases or decreases the range of color that gets Popped. The result is not quite as drastic (or comical) when Show All Colors is unchecked.

Pop Color Examples

Figure 10.4 In a picture where there are already many bright colors, Pop Color doesn't work very well if you choose a small color source. The effect is more pronounced if you let Photoshop.com choose skin tones or choose a larger color source yourself and increase the Fuzziness.

Figure 10.5 The background in the image doesn't have much color, so Pop Color doesn't have much effect on it—until you choose the skin tones! Selecting Show All Colors reveals the deep green in the vest, which makes a lovely contrast to his now-purple skin.

Figure 10.6 Lush in its native green, this plant looks like something from another planet when we replace the green with other colors.

Hue

Don't expect a lot of hue and cry over this attribute; it's easy to understand and change.

What Hue Means, and How It Changes Photos

Unlike Pop Color, which changes only one color or color range, Hue changes all your photo's colors at once. A much simpler effect, Hue offers fewer choices for variation. But they're good ones, washing your image in brilliant purple, red, orange, green, aqua, blue, and variations within those—or altering all the colors of your image so that they're the exact complements of their originals.

What You See in the Hue View

The Hue screen is much like what you see in the other Photoshop.com tools (see Figure 10.7):

❶ **Reset to original.** Back to the middle of the thumbnail row, our bailout button sits at the center of a range of colors.

❷ **Thumbnails.** With your original image at the center of an imaginary color wheel, each of the thumbnails is a measured distance within a 180-degree turn in each direction around the wheel.

❸ **Slider.** If you want to have finer control over the Hue, use the slider to move between the thumbnail images' regular intervals.

❹ **Picture-in-Picture.** Zoom in to see how the different Hue settings affect detail in your photograph; use the P-in-P tile to change your focus within the work area.

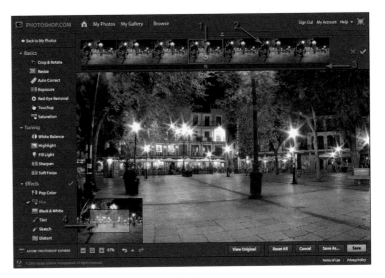

Figure 10.7 The Hue tool changes all of the colors in your image at once.

Working with Hue

The color wheels we learned in school, with their primary colors of red, yellow, and blue, actually don't work the same in imaging of any kind (it's the main reason why my spinning color wheel never turned white).

For imaging—painting, printing, and photography—red and yellow are actually near neighbors, making red's opposite cyan, not green. Primaries, therefore, in this color wheel are no longer red, yellow, and blue—they're red, *green*, and blue (which is where we get the RGB designation when working with color mixes).

What all this means for the Hue tool is that we're using various points around a 360-degree color wheel (see Figure 10.8) to change all the colors in our image relative to each other. From center, we go 180 degrees to the left (-180) to reach the exact complements of the colors in our original image, and 180 degrees to the right (+180) to reach the complementary colors from the opposite direction.

For images with a narrower range of colors, this results in a wash of color also within a narrow range. For images whose range of colors is broad, altering the Hue will move all the colors in relation to each other, resulting in an image that is still multicolored, but all skewed from the original.

Figure 10.8 Hue changes shift colors around the rim of this color wheel.

Despite the complexities of color theory, the *process* of altering your image's Hue is quite simple.

❶ In the Hue view of the Editing screen, move your mouse across the thumbnail images one at a time.

❷ Photoshop.com will project a preview of the updated hues over your image in the main work area.

❸ Zoom in to see how changing the Hue affects the details of your photo.

❹ If the alterations suggested by each thumbnail aren't quite right, you can move the slider back and forth for finer variations in Hue.

❺ Either selecting a thumbnail or a slider position will select that Hue option.

❻ Zoom out to see the effect your change has on the whole picture.

❼ When you have achieved the color you want, click the Apply checkmark to accept the change and return to the main Edit window.

Hue Examples

Figures 10.9-10.11 show some examples of hue adjustments.

Figure 10.9 Because this market square displays a relatively narrow range of colors, selecting a Hue washes the image in a narrow range of color. Note that some small details stand out in bright contrast in some views because they fall outside the mean color range.

Figure 10.10 Because this ceremonial costume's colors fall across the full range of colors, changing Hue turns the whole thing sideways, color-wise, but in the cropped version does not have the same color wash effect as in Figure 10.11.

Figure 10.11 The uncropped version of the same picture does show us amazing alien skies and dramatically alters the man's skin tones. The overall effect is much more dramatic in this view.

Black & White

Some images that are merely nice in color can be breathtaking in black and white. The play of light and shadow, without color, becomes more evident; details you don't notice in color stand out in sharp relief when reduced to blacks, grays, and whites. What might be otherwise ordinary pictures become art.

In other cases, it's not art but utility we're after—in the entertainment industry, for example, it is still a requirement to provide a black and white 8x10 glossy headshot.

And sometimes it's just cool.

What Black & White Means, and How It Changes Photos

You might think that converting an image from color to black and white is a simple, single step. It turns out there are options. Interestingly, shooting in color first and converting to black and white is more versatile than just shooting in black and white to begin with. During conversion, the color data can be used differently to produce different results. The colors we see become variants in shading only, but what happens if you filter those colors to stand out or step back?

What You See in the Black & White View

Photoshop.com offers a number of different conversion options. One of the simplest interfaces in the Editing toolkit, the Black & White tool offers a few simple options that yield dramatically different results.

However, instead of just a single button that simply discards all the color information in your picture, Photoshop.com offers multiple settings that filter individual color channels, having the effect of changing contrast and emphasis. When a color filter is used in this context, the corresponding colors and their neighbors are emphasized or de-emphasized in proportion to their proximity to the color being filtered. In other words, when you enable the red filter, everything red turns white, everything orange turns gray, yellow and magenta turn light gray, green and blue are darker, and cyan is black (see Figure 10.12).

❶ **Reset to original.** Once again at the beginning of the line, our old friend the Reset icon shows us the original color image in thumbnail form.

❷ **Desaturate.** Having the same effect as moving the slider in the Saturation tool all the way to the left, this setting simply removes all saturation from all colors.

❸ **Red filter.** This emphasizes colors on the red side of the color wheel, and darkens the complementary colors.

❹ **Green filter.** This emphasizes colors on the green side of the color wheel, and darkens the complementary colors.

❺ **Blue filter.** This emphasizes colors on the blue side of the color wheel, and darkens the complementary colors.

❻ **Light yellow filter.** This emphasizes colors on the yellow side of the color wheel, and darkens the complementary colors.

❼ **Orange filter.** This emphasizes colors on the orange side of the color wheel, and darkens the complementary colors.

Figure 10.12 Photoshop.com offers several conversion options that filter different colors to different shades of gray within the resulting image.

Working with Black & White

The advantage of so many conversion options is that you get to decide which details are important in your photograph, because each of the filters emphasizes different details. The colors in your original image also, of course, influence the result.

It's a fascinating tool—who knew that black and white would have so many variations?

Let's go through the process.

❶ In the Black & White view of the Edit screen, start moving your mouse slowly over each thumbnail in turn to see the preview results in the main work area.

❷ Zoom in on details to see how the different settings affect those details. Check the ones you want to emphasize to see how each setting causes it to respond, whether it comes forward in the image or lays back.

❸ Zoom out again to view the total picture.

❹ When you find a conversion type that you want, click on its thumbnail, then click the Apply checkmark to accept it and return to the main Edit window. Don't forget to save your work!

Black & White Examples

Figures 10.13 and 10.14 show some examples of black and white views.

Figure 10.13 Because the color of this beadwork is part of what makes it so amazing, it's not necessarily a good candidate to convert to black and white. However, the bright colors do very clearly show the differences between the conversion filters.

Figure 10.14 With strong colors in a similar palette, such as the ones in this portrait, the different black and white conversion methods yield surprising results.

Tint

Have you ever wondered how to get your cat to turn purple (well, besides taunting him with a sealed tank full of fish)? Or how they got that girl to turn blue in *Charlie and the Chocolate Factory*? Or how to make a picture in sepia tone so it gets that old-fashioned look?

The technique is called Tint and Photoshop.com gives you the power to do it.

What Tint Means, and How It Changes Photos

With the Tint tool, you are once again changing all the colors in your photograph at once, but unlike Hue, where the whole palette of colors in your image rotates around the color wheel in relation to one another, Tint moves all the colors to one side, coloring your image in monochrome—but not black and white.

What You See in the Tint View

Consistent with the other Edit tools, the Tint view shows you a row of thumbnails that preview your options (see Figure 10.15).

❶ **Reset to original.** Once again at the left end of the thumbnail row, your original image can always be restored by selecting the Reset icon.

❷ **Sepia tone.** Like those old-time Western photographs, this renders your image in tones of brown and beige.

❸ **Green.** Turn your cityscape into the Emerald City!

❹ **Cyan.** Or go underwater with a cyan tint.

❺ **Blue.** Chill things a bit with a blue tint.

❻ **Magenta.** Add the royal touch.

❼ **Red.** See things through a red haze.

❽ **Slider.** Find points in between the more straightforward colors of the thumbnail images: tune the color of your Tint more finely with the slider below the thumbnail images.

❾ **Picture-in-Picture.** In conjunction with the zoom tool, the P-in-P tile in the lower-left corner is back, so you can close in on detail and shift focus in the image work area.

Working with Tint

Because Tint washes your whole image in a single color, the process and the choices are pretty straightforward.

❶ In the Tint view of the Editing screen, move your mouse across the thumbnail images one at a time.

❷ Photoshop.com will project a preview of the updated color over your image in the main work area.

❸ Zoom in to see how changing the Tint affects the details of your photo.

❹ If the alterations suggested by each thumbnail aren't quite right, you can move the slider back and forth for finer variations in Tint.

❺ Either selecting a thumbnail or a slider position will select that Tint option.

❻ Zoom out to see the effect your change has on the whole picture.

❼ When you have achieved the color you want, click the Apply checkmark to accept the change and return to the main Edit window.

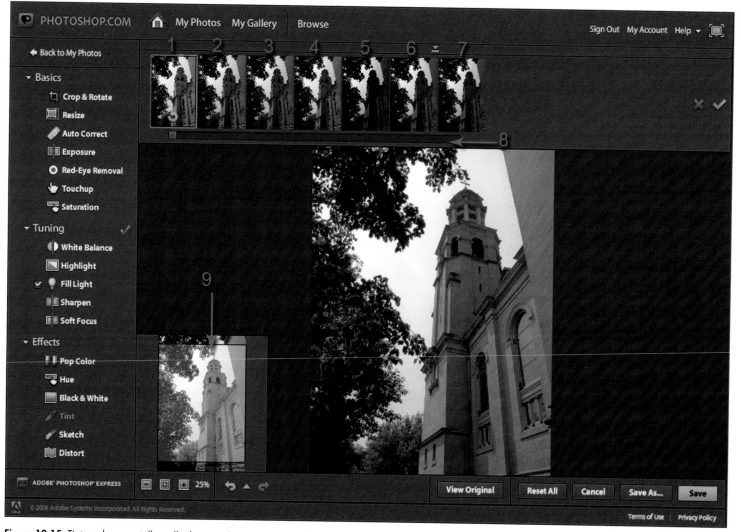

Figure 10.15 Tint works especially well when you have expanses of color—they really show off the alteration!

Tint Examples

Figures 10.16 to 10.18 offer some examples of tint adjustments.

Figure 10.16 The different Tints create such different moods in an image like this, already awash in green in its original form.

Figure 10.17 Taken with a mobile phone camera, the original image is grainy and lacks a bit in the Saturation department. The grainy quality turns out to be an advantage in Sepia tone, contributing to the aged look of the photo.

Figure 10.18 While changing it to Sepia tone doesn't do much for this action shot, the other Tints do—you could match an image like this to the colors of a team website, for example, and use it as an exciting background or splash page image… or as the background to your Photoshop.com slideshow!

Sketch

You've seen them—photographs that look like drawings, or are they drawings that look like photographs? They're so good it's hard to tell. How do they *do* that?

With Photoshop.com, you now have the ability to turn your photograph into a very interesting drawing.

What Sketch Means, and How It Changes Photos

Offering a limited (presumably growing) range of options, Sketch in its current form on Photoshop.com functions like an exaggerated version of the Sharpen tool. Like Sharpen, it heightens the distinction between colors by snapping pixel colors to

their nearest neighbors and sharpening lines between them. Sketch goes further, though, and snaps expanses of color together—reducing detail and creating what seem to be broader strokes of color, with sharp edges.

The end result is a picture that looks most like an ink drawing or a watercolor with intense paint colors, in varying levels of detail.

What You See in the Sketch View

Because Photoshop.com is an online service, there's a good chance that Adobe will be continually expanding the tools it offers here (we'd be very surprised if they didn't), including the Sketch tool. In its state at the time of this

writing, here's what it looks like (see Figure 10.19):

❶ **Reset to original.** That saving grace, the Reset button, remains at its place at the left end of the thumbnail row.

❷ **Thumbnails.** Each of the thumbnail views shows you what your image looks like when pixel colors are snapped together differently, emphasizing different colors and details.

❸ **Slider.** Not of much use at the moment because the changes in the Sketch adjustments snap to those set in the thumbnails, the slider will—we assume—eventually offer finer control over the level of detail.

❹ **Picture-in-Picture.** As in other tools, when you zoom in on detail, the P-in-P tile in the lower left lets you move around and shift focus to different areas of your image in the work area.

Working with Sketch

It's interesting to see how detail in a photo shifts around as color groupings are snapped together differently. The result can be more detail, or less, as darker and lighter areas attract smaller and larger amounts of color. Here's how it works:

❶ In the Sketch view of the Editing screen, move your mouse across the thumbnail images one at a time.

❷ Photoshop.com will project a preview of the updated Sketch over your image in the main work area.

❸ Zoom in to see how changing the Sketch setting affects the details of your photo.

❹ Either selecting a thumbnail or a slider position will select that Sketch option.

❺ Zoom out to see the effect your change has on the whole picture.

❻ When you have achieved the effect you want, click the Apply checkmark to accept the change and return to the main Edit window.

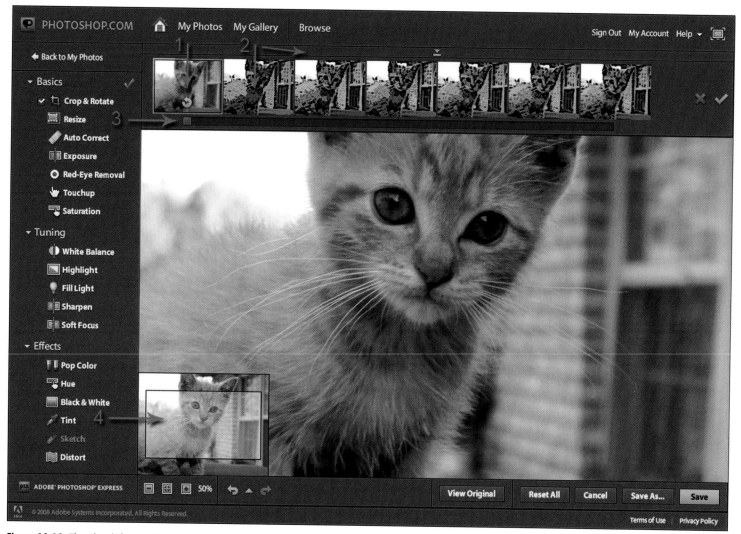

Figure 10.19 The Sketch feature lets you turn a photo into an ink drawing.

Sketch Examples

Figures 10.20-10.22 show examples of sketch effects.

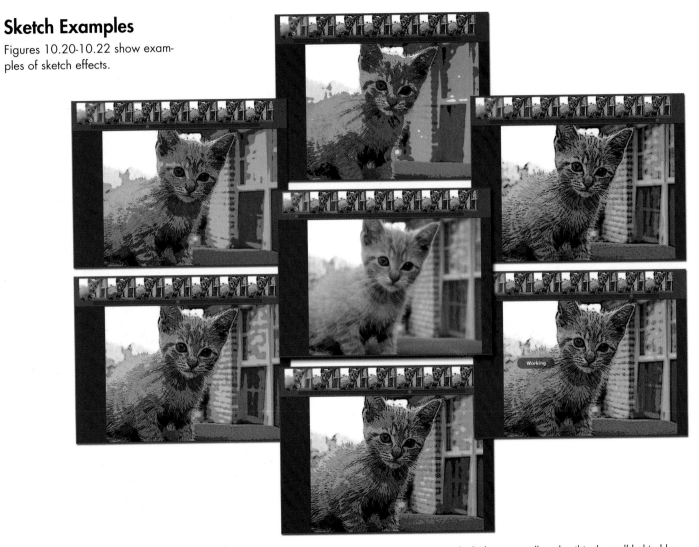

Figure 10.20 Different Sketch settings emphasize and de-emphasize kitty's fur, eyes, and whiskers, as well as detail in the wall behind her.

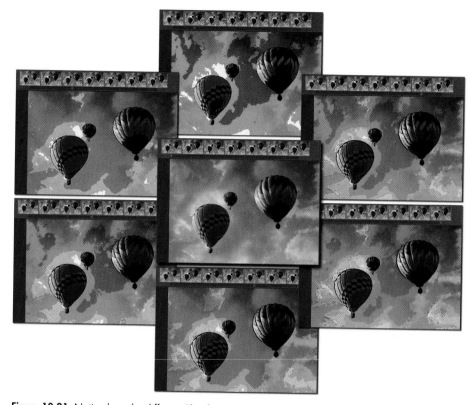

Figure 10.21 Notice how the different Sketch settings result in different textures in the sky, and in the colors of the balloons and their borders.

Figure 10.22 Effect on effect—the ghost images in this photograph are already very interesting, particularly with such haunting lighting. Sketch makes the photograph look like something out of a (really good) graphic novel.

Working with Distort

Now at last we come to the end, and I think the folks at Photoshop.com saved the best—or at least the most fun—for last.

This is where we get to give our critters or our humans buggy eyes, project our buildings onto spheres, or put our best friend in front of the funhouse mirror.

What Distort Means, and How It Changes Photos

In all the other tools in Photoshop.com, no matter how much you touch up, tweak, tint, or otherwise alter pixels, the pixels stay where they are.

With the Distort tool, we're moving them around in various ways. You can twist up your whole photo, or just part of it, make it fuzzy or pixilated, and more. And the possibilities within each of these options are nearly endless.

What You See in the Distort View

The Distort screen is a little different from most of the other features in the Editing toolkit. Similar to the Pop Color feature, selecting one of the primary options opens a secondary function—the slider—to refine details.

Here's what you see when you first open the Distort view (see Figure 10.23):

❶ **Reset to original.** Instead of its familiar place among a row of thumbnail images, the Reset button is now back with its mates in the upper-right corner.

❷ **Twirl.** Stir up your image with the Twirl function.

❸ **Stretch.** The photographic equivalent of a taffy pull, this gives you the ability to stretch or pinch your image.

❹ **Bulge.** This is the one time when you might want a little extra around the middle.

❺ **Ball shape (sphere or globe).** Your image can look like a globe with this function.

❻ **Fuzz out the details.** Just like those secret confessions on TV (which is silly, because if they're on TV, it's not a secret any more) where the Mafia dude's face looks like a mess of fuzzy pixels, you can hide features behind this function.

❼ **Slider.** Depending on which of the above Distort tools you choose, this slider controls how much or how little distortion, what angle, what depth, what extent, etc.

◆ When you choose Twirl, the slider controls the angle of the twirl, resulting in a clockwise or counterclockwise twist.

◆ Choosing Stretch reveals two sliders: one for angle and one for amount.

◆ Selecting Bulge shows a single slider again, controlling the amount (depth) of the bulge, and can be either a positive or negative bulge.

◆ Selecting Ball Shape also shows a single slider to control the amount—in this case, how much of the globe appears above the surface of your image.

◆ With Fuzz out the details, the slider controls the extent of the fuzz, with the negative (left) end being a complete blur and the positive (right) end being gradually larger pixels.

❽ **Target area.** Click and drag a circular or oblong target area for your distortion effect. For some of the effects, you can make the area large enough to encompass the entire image, or only distort parts of it.

> ### Note
> With each of the Distort tools, you can play with a single area or multiple areas within your image.

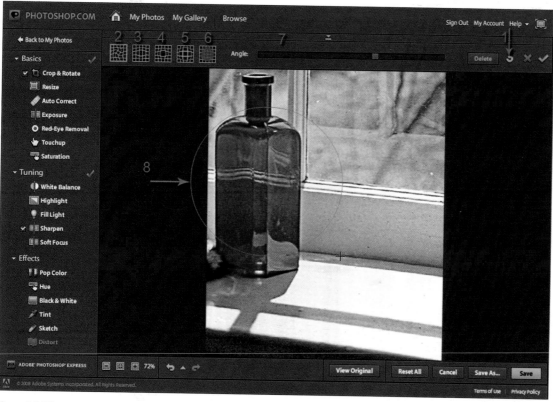

Figure 10.23

Working with Distort

Exploring the Distort tool is a little less simple than the other Edit tools because there's no preview capability. So you must:

❶ Select an effect to work with.

❷ Click and drag your mouse over a target area on your image. A blue target frame will appear as a circle or vertical or horizontal oval, depending on the angle at which you drag your mouse across the image. Changing the angle changes the shape of the image.

❸ Release the mouse button to apply the Distortion feature to the working image.

❹ With the slider(s), control the depth and/or extent of the distortion within your target area.

❺ You can also change the size and shape of your target area after the distortion is applied by clicking and dragging from inside the frame to move it, or clicking and dragging on a border handle at the edge to resize or reshape it.

❻ Okay, you've had your fun. Now click the Apply checkmark to make it stick.

Distort Examples

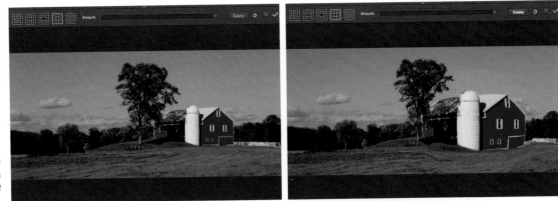

Figure 10.24 Adding Globe distortion to this barn gives us the effect of looking at it through a magnifying glass.

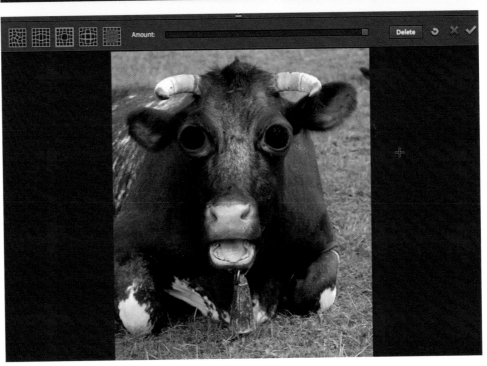

Figure 10.25 This poor bull. We've laughed at him all the way through the book, and now the final insult: we bulge his eyes out. Is it something we said? Or did he just get goosed?

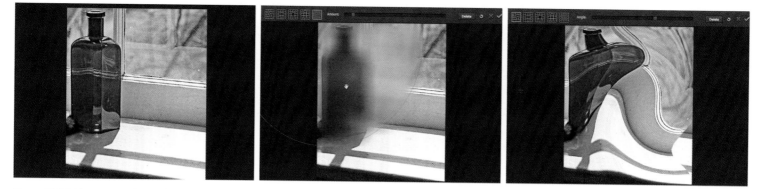

Figure 10.26 This is your photo. This is your photo on drugs. This is your photo on martini with a twist.

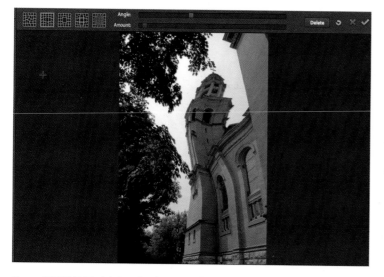

Figure 10.27 With the Stretch amount on the negative side of the scale, it becomes a reverse stretch, actually a pinch, and has an interesting effect on the otherwise, er... straightforward lines of this church.

Figure 10.28 Nobody can know who this guy is, or else his goose is cooked. So we fuzzed out his face.

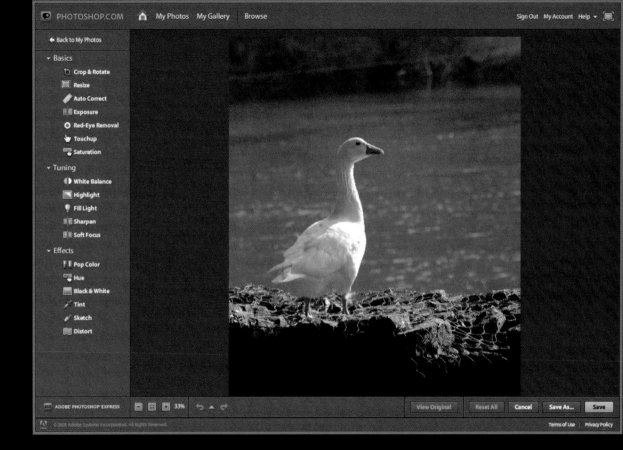

Glossary

aspect ratio The proportions of an image as printed, displayed on a monitor, or captured by a digital camera. An 8 x 10-inch or 16 x 20-inch photo each has a 4:5 aspect ratio. When you change the aspect ratio of an image, you must crop out part of the image area, or create some blank space at top or sides.

backlighting A lighting effect produced when the main light source is located behind the subject. Backlighting can be used to create a silhouette effect, or to illuminate translucent objects.

blowup An enlargement, usually a print, made from a negative, transparency, or digital file.

blur In photography, to soften an image or part of an image by throwing it out of focus, or by allowing it to become soft due to subject or camera motion. In image editing, blurring is the softening of an area by reducing the contrast between pixels that form the edges of details in the image.

bounce lighting Light bounced off a reflector, including ceiling and walls, to provide a soft, natural-looking light.

brightness The amount of light and dark shades in an image, usually represented as a percentage from 0 percent (black) to 100 percent (white).

cast An undesirable tinge of color in an image.

color correction Changing the relative amounts of color in an image to produce a desired effect, typically a more accurate representation of those colors. Color correction can fix faulty color balance in the original image, or compensate for the deficiencies of the inks used to reproduce the image.

composition The arrangement of things in an image, including the main subject, other objects in a scene, and/or the foreground and background.

contrast The range between the lightest and darkest tones in an image. A high-contrast image is one in which the tones are primarily black and white, with few shades in the middle. In a low-contrast image, the tones are closer together, mostly in the middle, with few, if any true blacks and whites.

contrasty Having higher than optimal contrast.

crop To trim an image or page by adjusting its boundaries.

depth-of-field A distance range in a photograph in which all included portions of an image are at least acceptably sharp.

desaturate To reduce the purity or vividness of a color, making a color appear to be washed out or diluted.

diffuse lighting Soft, low-contrast lighting.

diffusion Softening of detail in an image by randomly distributing gray tones in an area of an image to produce a fuzzy effect. Diffusion can be added when the picture is taken, often through the use of diffusion filters, or in post-processing with an image editor. Diffusion can be beneficial to disguise defects in an image and is particularly useful for portraits of women.

existing light In photography, the illumination that is already present in a scene. Existing light can include daylight or the artificial lighting currently being used, but it is not considered to be electronic flash or additional lamps set up by the photographer.

exposure The amount of light used to make a picture; too little results in a photo that's too dark (underexposure); too much gives you a photo that's too light (overexposure).

fill lighting In photography, lighting used to brighten shadows. Reflectors or additional incandescent lighting or electronic flash can be used to brighten shadows. One common technique outdoors is to use the camera's flash as a fill. Or, you can use Photoshop.com to lighten dark areas to produce the same effect.

framing In photography, composing your image in the viewfinder. In composition, using elements of an image to form a sort of picture frame around an important subject.

high contrast A wide range of density in a print, negative, or other image.

highlights The brightest parts of an image containing detail.

image rotation A feature found in some digital cameras, which senses whether a picture was taken in horizontal or vertical orientation. That information is embedded in the picture file so that the camera and compatible software applications automatically can display the image in the correct orientation.

lens One or more elements of optical glass or similar material designed to collect and focus rays of light to form a sharp image on the film, paper, sensor, or a screen.

monochrome Having a single color, plus white. Grayscale images are monochrome (shades of gray and white only).

negative A representation of an image in which the tones are reversed: blacks as white, and vice versa.

noise In an image, pixels with randomly distributed color values. Noise in digital photographs tends to be the product of low-light conditions and long exposures, particularly when you have

set your camera to a higher ISO rating than normal.

overexposure A condition in which too much light reaches the film or sensor, producing a dense negative or a very bright/light print, slide, or digital image.

panorama A broad view, usually scenic. Many digital cameras have a panorama assist mode that makes it easier to shoot several photos that can be merged or stitched together later.

pixel The smallest element of a screen display that can be assigned a color. The term is a contraction of "picture element."

portrait The orientation of a page in which the longest dimension is vertical, also called tall orientation. In photography, a formal picture of an individual or, sometimes, a group.

red eye An effect from flash photography that appears to make a person's eyes glow red, or an animal's yellow or green. It's caused by light bouncing from the retina of the eye, and it is

most pronounced in dim illumination (when the irises are wide open) and when the electronic flash is close to the lens and therefore prone to reflect directly back. Image editors can fix red eye through cloning other pixels over the offending red or orange ones. Photoshop's Red Eye Tool can quickly remove such color casts.

resize To change the size or resolution of an image.

retouch To edit an image, most often to remove flaws or to create a new effect.

saturation The purity or richness of color.

sensitivity A measure of the degree of response of a sensor to light, measured by the ISO setting of your camera. Higher ISO numbers equal more sensitivity, or the ability to shoot in less light.

shadow The darkest part of an image, represented on a digital image by pixels with low numeric values or on a halftone by the smallest or absence of dots.

sharpening Increasing the apparent sharpness of an image by boosting the contrast between adjacent pixels that form an edge.

tint A color cast added to an image.

underexposure A condition in which too little light reaches the film or sensor, producing a thin negative, a dark slide, a muddy-looking print, or a dark digital image.

vignetting Dark corners of an image, often produced by using a lens hood that is too small for the field-of-view, or generated artificially using image-editing techniques, often to highlight an image such as a portrait.

white balance The adjustment of a digital camera to the color temperature of the light source. Interior illumination is relatively red; outdoors light is relatively blue. Digital cameras often set correct white balance automatically, or let you do it through menus. Image editors can often do some color correction of images that were exposed using the wrong white balance setting.

zoom In image editing, to enlarge or reduce the size of an image on your monitor. In photography, to enlarge or reduce the size of an image using the magnification settings of a lens.

Index

MAXIMIZE
YOUR DIGITAL SLR CAPABILITIES!

Course Technology PTR has the resources digital SLR photographers need to take professional-quality pictures. Our dSLR-focused books will show you how, when, and why to use all the cool features, controls, and functions of your camera to take great photographs of anything. Written by David D. Busch, a best-selling author and experienced digital photographer, and filled with expert tips and techniques, our books have the information you need to become a dSLR pro!

David Busch's Nikon D60 Guide to Digital SLR Photography
1-59863-577-8 • $29.99

David Busch's Quick Snap Guide to Using Digital SLR Lenses
1-59863-455-0 • $29.99

Canon EOS 40D Guide to Digital SLR Photography
1-59863-510-7 • $29.99

David Busch's Nikon D300 Guide to Digital SLR Photography
1-59863-534-4 • $29.99

Canon EOS Digital Rebel XTi/400D Guide to Digital SLR Photography
1-59863-456-9 • $29.99

Mastering Digital SLR Photography 2E
1-59863-401-1 • $39.99

Canon EOS Digital Rebel XT Guide to Digital SLR Photography
1-59863-337-6 • $29.99

Quick Snap Guide to Digital SLR Photography
1-59863-187-X • $29.99

Canon EOS 30D Guide to Digital SLR Photography
1-59863-336-8 • $29.99

Digital SLR Pro Secrets
1-59863-019-9 • $39.99

Course Technology PTR books are available at fine retailers nationwide and your local bookstore.
See our complete list of titles and order at www.courseptr.com or call 1-800-354-9706.